# Behind THE CROWN

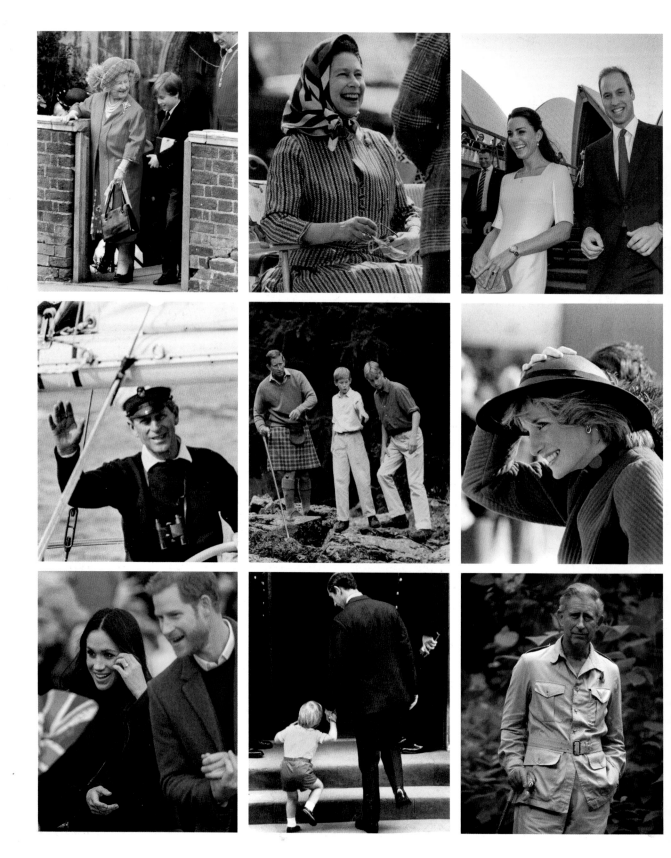

# Behind THE CROWN

*My Life Photographing the Royal Family*

# Arthur Edwards MBE

HARPER

*An Imprint of* HarperCollins*Publishers*

HarperCollins books may be purchased for educational, business, or sales promotional use. For information, please email the Special Markets Department at SPsales@harpercollins.com.

Originally published in the United Kingdom in 2022 by HarperCollins*Publishers.*

FIRST U.S. EDITION

Design and layout by Louise Leffler

Library of Congress Cataloging-in-Publication Data has been applied for.

ISBN 978-0-06-332297-4

22 23 24 25 26   LSC   10 9 8 7 6 5 4 3 2 1

# Contents

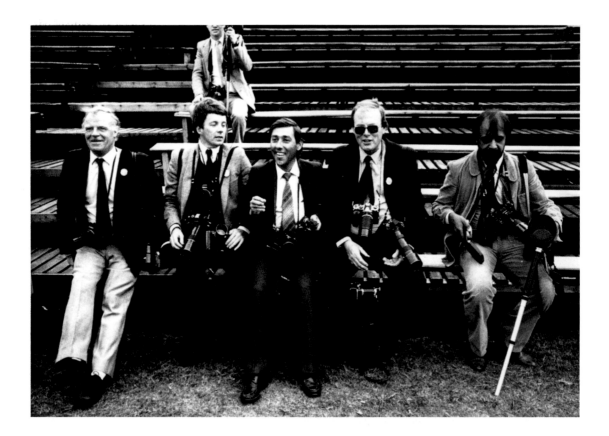

# Introduction

Every Christmas morning I set off from my Essex home for the 100-mile drive to Norfolk to see what you might call 'the other family' in my life. Whatever the weather, I have to be at St Mary Magdalene Church in Sandringham before 11am for the Windsor dynasty's traditional festive service. These days I take my wife Ann with me, but in years gone by it's been a wrench leaving behind her and my three, now grown-up, children John, Paul and Annmarie.

For 45 years I've chronicled the Royal Family for the *Sun* newspaper with my camera. I've witnessed their triumphs and disasters, their laughter and tears, when they've found love and when their relationships splinter. I'm there when they emerge from the maternity wing as wailing newborns and I'm there again when they marry before a joyous nation. And when they're laid to rest on those solemn occasions that this country marks so well, I'm on hand to capture history being made.

▲ The Royal Rat Pack taking a break on tour. From the left: the *Daily Express*'s Stan Meagher, freelance Tim Graham, the *Daily Mail*'s James Gray, myself and freelance Anwar Hussain.

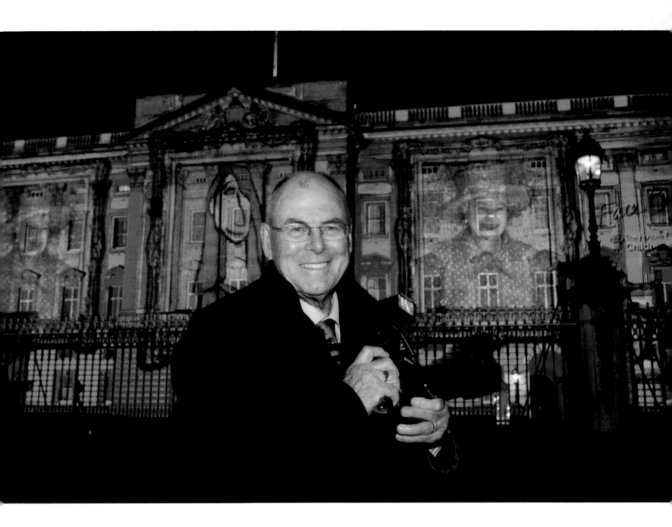

In September I was at Westminster Abbey for our late Queen's state funeral as dignitaries from across the globe looked on.

So on Christmas morning, I'm at Sandringham in good time to make sure I have the best position among the other waiting media. Often it's so cold that the Royal party's breath fills the air like steam from an old-fashioned train, as they wrap up in fancy overcoats. Others would prefer to be at home with a sherry and a mince pie, but I'm more than happy to be there every year. It's my job, it's what I do, it's who I am.

After over four decades of photographing the Windsors I'd like to think I've developed something of a rapport with them, particularly our new King Charles III and his lovely wife, the Queen Consort. Mind you, there have been a few hiccups along the way.

Back in 1980 I was trudging down a track on Prince Charles's Gloucestershire estate, Highgrove. I hadn't joined the Ramblers'

▲ My portrait of the Queen was projected onto the side of Buckingham Palace alongside childrens' paintings of the monarch in 2012. It was a proud moment for this Fleet Street photographer.

**Clockwise from top left:**

Prince Charles is reprimanding me for a picture I took of his bald spot that was splashed on the front page of the *Sun* in 1977.

Two pensioners having a friendly chat during an engagement. One just happens to be the heir to the throne.

This is the 70th birthday cake that the *Sun* baked for the Prince in 2018. The 70 *Sun* readers who attended were all given a slice to take home.

I produced an album of some of the best pictures of the Prince that I had taken. He looked delighted.

Prince Charles at a 70th-birthday tea party organised by the *Sun* at Spencer House, in London.

I was laughing at one of Charles's jokes on a Press visit. He's renowned for his great sense of humour.

Association – I was using a public footpath to get closer to the house for some long-lens shots. Suddenly, in the distance, I saw a horseman galloping towards me across the springy turf. As the mounted figure came closer, I could make out a red-faced and irate heir-to-the-throne in the saddle.

The Prince bellowed, 'What are you doing on my land?'

I replied, 'It's not your land. It's a public footpath, and I'm just doing my job.'

Charles icily retorted, 'Some job.'

'Well, at least I have a job,' I shot back.

The Prince turned puce with rage, gathered his reins and galloped off.

One of the police protection officers on duty later told me that they were having a coffee break at Highgrove when the Prince stormed in, banged his whip on the table, and yelled: 'You're supposed to be guarding me, and Arthur Edwards is on my front lawn!'

Slowly, our relationship thawed, but it wasn't until 2004 that things really changed. The then Education Secretary Charles Clarke had branded the Prince old-fashioned and out of touch, so I went in to bat for him in the pages of the *Sun*. I pointed out that his views on organic farming, architecture and health had become mainstream, writing, 'You could call him a visionary.' He read the piece and realised how much I admired him.

Today Charles calls me Arthur and I call him Your Majesty. On my landmark birthdays I receive cards and gifts from the

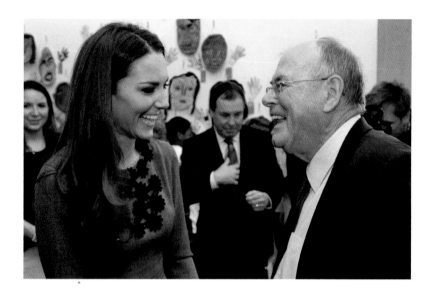

Chatting to the Duchess of Cambridge at a photography exhibition at Dulwich College, south London, in 2012.

This painting of me by Catherine Goodman was exhibited at the National Portrait Gallery. The Duchess of Cornwall kindly opened the exhibition in 2014. I now have the picture in my home.

Dancing to Bill Haley's 'See You Later, Alligator', with Camilla at a Royal Voluntary Service tea dance in Bristol in 2017. She said: 'We should go on *Strictly Come Dancing*, but don't tell my husband.'

All wrapped up for winter as Prince William leaves a church service. You're out in all weathers in this job.

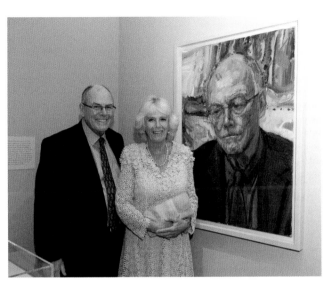

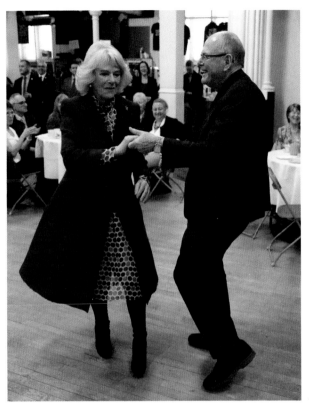

King. For his 70th birthday in 2018 I organised a party for Charles, with 70 *Sun* readers who were also celebrating the arrival of their seventh decade. He loved it. I have huge respect for how hard he works and how passionately he has campaigned on issues like the environment.

I've covered more than 200 Royal tours in over 120 countries. Sometimes it felt like my feet hardly touched the ground. Along the way I've photographed seven Royal weddings, five funerals and seven births. I travelled the world with Princess Diana – a woman who looked like a film star but had the compassion of a nun. I've met presidents and popes and was greeted by Nelson Mandela with the words, 'Welcome to South Africa.' Not bad for an East End boy who left school at 15.

I was born in August 1940 in Epping, Essex, before being taken home to East India Dock Road, Stepney, in east London. My dad – also called Arthur – was a lorry driver and my mum Dorothy ran the house. A month later Adolf Hitler unleashed the Luftwaffe on Britain and one night our home was blown to smithereens while we were hiding in a bomb shelter. I was evacuated to Bideford, in Devon. If I'd stayed in the East End I might not be here to write this today.

Dad died when I was 16 and Mum worked as an office cleaner to put food on the table. She didn't want me to end up working in the docks like most of my school mates, so she saved up to buy me a £46 Rolleiflex camera. That was a fortune to her, I don't know how she did it.

After leaving school, I got a job in a film-processing

▲ On tour in India with the Prince of Wales. It's one of my favourite countries.

▲ At the Concert for Diana in 2007. William and Harry invited my wife Ann and me to the Royal box.

▶ Having a rest in St James's Park after a frantic day covering the Diamond Jubilee in 2012. The empty champagne bottle is nothing to do with me.

darkroom before becoming assistant to top fashion photographer John French. But haute couture wasn't really my thing, so I got a job at the *East London Advertiser* and never really looked back. In 1975 I joined the *Sun* and loved its cocky attitude and brash humour. I did my first Royal tour in 1977 and truly found my calling.

You can't do this job as long as I have without having a fondness and respect for the monarchy. They've had to adapt and change over the decades. I've watched the age of deference pass into the era of instant social-media coverage, where everyone has a camera on their phone.

We have all been so lucky to live through the second Elizabethan age. Over 70 years, the Queen led by example with quiet dignity whenever this nation's back has been against the wall. I was so proud when she presented me with my MBE in 2003. At the investiture Her Majesty said, 'So let's have our picture taken together.' Her passing was a traumatic experience for both myself and the country. The ten days of mourning, with such an outpouring of national emotion, will stay with me forever.

My journey from Stepney to Buckingham Palace couldn't have happened without the support of my dear wife Ann. I'm now 82 and this Christmas I'll be heading for Sandringham once more. I never tire of photographing our Royal Family and I still get a thrill seeing my pictures published. That's the oxygen that keeps me going.

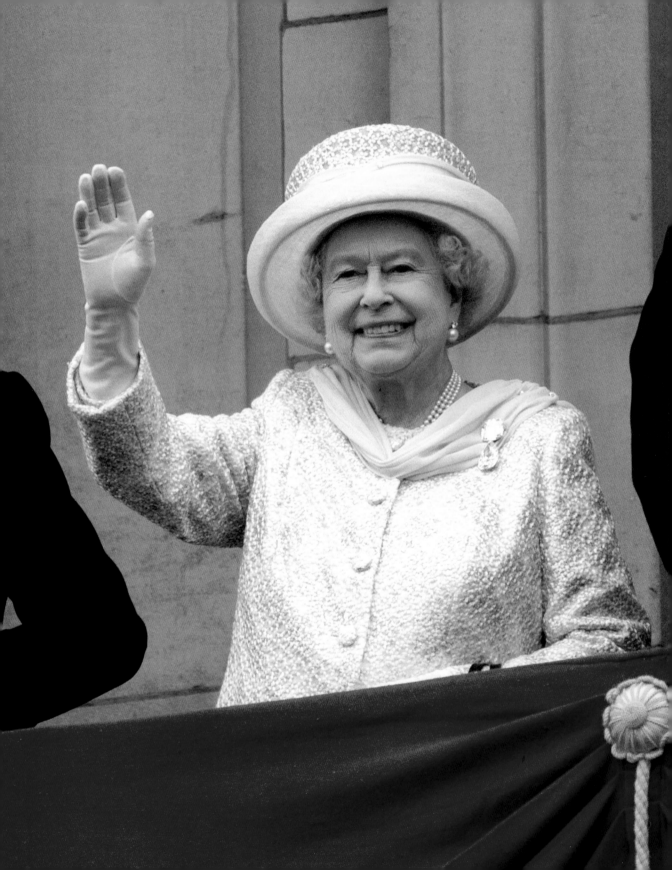

# Queen Elizabeth II

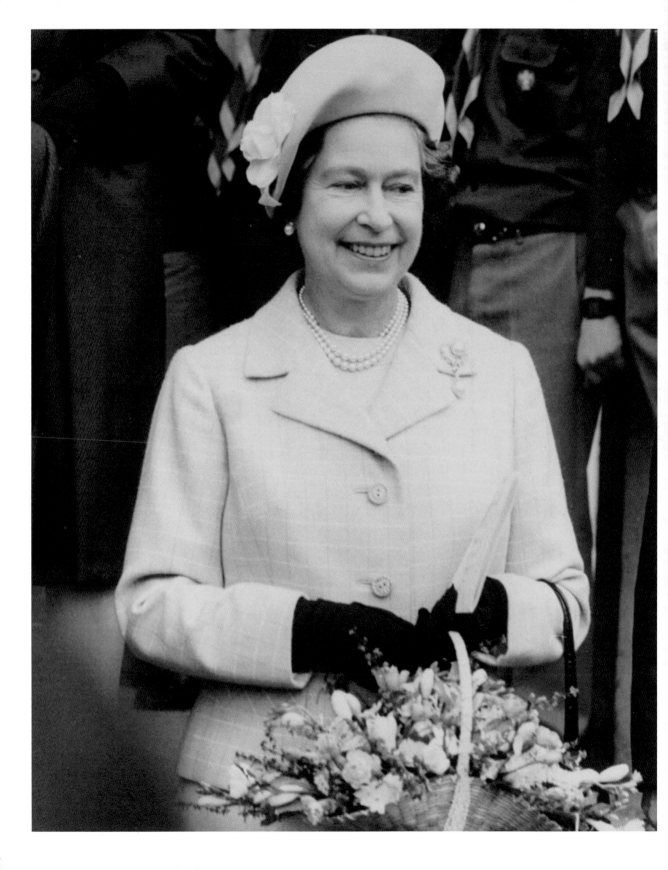

# Queen Elizabeth II

*I*n all the years that I photographed the Queen, I followed her right around the globe, and an overseas tour was always ultra special. When you travelled with the Queen you would see some amazing things and how wonderful Her Majesty was and how she coped with it all. Whether it was a welcome on the White House lawn or in the Pope's Vatican Library, it was history in the making. I've done more than 200 overseas Royal trips but the one I remember most vividly is the Queen's visit to Ireland in 2011. It was a pivotal moment; no British monarch had travelled there for a hundred years. It was so poignant when she laid a wreath at the Garden of Remembrance where those who died fighting for Irish independence from Britain are commemorated. Later she attended a concert at the Convention Centre in Dublin, and when she thanked the performers, the audience stood up and applauded her for five minutes. You could see in her eyes how much that meant. Our longest-reigning monarch, the Queen will be remembered for being probably the most-loved person in Britain, which was reinforced by her 2022 Jubilee.

◀◀ **The diamond of our nation, 2012**

The Queen took to the balcony at Buckingham Palace with her family to greet the hundreds of thousands of well-wishers who turned out to celebrate 60 years of her reign. Sadly Prince Philip was in hospital for the Diamond Jubilee celebrations.

◀ **The flowering of a monarch**

As Patron of The Scout Association, the Queen attended a service at St John's Church in central London.

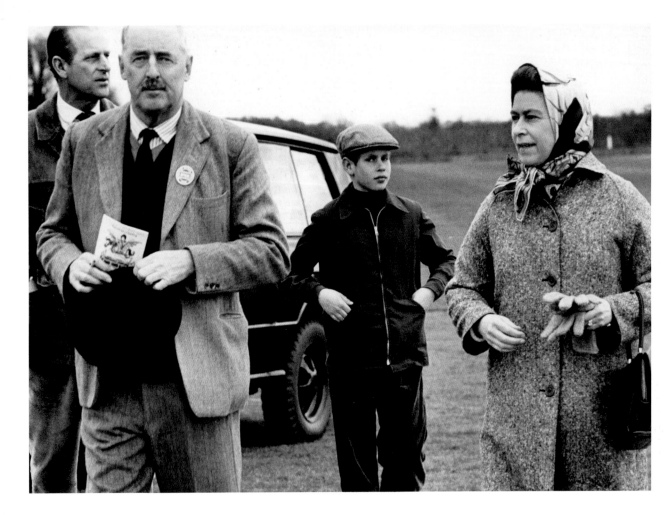

**▲ A family day out, 1976**

In 1976, I got to photograph The Queen for the first time. I was at the Windsor Horse Show waiting to see if Charles might turn up with a girlfriend. Instead, I photographed Her Majesty getting out of a car with Prince Philip and Prince Edward.

'Suddenly this Range Rover pulled up and out got the Queen, the Duke of Edinburgh and Prince Edward. The Queen wore a headscarf and Edward a lovely cap. It was my first picture of the Queen. There would be thousands more.'

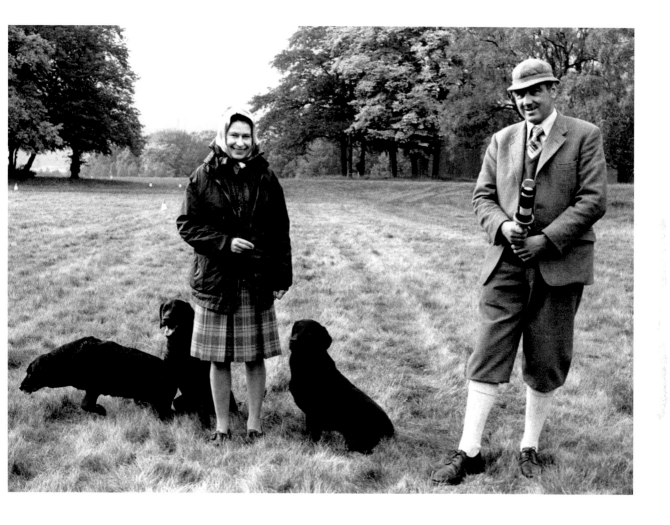

▲ **The Queen with trusted kennelman Bill Meldrum**

The Queen was most commonly associated with her beloved corgis, but at her Sandringham estate the labradors were real favouites. Bred from the Sandringham strain of Labrador since 1911, all of the Royal dogs are working animals, and many are also Field Trial Champions.

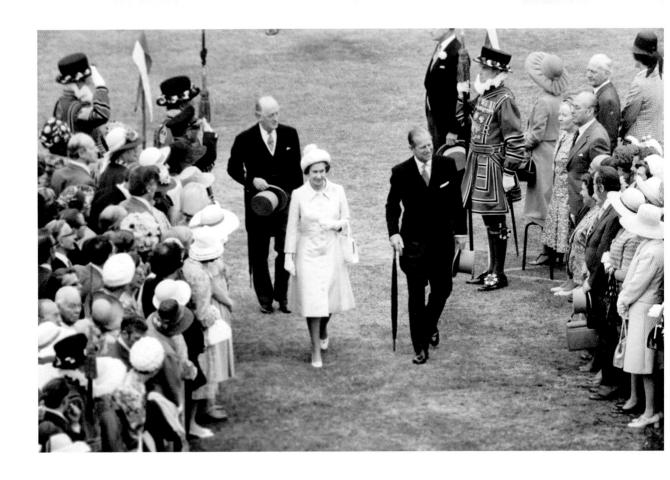

**▲ The Queen and Prince Philip, 1977**

**▶ Remembering the fallen, 1976**

The Queen's Garden Parties were a regular summer event throughout her reign. It is a less formal occasion on which Her Majesty was able to meet invited guests.

The Queen always took great pride in laying a wreath on behalf of the nation at the Cenotaph on Remembrance Sunday. She did so for the final time in 2017.

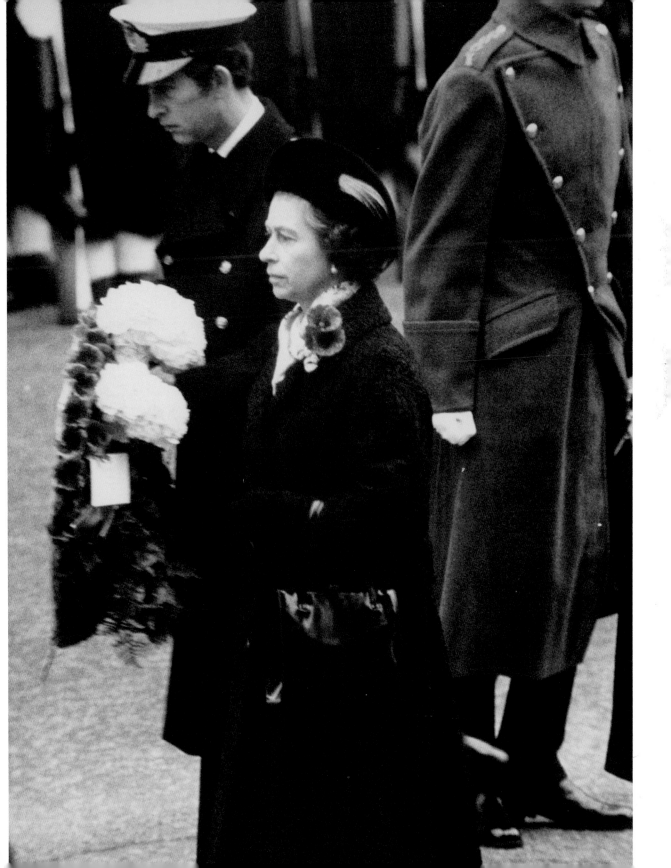

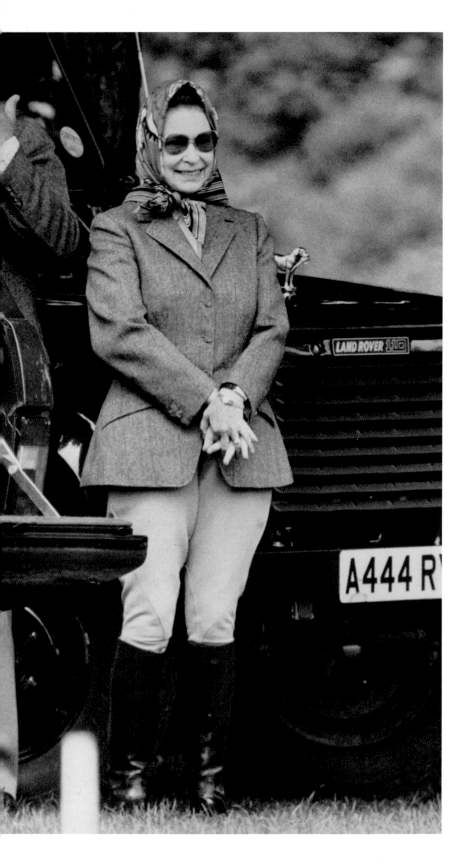

**◀ Perfectly dressed from head to toe**

The Queen's love of a headscarf dated back to the 1940s. It was her most favoured accessory while out riding, at the Windsor Horse Show and while on her estates. They were always beautifully coordinated with her clothes and gloves, of course.

**▶ A shared passion, 1978**

This was one of my earliest shots of the Queen. It's a lovely moment captured for posterity of mother and daughter, two great horsewomen out on the Sandringham Estate.

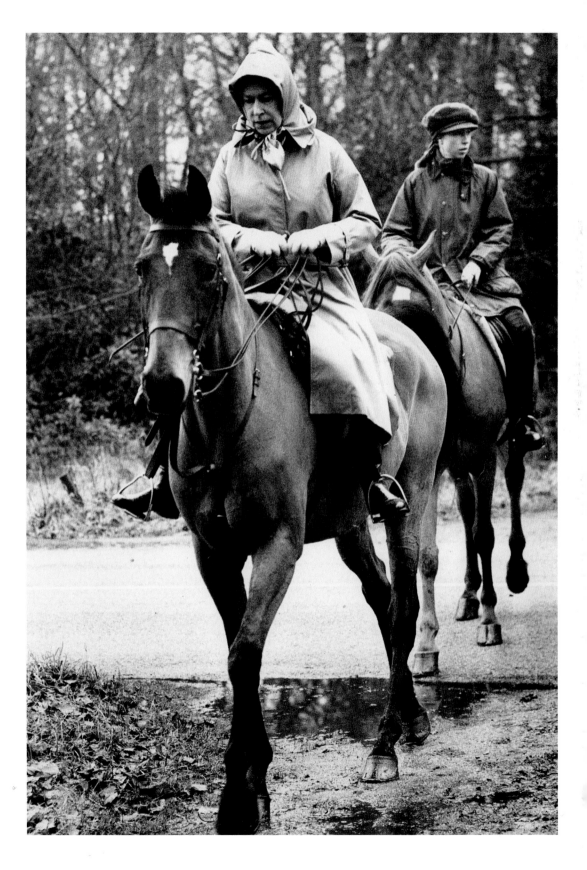

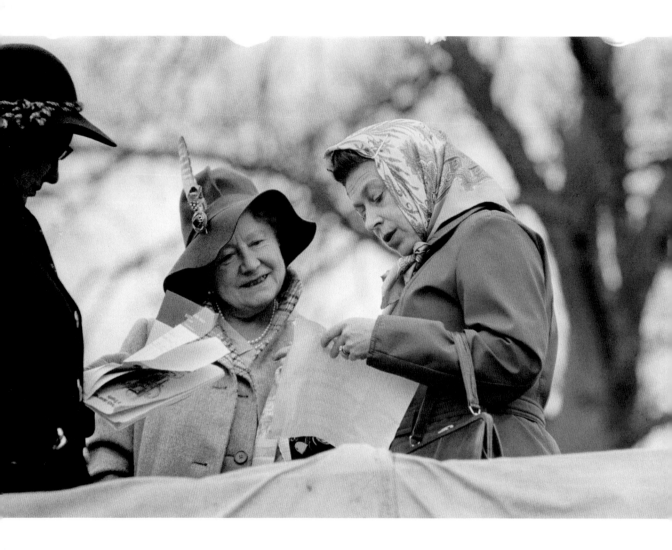

**▲ Checking out the form, 1979**

The Queen and her beloved mother
shared a love for horses and a
huge knowledge of all the entered
competitors. Here at Badminton
Horse Trials they looked like they
were sharing tips!

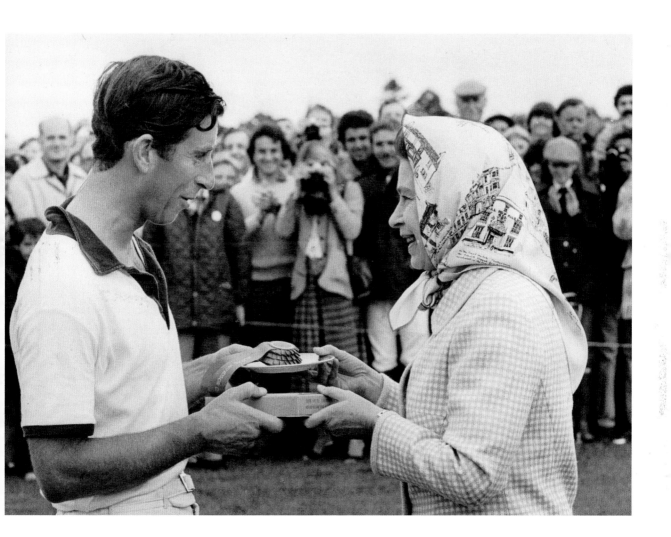

**▲ Proud mother, 1978**

The Queen had the joyful duty of presenting her son Charles with the runners-up trophy at a polo match at Windsor.

'The warm smiles exchanged between the Queen and Prince Charles says everything you need to know about their relationship.'

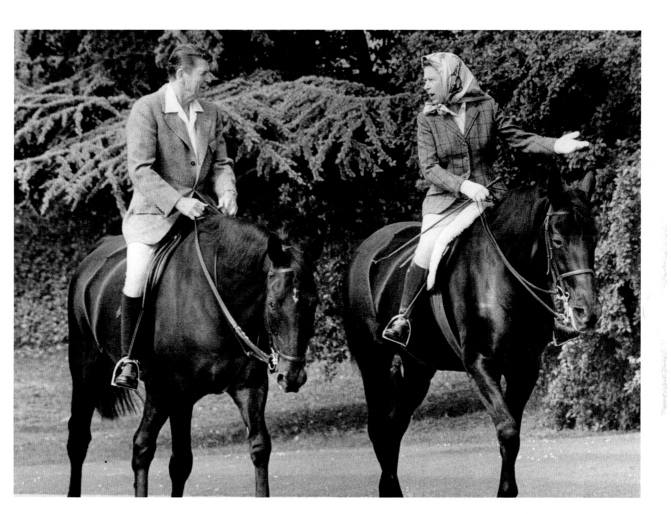

**◀ In her element at Windsor Horse Show, 1981**

When the Duke of Edinburgh used to compete in carriage driving at the Windsor Horse Show you could see Her Majesty's face change. She was concerned when he made a mistake and cheered him on when he won. When those moments came you had to be quick to capture them.

**▲ An unlikely friendship, 1982**

The Queen took a less formal approach for this Press photocall for the State visit of the 40th President of the United States, Ronald Reagan, to Windsor Castle. Her Majesty took the fellow horse lover and confident rider on an hour-long ride around the estate, which left his Secret Service outriders in a state of near panic!

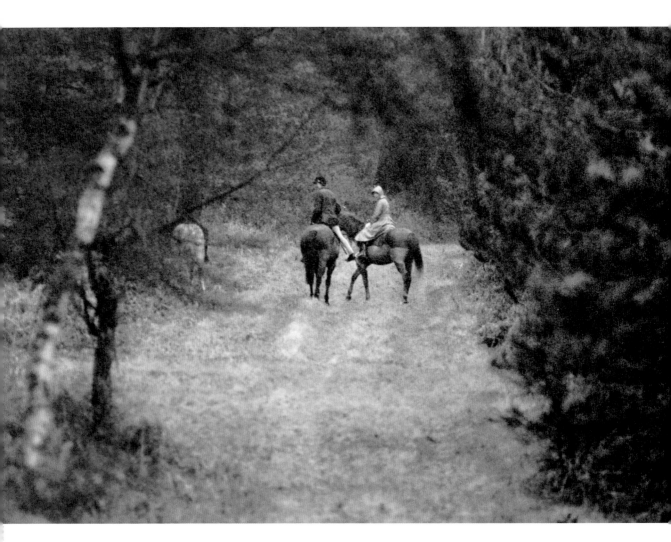

'Unlike the Queen, Diana was
never comfortable horse riding.
These rare images were captured
on the Sandringham Estate.'

▲ **Getting to know the family, 1983**

The Queen and Princess Diana out
riding together.

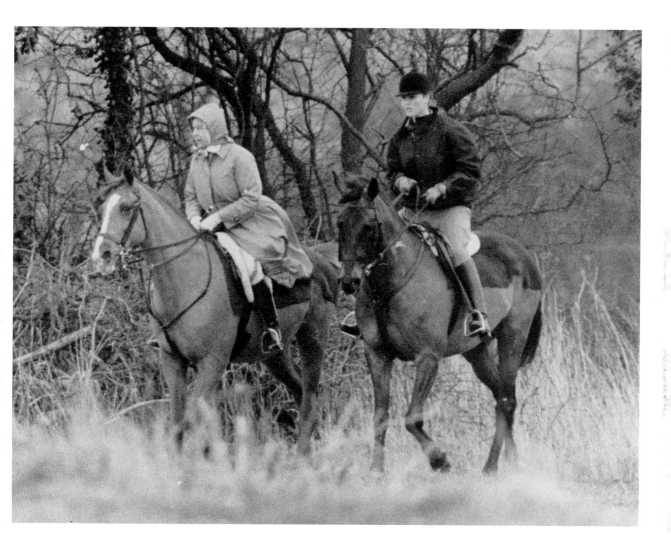

### ▲ In their stride, 1983

Unlike Diana, the Duchess of York is an expert horsewomen. Here she is trotting along the river bank at Windsor with the Queen.

### ▶ A happy group, 1978

Diana's sister, Lady Sarah Spencer, on this wintry ride.

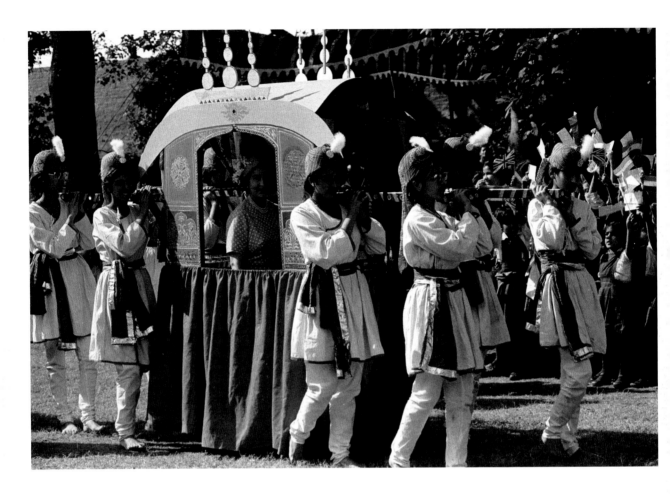

▲ 'Sitting' pretty, 1983

My first tour with the Queen was in November 1983 to Africa, Bangladesh and India. This picture was taken at St Thomas' School in New Delhi. As Her Majesty was about to leave, the school girls asked if she would take a ride in their palanquin, or sedan chair. The Queen happily obliged and seemed to be sitting perfectly poised. In fact the girls 'carrying' her were under no strain at all as the Queen was not sitting but walking along under the canopy.

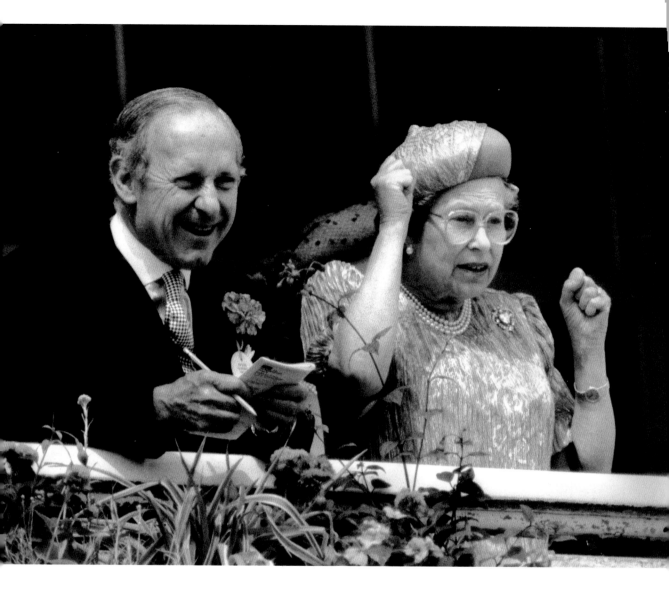

**▲ Always a good sport, 1984**

The Queen immersed herself fully in racing, with her expert eye. Sir William Heseltine, then her private secretary, looks equally enthusiastic at this racing meet as the horses near the finish line.

'I've got some fantastic pictures of Her Majesty when she was cheering one of her racehorses home and it entered the final furlong. She could get very, very animated.'

**◀ Stepping out with Granny, 1989**

The Queen was there to hold Prince Harry's hand at his first public church outing at St George's, Windsor, on Easter Sunday.

**▲ Queen leaves Windsor polo, 1989**

The Queen was always happy to wave after a good day out at the polo.

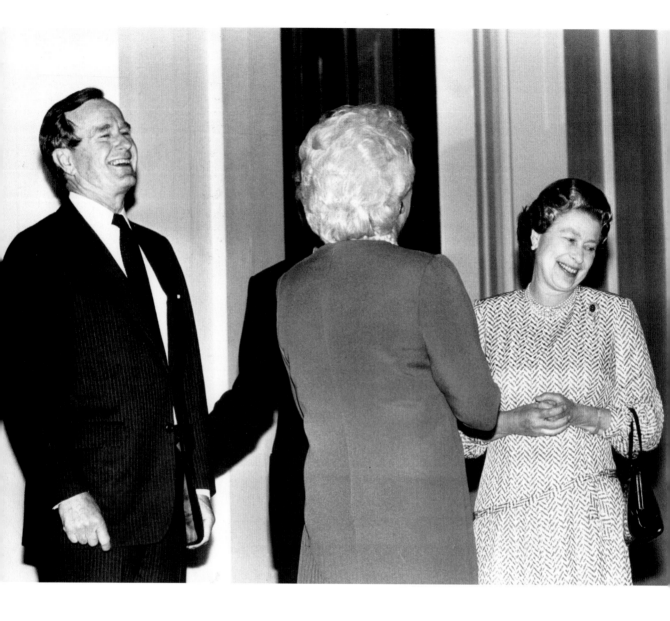

**▲ Sharing a joke with President and Mrs Bush at the Palace, 1989**

The Queen was a perfect host to visiting heads of state and their favourite place to stay was always Buckingham Palace. There's room on the front lawn for helicopters to land and the service is second to none.

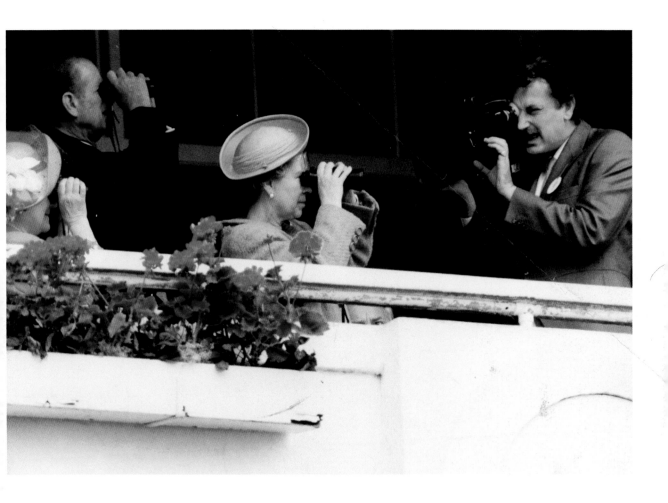

▲ **Watching me, watching you, 1991**

The Queen and her companions
were intent on watching the race
despite the cameraman who was
making a film about her 40 years
on the throne.

'The lesson you learned
when working with the
Queen was that you
had to be patient to get
that picture. Nothing is
rehearsed and she didn't
do any stunts.'

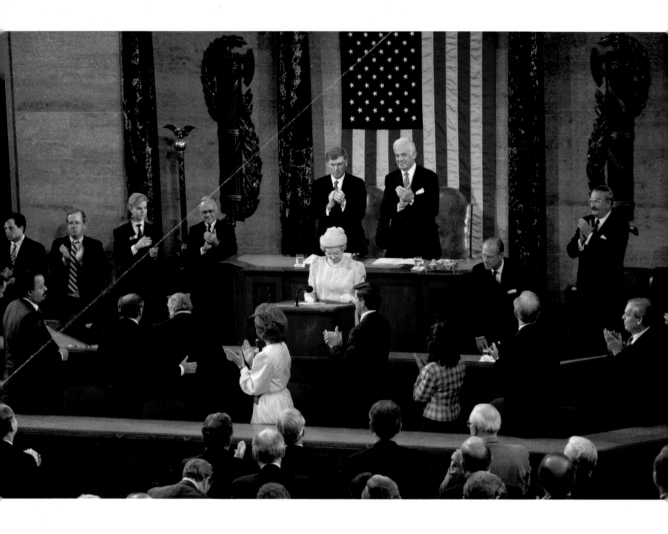

### ▲ A standing ovation in Congress , 1991

George Bush had welcomed the Queen the day before on the White House lawn, but he was a very tall man, and when the Queen stepped up to his lectern, all you could see was the top of her hat. The next day the controversy was quite embarrassing for the President. But the Queen saw the funny side of it and at the joint address in the Congress she stood up to make her speech, adjusted her glasses and said: 'Ladies and gentlemen, I hope you can all see me now.' The assembled politicians clapped her for two minutes. It was an overwhelming response. It was so moving, the hairs stood up on the back of my neck.

### ▶ The Queen is in the House, 1992

One of the most important official roles of the monarch is the State Opening of Parliament, which takes place at the beginning of each new Parliamentary session. The Queen was always beautifully dressed for the occasion.

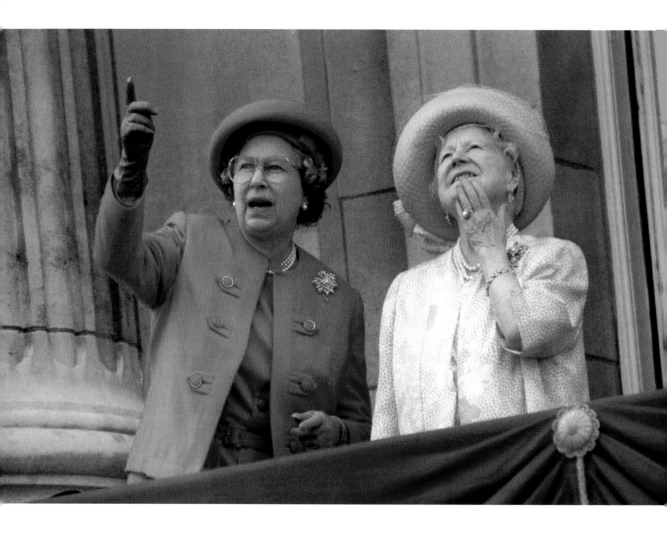

▲ **A moving moment on VE Day, 1995**

The Queen and the Queen Mother watching the flypast of historic aircraft at the Battle of Britain Memorial Flight from the Buckingham Palace balcony. Moments later the Queen Mother was seen wiping a tear from her eye.

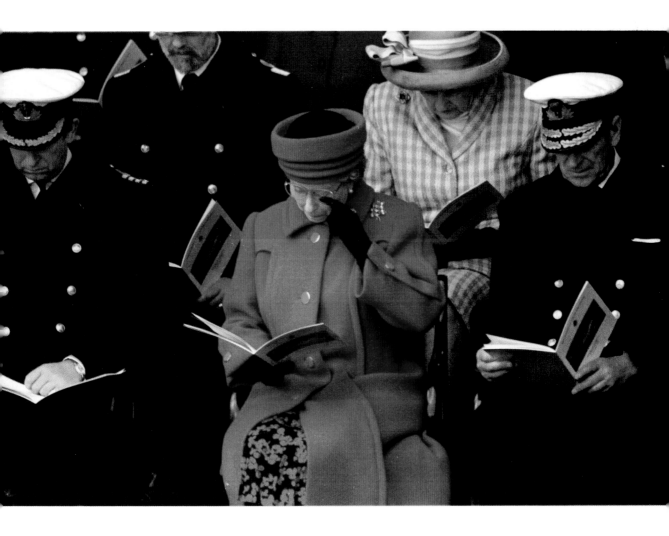

**▲ Bye bye, Britannia, 1997**

After more than 40 years in service
to the Royals – and a thousand
happy memories for Her Majesty
and family – the Royal Yacht
*Britannia* was decommissioned
in December 1997, to the Queen's
great sorrow.

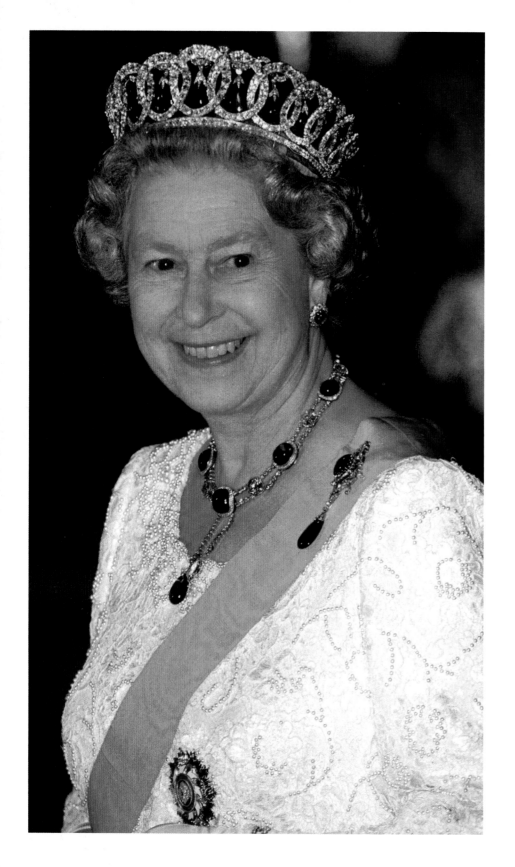

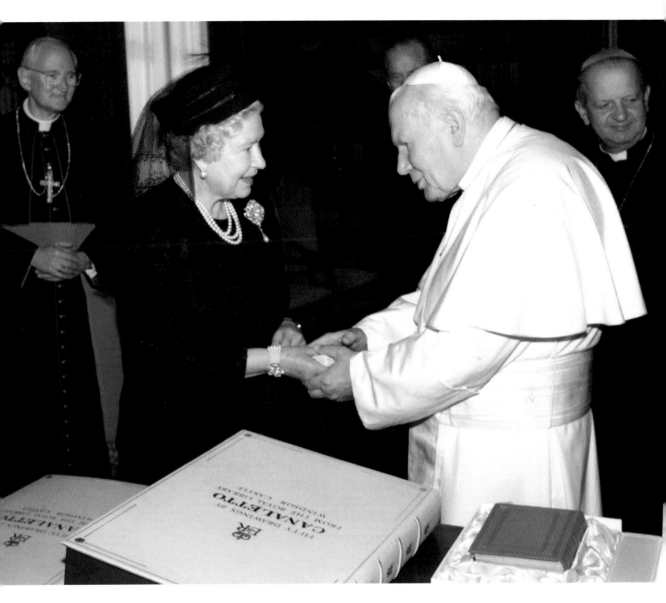

**▲ The last goodbye, 2000**

His Holiness Pope John Paul II and the Queen exchange gifts during an audience at the Vatican in Rome. Her Majesty presented the frail Pope with a bound volume of Canaletto paintings from the Royal Collection at Windsor, he gifted an antique copy of the New Testament and some rosary beads. It was to be their last meeting.

**◄ A picture of elegance at the Grand Palace, Thailand, 1996**

The Queen and Prince Philip attending a banquet in honour of her five-day state visit hosted by King Bhumibol Adulyadej of Thailand on the 40th anniversary of his accession.

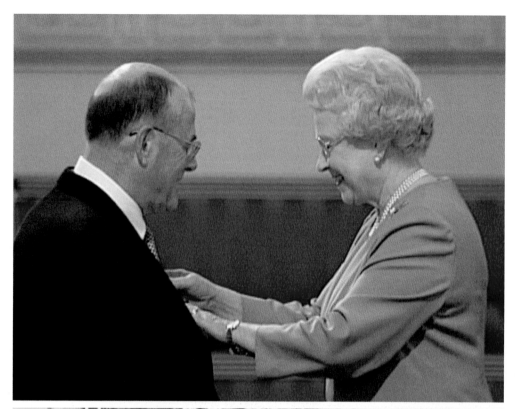

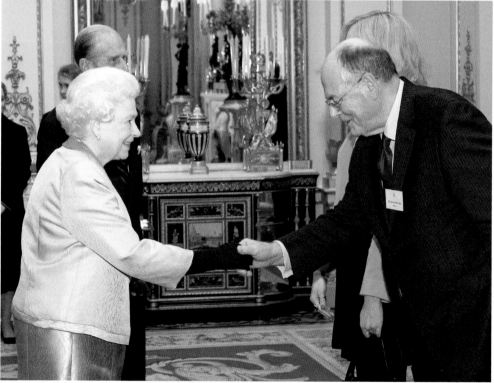

**▼▲ A very different trip to the Palace, 2003**

**◀ Representing the Press, 2003**

One of the proudest moments of my career was receiving an MBE. And it was an extra-special occasion because it was presented by the Queen herself. She said, 'I can't believe I'm giving you this. How long have you been coming to the Palace to photograph me?' I replied, '27 years, Ma'am.' She said, 'Well, let's have our picture taken together then.' One week later I was at the Royal Windsor Show and we met again. The Queen approached me and joked, 'Why aren't you wearing your medal?' I jokingly shot back , 'If I'd known you were coming, Ma'am, I would have worn it!'

I was given the honour of receiving the Royal Family on behalf of the Press. Often during my career I've sent pictures I took of the Queen on her overseas visits to Her Majesty. On this day she thanked me for the pictures and I said, 'Any time, Ma'am'.

**◄ A golden smile, 2004**

The Queen had an amazing smile, one that lit up the whole room. She had a great sense of humour.

**► Letting bylines be bylines, 2006**

The Royal Family might not always have the greatest affection for the Press, but Her Majesty put that aside when she officially opened 'Front Page', an exhibition to mark the centenary of the Newspaper Publisher's Association.

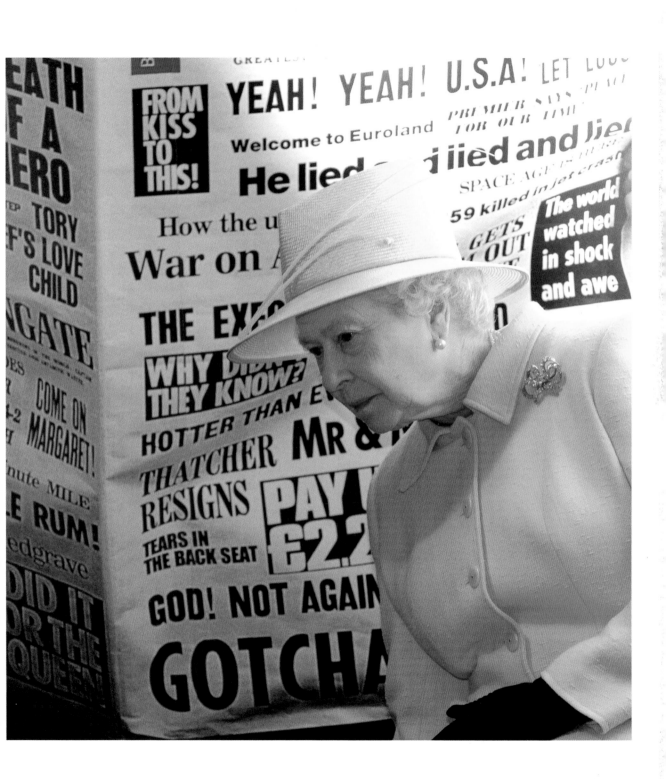

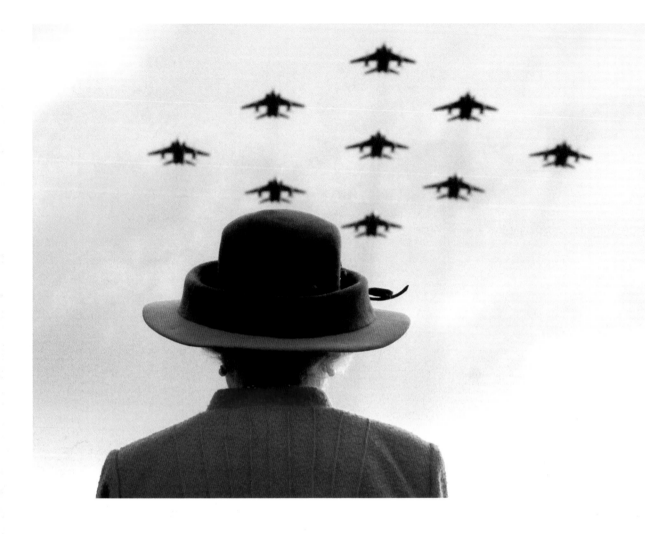

'I only had one chance to
get this picture, but thankfully
I'd watched the rehearsal and
I knew where the Queen
would be standing.'

▲ **A diamond tribute, 2006**

A traditional and spectacular feature
of national celebrations is the RAF
flypast. For the 65th anniversary
of the airfield at Coltishall, Norfolk,
the Queen was greeted with this
diamond formation flypast of nine
Jaguar aircraft.

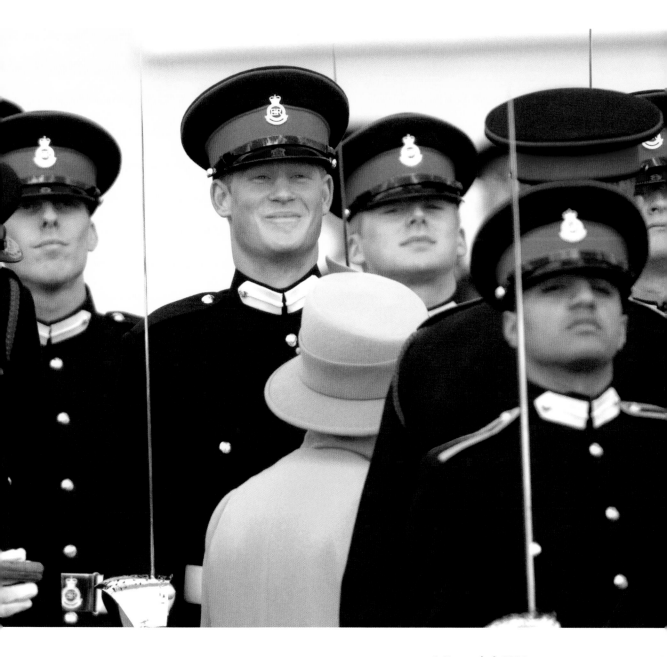

### ▲ Harry who?, 2006

The Queen was immensely proud
to inspect the new cadets at the
Sandhurst passing out parade.
As she moved along the line
she smiled at Prince Harry and
exclaimed, 'I think I know this cadet!'
The Prince blushed in response.

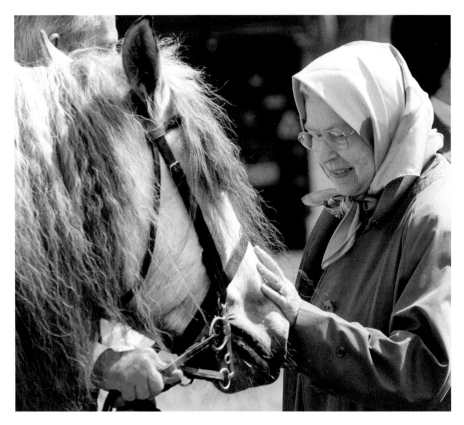

◀ **All the Queen's horses, 2007**

A congratulatory pat for Balmoral Melody after she won Supreme Champion in the Highland Pony Class at the Royal Windsor Horse Show.

▶ **Backing a winner, 2005**

Her Majesty adored racing and I just love the look of delight on her face in this picture, one of my favourites taken on Derby Day in June 2005.

▶ **Never work with children or animals…, 2005**

Royal visits are planned with military-style precision. But sometimes the unexpected happens. It was a funny moment when this toddler crawled in front of the Queen.

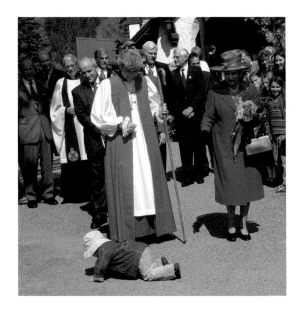

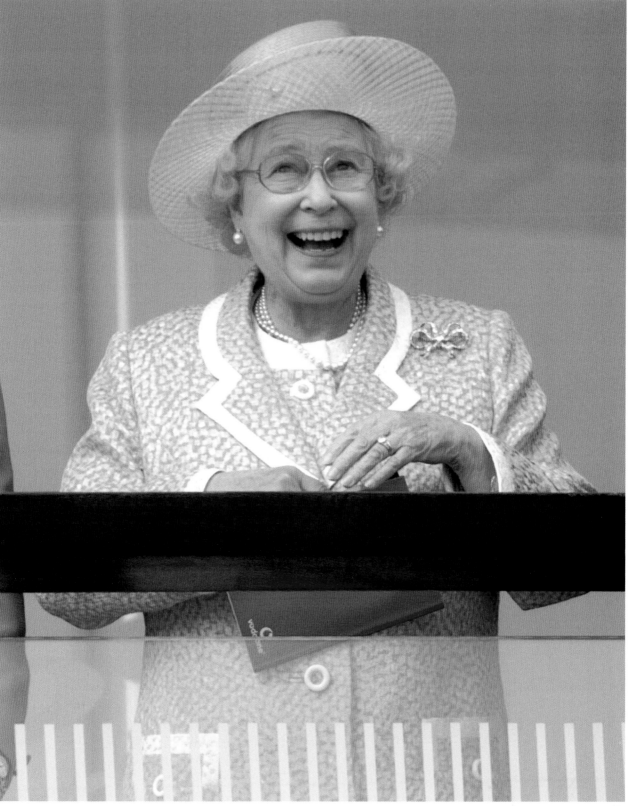

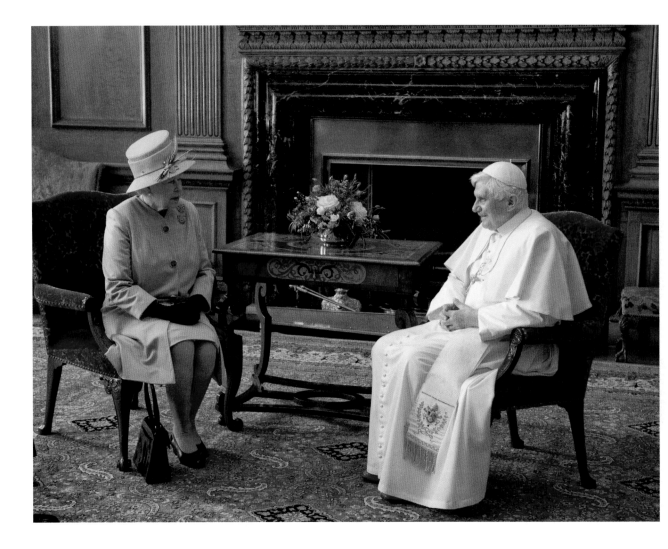

**▲ Private audience with His Holiness Pope Benedict XVI, 2010**

The Pope's state visit was a huge success despite controversy over its cost. His Holiness was greeted with warmth by the Queen and Prince Philip. When the Pope was asked what his favourite part of his tour was, he replied: 'All of it.'

**▶ Hardworking head of state, 2008**

Dressed in her ceremonial robes, the monarch delivers the Queen's Speech, setting out her Government's Parliamentary programme.

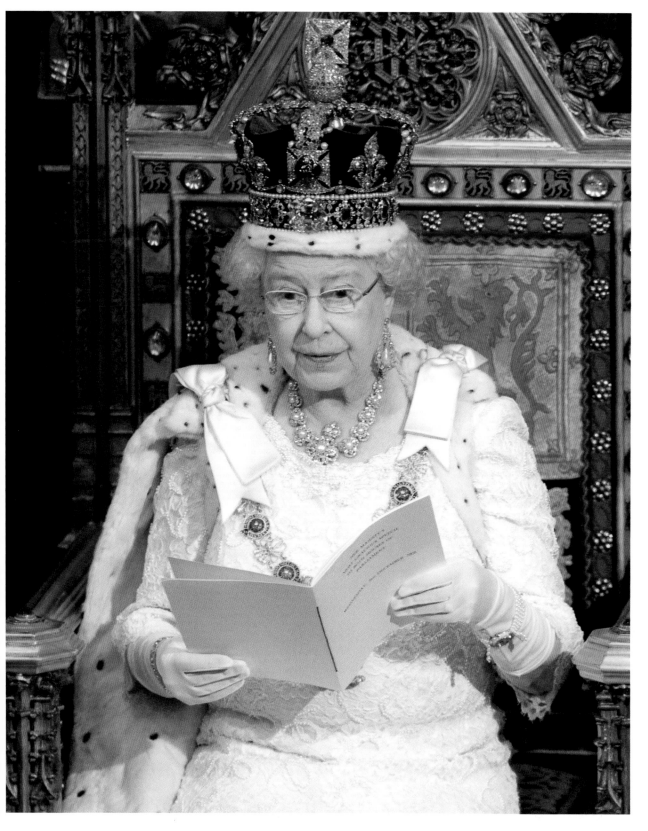

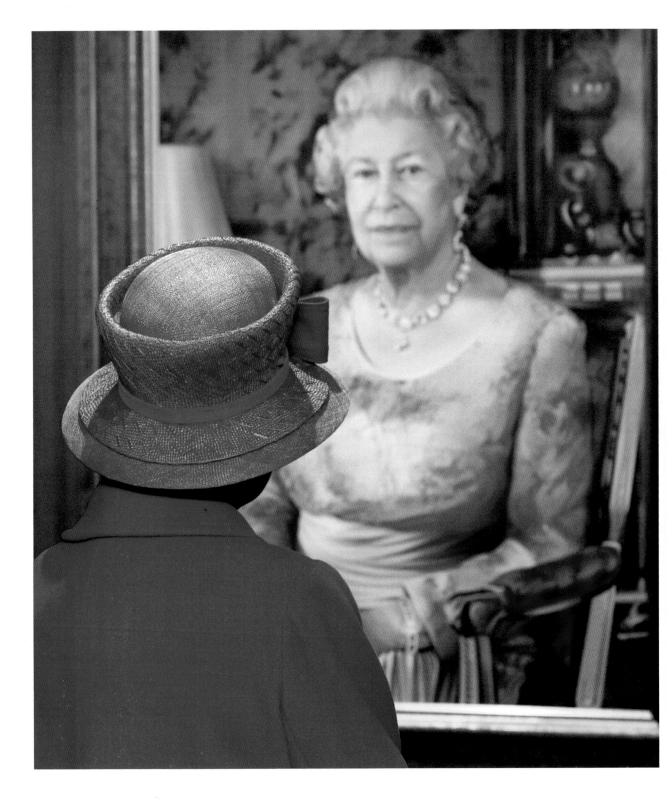

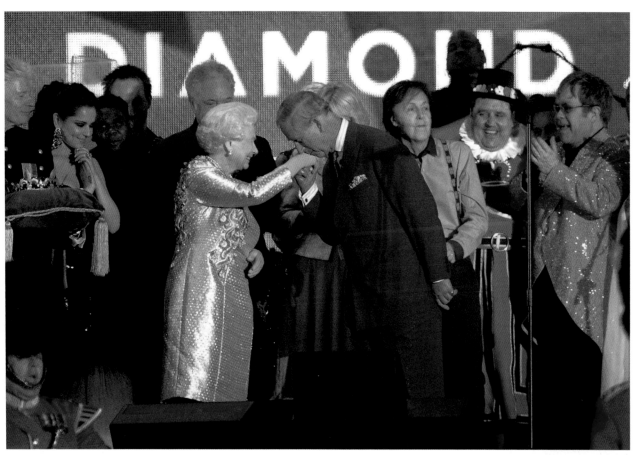

### ◀ The new Queen Elizabeth, 2010

I love this shot. I didn't need to see her face for this picture. She was viewing a portrait of herself on the cruise liner *Queen Elizabeth*.

### ▲ So proud of you, Mummy, 2012

A sweet moment on a night celebrating the Queen's Diamond Jubilee. Prince Charles gave a moving tribute to his mother and her reign, opening his speech with 'Mummy...'.

### ▶ An historic visit to Ireland, 2011

The Queen greets the late poet Seamus Heaney at Dublin Castle. The President of Ireland, Mary McAleese, seated Seamus on the top table. It is still my favourite tour of all time.

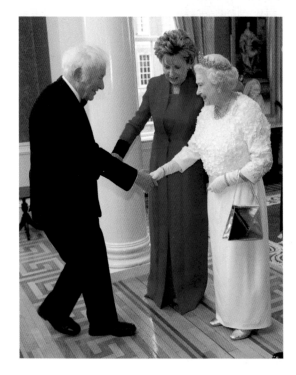

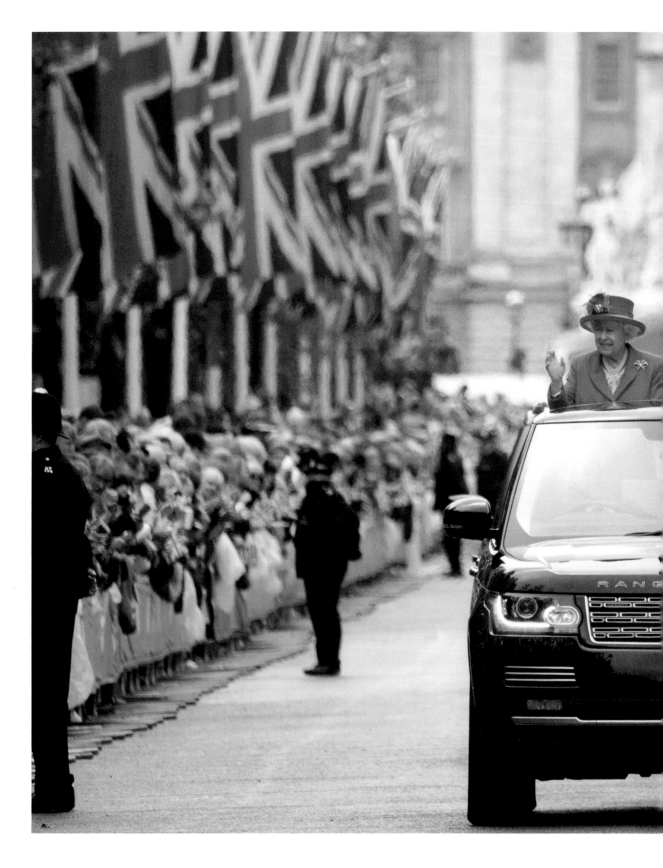

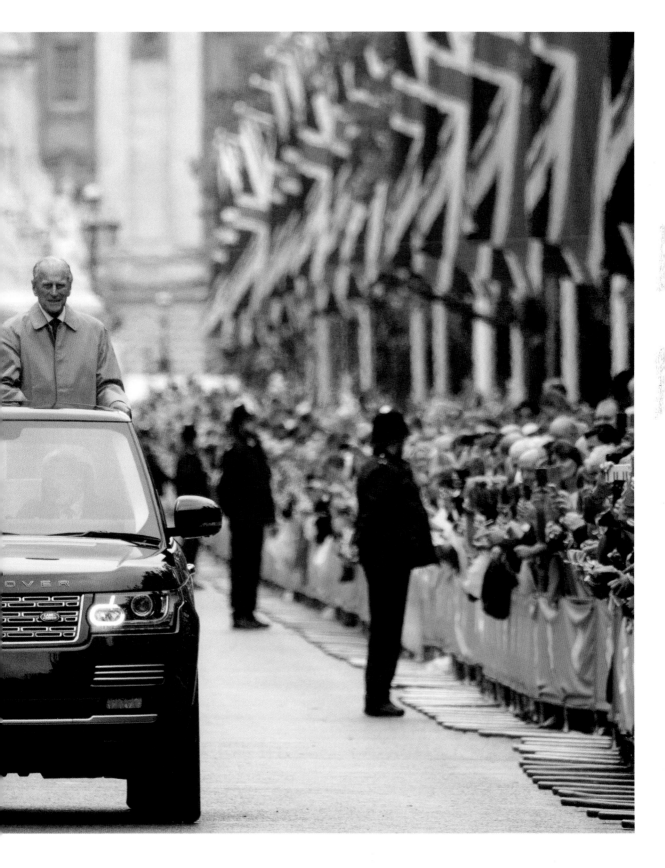

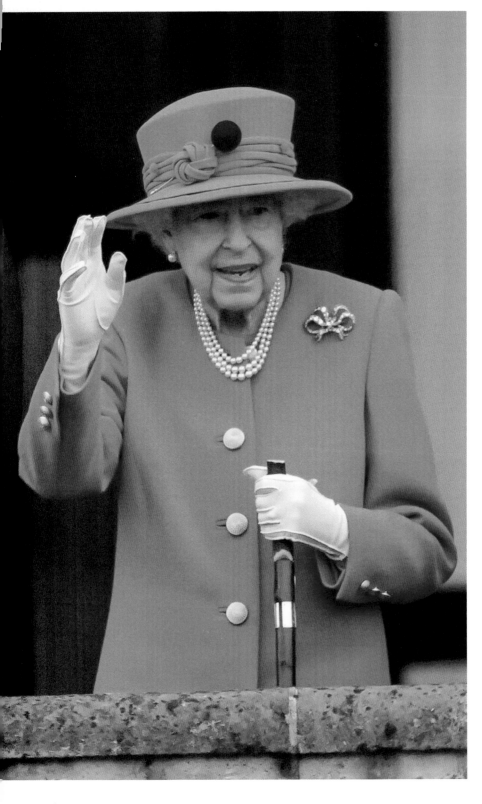

### ◄◄ Happy birthday, Ma'am, 2016

A joyous picture that marked the mood of the country. The Queen's motorcade made its way down The Mall to the delight of huge cheering crowds gathered for the world's largest street party in honour of the monarch's 90th birthday.

### ◄ What a weekend, 2022

The Queen's Platinum Jubilee showed the best of Britain, and the astonishing strength and commitment of our monarch. Despite not being able to attend all events, the Queen managed to greet her adoring crowds and looked elegant every time.

### ◥► Celebrating 70 years, 2022

The first day was the most important day of the Jubilee celebrations because it was the Trooping of the Colour and the official birthday of the Queen. We knew that of all the days, this was the one on which she would make a special appearance.

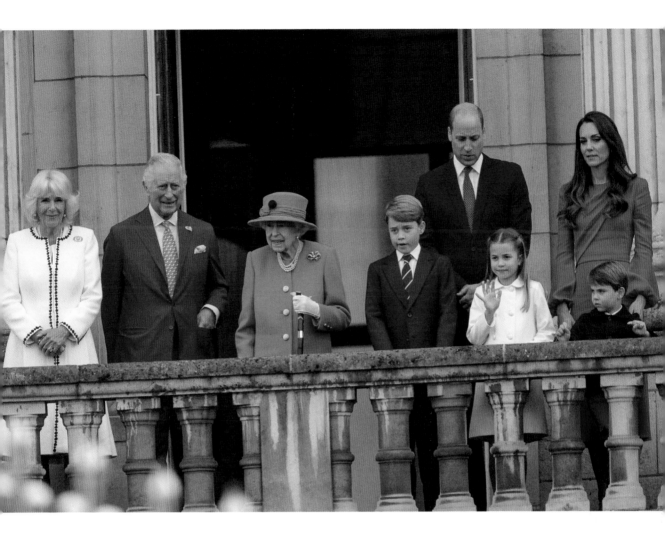

'We didn't know exactly when the Queen would make an appearance during the four days of her Platinum Jubilee celebrations. But I was lucky enough to photograph her on the Buckingham Palace balcony on two of those days.'

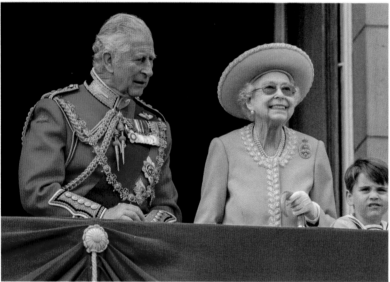

### ▲ The generation game, 2022

As well as being a celebration of the Queen's astonishingly long reign, the Jubilee was very much a moment to celebrate the future generations of the Royal Family. Cheeky young Prince Louis stole the show, and the hearts of the country!

### ▲▲ The future Royals, 2022

Fortunately, when the Queen emerged on the balcony with her family I had an allotted position in the forecourt of Buckingham Palace, so I got this super picture.

### ▶ She's the one, 2022

I got this one beautiful portrait of the Queen with a finger up in the air. The next day it was the front-page picture with the headline 'The One Show'. I was so proud of that picture. And I was thrilled about it being on the front of the paper, I still get such an incredible buzz out of that.

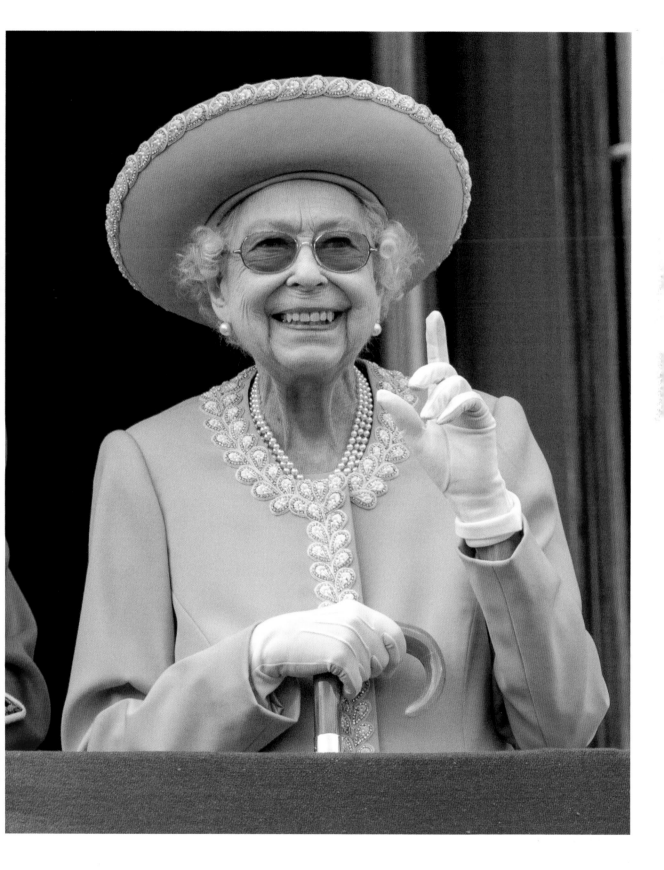

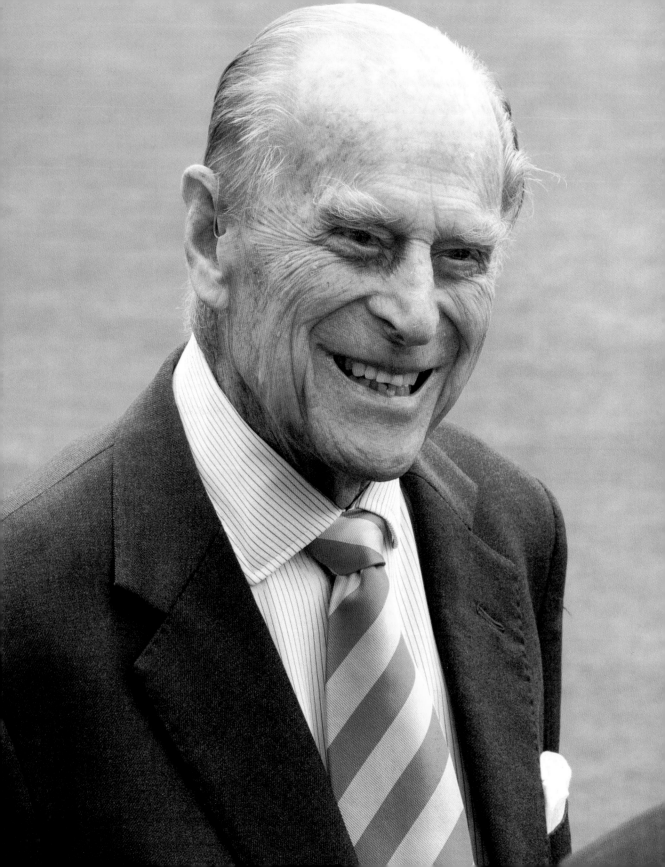

# The Duke
of Edinburgh

# The Duke of Edinburgh

I f I'd have been asked to shadow Prince Philip rather than Prince Charles by my editor in 1977, I don't think I'd have lasted a month in the job. When I did photograph the Duke he was incredibly abrupt and didn't even acknowledge me, let alone talk to me. He was his own man and had little time for the media, but I still had huge respect for him. His service in the Second World War saw him mentioned in dispatches for his heroism, yet he gave up his glittering Naval career when he married the Queen and became the most brilliant consort; no one could have done a better job. His dedication to his wife was immense, but even so he always did exactly what he wanted, not what was expected of him. On a visit to the Dublin's Guinness brewery he was poured a pint of the black stuff and the Press pack expected a great picture. Instead, he just smiled and walked away without even a slurp. An aide later told us: 'He doesn't like Guinness.'

◀◀ **It's not quite cricket, 2017**

The Duke of Edinburgh on a visit to Lord's, the home of cricket, to officially open the new Warner Stand It was the Prince's penultimate engagement before retiring from public life. He strode to the crease with a cricket bat like he was going to open the batting for England.

◀ **A Maundy moment of reflection, Ely, 1987**

The Queen and Prince Philip visited Ely Cathedral for the Maundy Service in what was only the third time a reigning monarch has been to the city in 700 years.

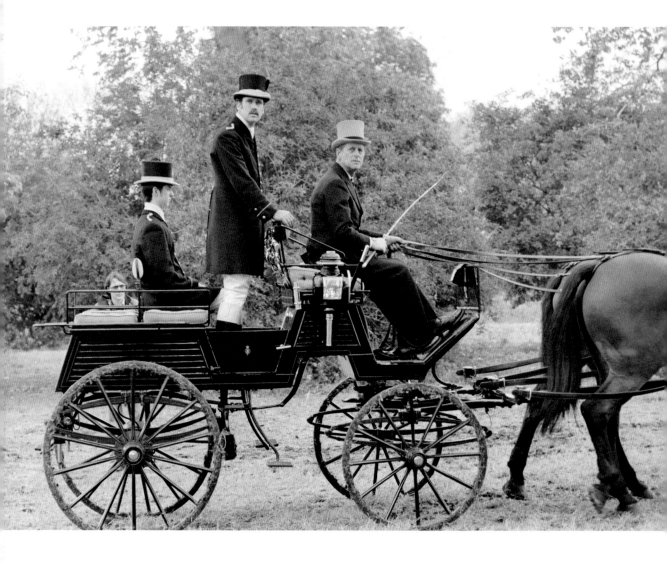

**▲ Your carriage awaits, Windsor, 1977**

Prince Philip took up carriage driving when he gave up polo. He was instrumental in getting the three-day event included in the Windsor Horse Show in the 1970s, and with his passion for it he helped it become an international sport, too.

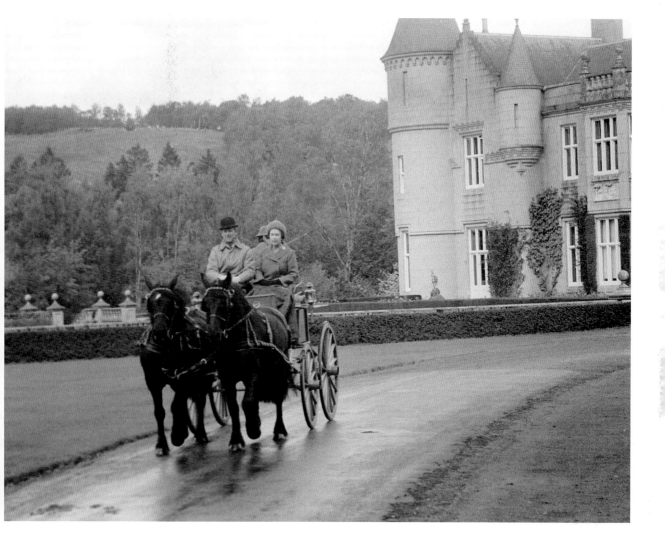

**▲ A trip for two around Balmoral, 1977**

Trips to Balmoral were perfect moments of relaxation for the Queen and Prince Philip and their extended family. But there was nothing the two of them liked more than to have time together driving around the estate.

'The Queen was head of state, but Prince Philip was almost certainly head of that family.'

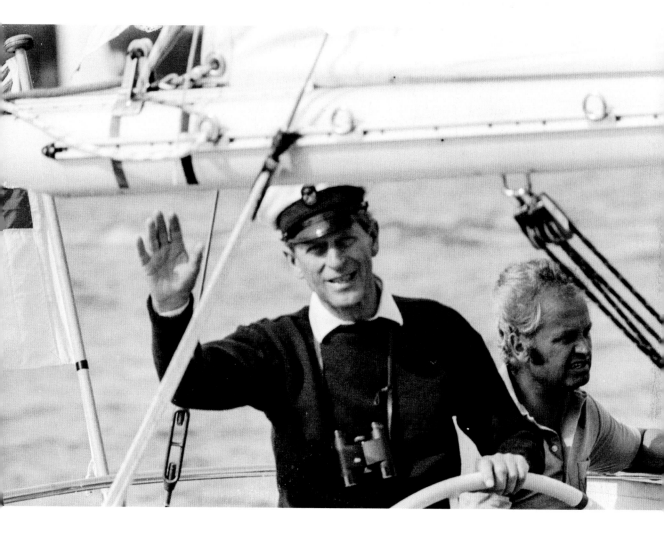

**◀▲ Sailing away, Cowes, 1979**

Prince Philip was a keen sailor and always liked to go to Cowes Week on the Isle of Wight. He was a regular competitor from the 1960s onwards.

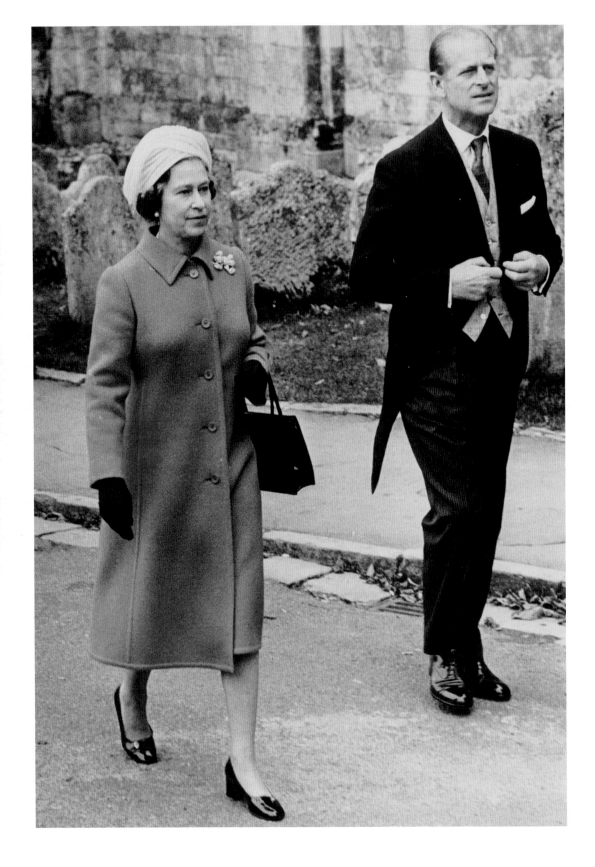

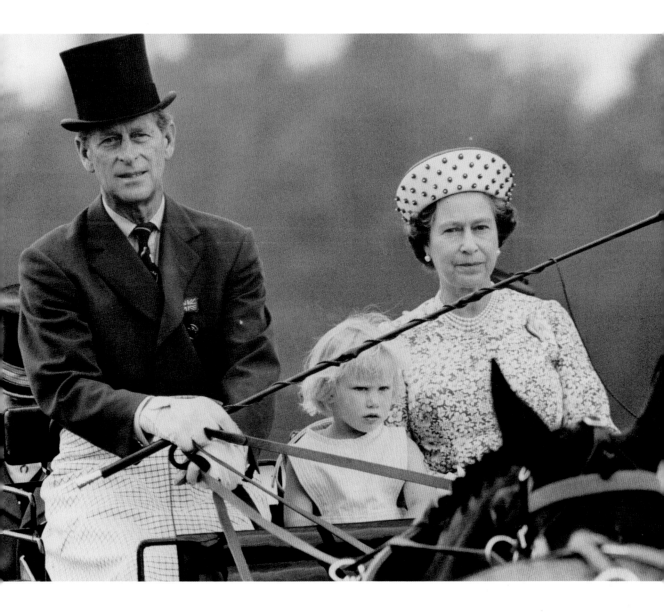

**◄ Towers of strength, 1979**

The Queen and Prince Philip
attending the wedding between
Lord Romsey - now titled Earl
Mountbatten - and Penelope
Eastwood. Just weeks earlier Lord
Romsey's grandfather, grandmother
and brother were murdered by
the IRA.

**▲ Starting them young, 1984**

A very serious-looking three-year-old
Zara Philips being taken for a carriage
ride at Smiths Lawn, Windsor. She
would go on to follow in her parents'
footsteps and pursue an equestrian
career, much to the pride and delight
of her grandparents.

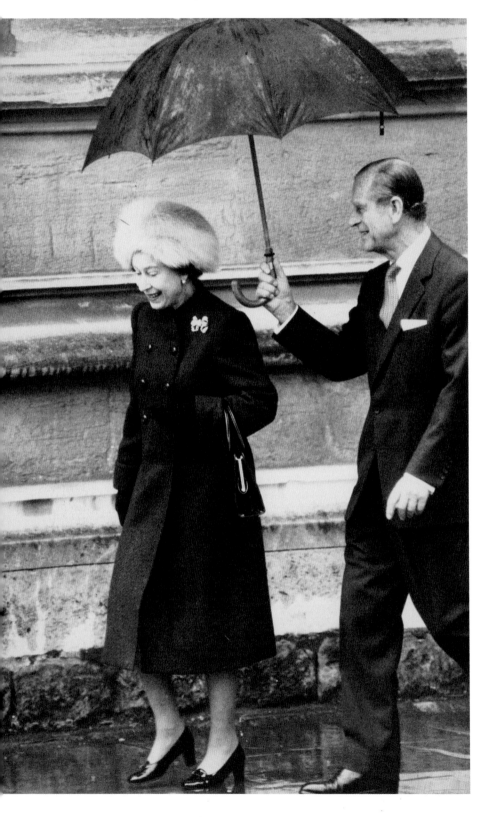

◀ **Always a gentleman, 1985**

The perfect consort in every way, and a loving husband, Prince Philip shelters the Queen from the rain as they walk to church on Christmas Day at Windsor Castle.

▶ **By order of the Queen, 1989**

The Queen and Prince Philip take a moment in full regalia as they prepare to welcome new members to the Order of the Garter, which would include King Juan Carlos of Spain.

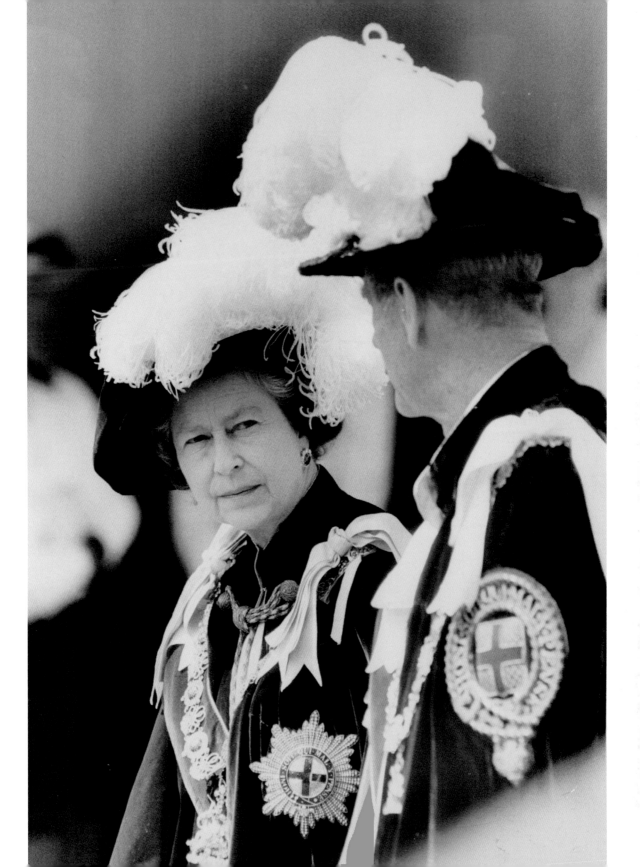

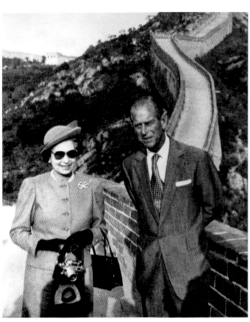

**◀▲ Crossing the divide, 1986**

The Queen was the first British monarch to visit the Land of the Red Dragon on a trip intended to deepen ties following the agreement to return Hong Kong to China. However, a private comment by Philip was published and the Queen was furious. The next day at a cultural event she was stony-faced.

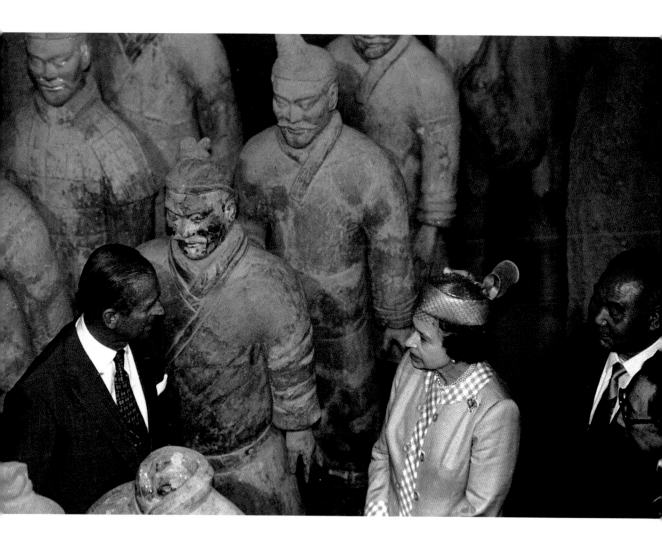

**▲ The terracotta soldiers , 1986**

A grim-faced Queen visited the Museum of Qin Terracotta Warriors in Xi'an, Shaanxi province, the same day Prince Philip made the gaffe. It was very much business as usual.

'He was an amazing man but he was his own man. He just didn't care if he offended people.'

**▲ A much-loved lord of the manor, 1989**

The Duke's staff adored him. They thought he was just a really lovely boss. When he had parties he would invite the cleaners, the maintenance men, the equerries, the private secretaries – everyone.

'Prince Philip treated the Press like telegraph poles. He just walked around you. He never acknowledged you, never did anything to please you, just tolerated you. He had no time for the media, he did it his way.'

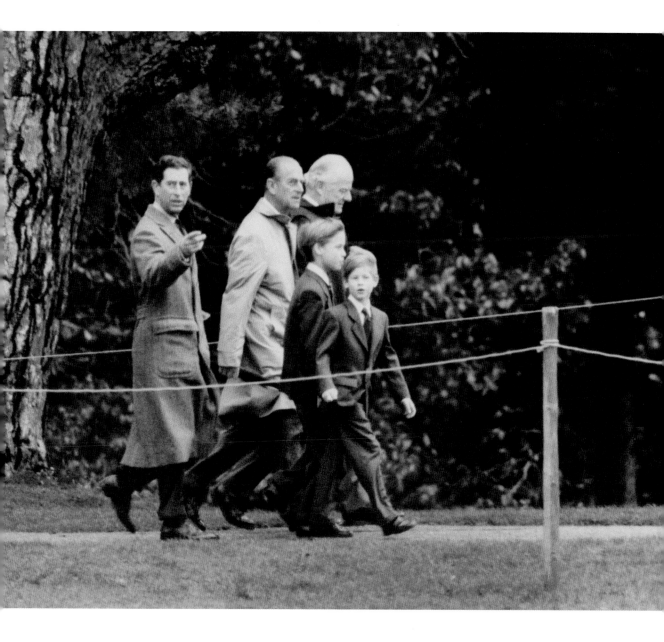

**▲ Festive family walk, 1993**

While interactions between Philip and his grandchildren were few and far between in public, he was ever the doting grandfather and had a close relationship with all of his eight grandchildren. Christmases at Sandringham were always a highlight.

Philip supported the Queen through thick and thin for over 70 years (pictured here during their golden anniversary year). It was a tough job but no one could have done it better. After you've captained your own ship in the Navy, it's a pretty tough gig to then play second fiddle and walk behind your wife for the rest of your life.

◀ **A moment with a mascot, 1998**

Prince Philip meeting mascot Kit during a state visit to Malaysia, where he and the Queen opened the 16th Commonwealth Games. Kit was promoting the next games to be held in Manchester in 2002.

**▲ The Duke delights Royal fans, 2000**

**▶ The Queen's speech, 2003**

Cheering crowds of Union Jack-waving Italians greeted Queen Elizabeth II and Prince Philip on their first trip to Italy in 20 years. As a Catholic, the highlight for me was when the Royal couple met Pope John Paul II, a brave, amazing man.

The Duke of Edinburgh listening intently as the Queen opens the Women at War exhibition at the Imperial War Museum. A proud veteran himself, he did much to help former service personnel.

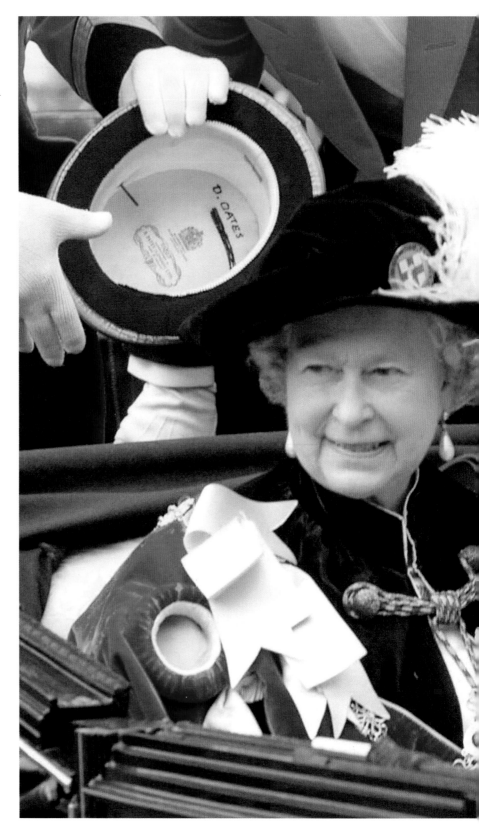

**▶ All smiles leaving St George's, 2000**

Thousands of spectators turned out to watch as the Royal Family took part in the annual Garter Ceremony at Windsor Castle. I particularly like the fact I got the inside of the footman's hat in the shot – Mr D. Oates!

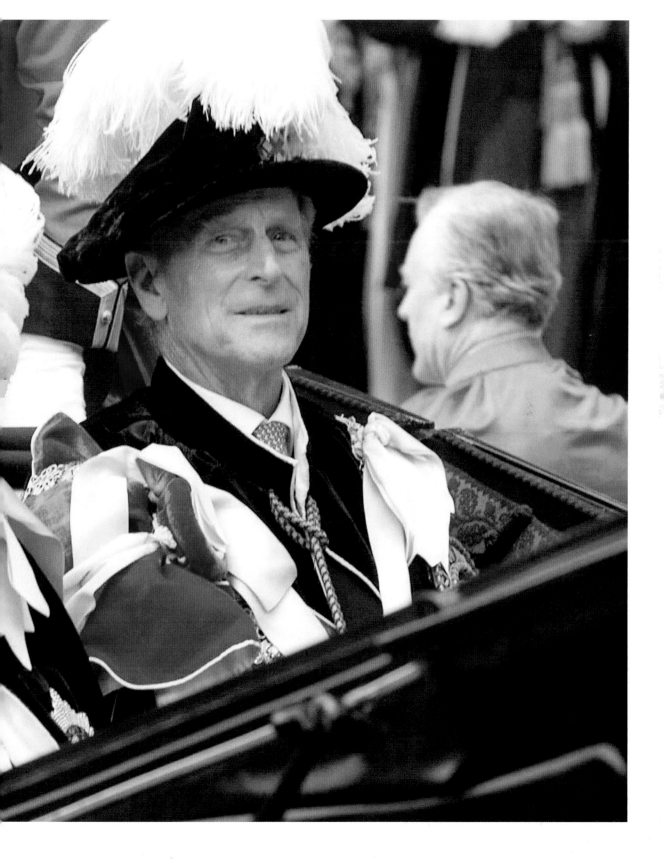

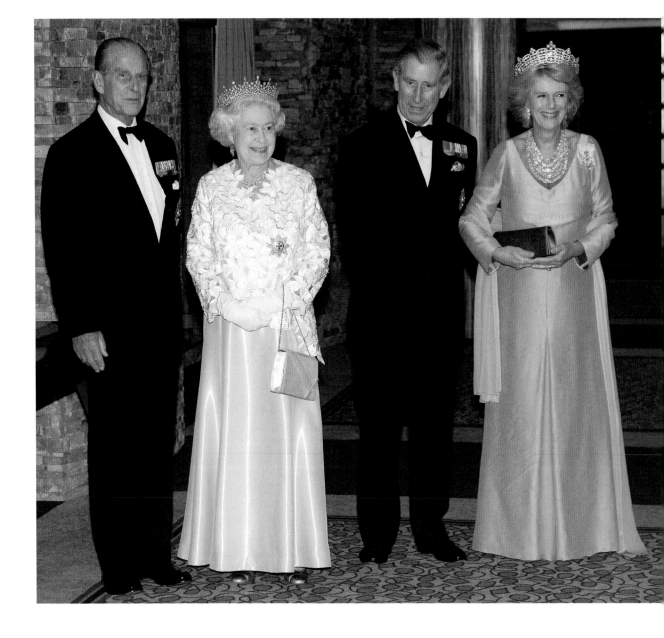

### ▲ The Queen and her Princes, 2007

This shot was taken at the Commonwealth Heads of Government meeting in Uganda. Camilla had taken on the role of the Duchess of Cornwall by now and she excelled at it. Prince Philip was more than a father-in-law to her – she felt he was a role model and she always took his advice gratefully.

### ▶ Remembering the fallen, 2007

Prince Philip was a Navy man through and through. He was always supportive of the veterans of the dozens of conflicts involving British service personnel from 1952, when he became the Queen's Consort until his retirement from royal duties in 2017.

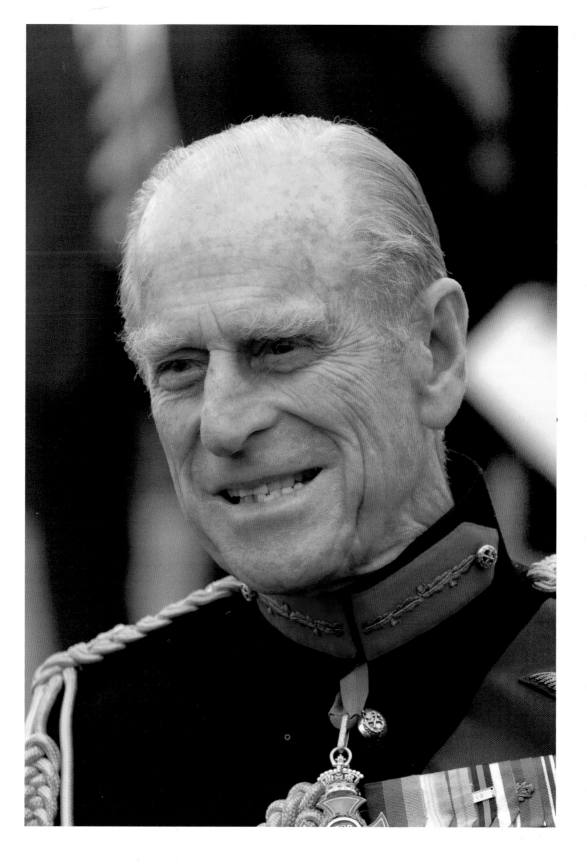

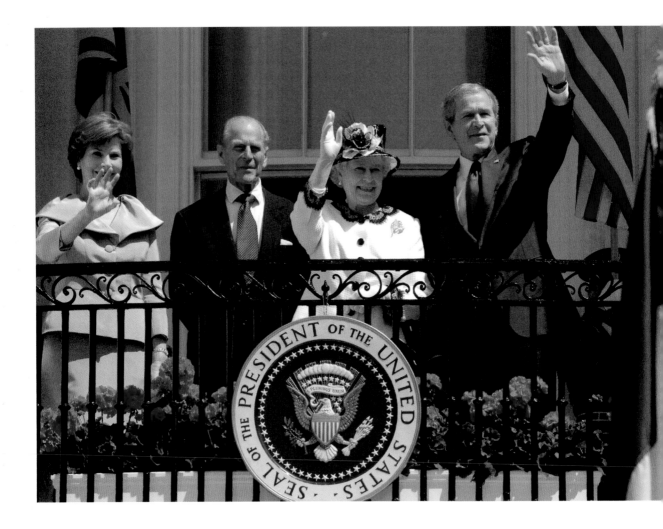

▶▲ **Lest we forget, 2008**

Prince Philip lost in his thoughts at the annual Service of Remembrance. While serving in the Royal Navy during the Second World War, the Prince fought in several battles and on one occasion saved his ship from enemy bombers. This annual service was one he held dear to his heart. This was the year the Queen and Prince Philip marked their diamond wedding anniversary with a trip to Malta, where they had lived during the early days of their marriage. Before that there was the small matter of a state visit to the United States of America to celebrate the 400th anniversary of the Jamestown settlement. The royal couple had made their first trip across the pond in 1957, when they met the then President Dwight D. Eisenhower.

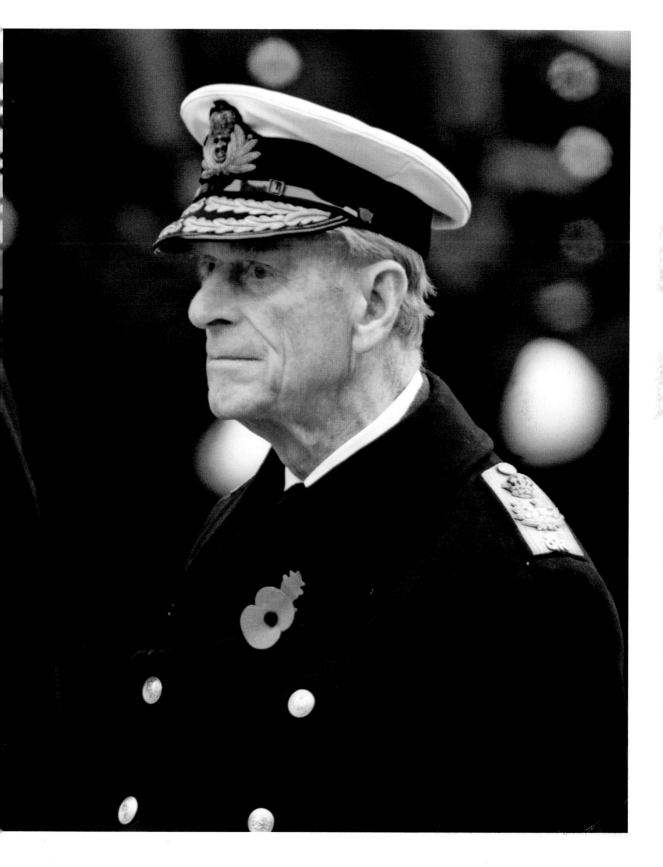

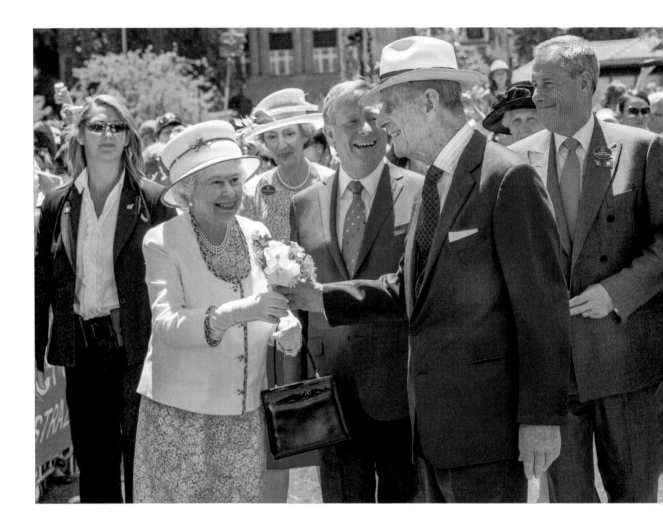

**◀ Happy to be here, Australia, 2011**

The Duke loved Australia and all its people. Here he is waving to the crowds after paying his respects to Australians who made the ultimate sacrifice in two World Wars.

**▲ Last tour Down Under, 2011**

I took this shot at the Great Aussie Barbie in Perth, Australia. It was the last day of the Queen's tour and it was quite touching as I think both she and Philip knew they would never go there together again. A well-wisher had given flowers to the Duke and he presented them to the Queen.

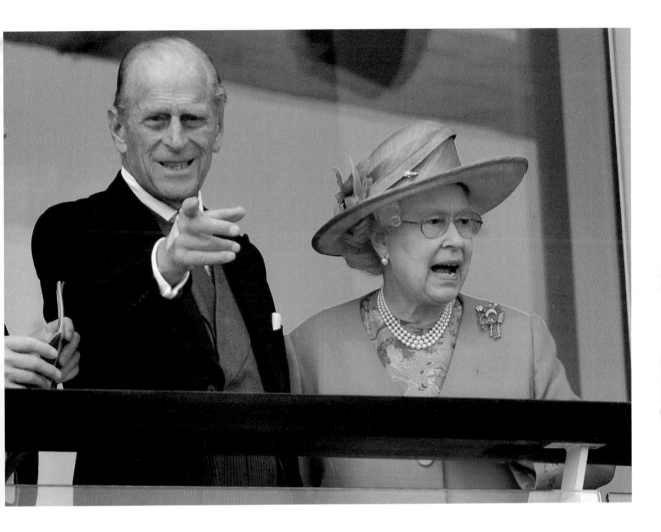

### ▲ Making a point, 2008

An equestrian through and through, Philip loved anything to do with horses, not least horse racing. Here he is having a fine old time with the Queen in their shared passion of watching the Derby.

### ▶ Come on!, 2013

This shot was taken at the 2013 Epsom Derby. The Duke, who had been in and out of hospital at the time, was feeling fully fit this day and it was wonderful to see him on form and urging on a horse he'd got in the royal sweepstake.

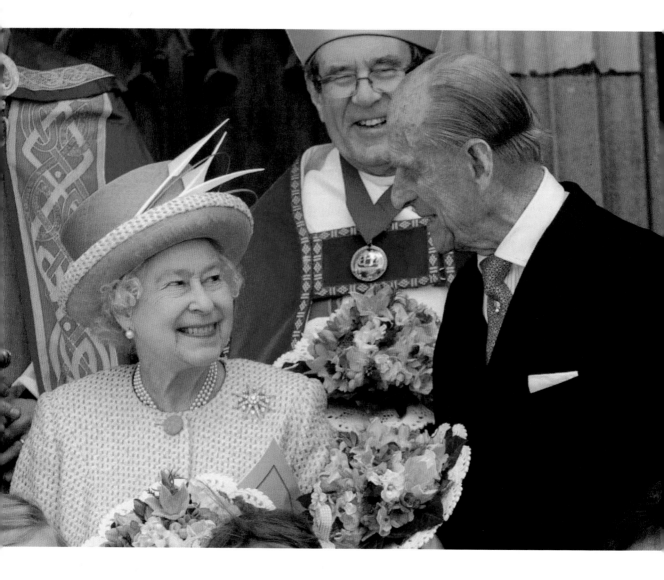

**▲ Service with a smile, 2012**

**▶ Beloved Grandpa, 2014**

I love this photo from the Maundy service at York Minster in 2012. Philip was sharing a joke with the Queen and whenever this happened, there was an immediate aura of loveliness about their exchange of smiles. It was as if the couple shared a special secret of happiness. Whatever the Queen has achieved, she couldn't have done it without him.

WIlliam and Harry's affection for their 'Grandpa', the Duke of Edinburgh, was always clear to see. Following Philip's death Harry said, 'He was authentically himself, with a seriously sharp wit, and could hold the attention of any room due to his charm — and also because you never knew what he might say next. I know that right now he would say to all of us, beer in hand, "Oh do get on with it!"'

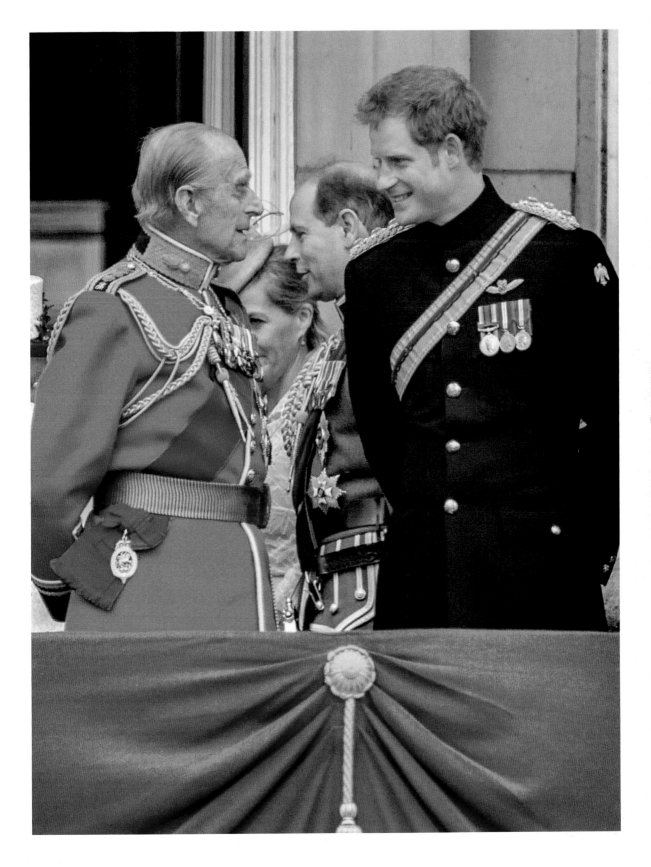

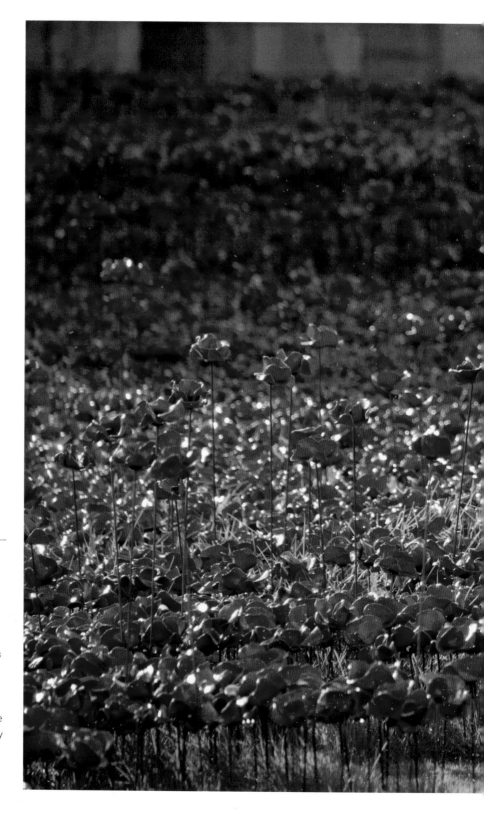

**▶ Seas of red, Tower of London, 2014**

London's famous Royal palace was awash with a sea of red poppies to commemorate the day Britain entered the First World War. That summer, 888,246 ceramic poppies were planted in the moat at the Tower; each flower representing a British military fatality during the conflict. The extraordinary display lent itself to this lovely shot of the Queen and Philip.

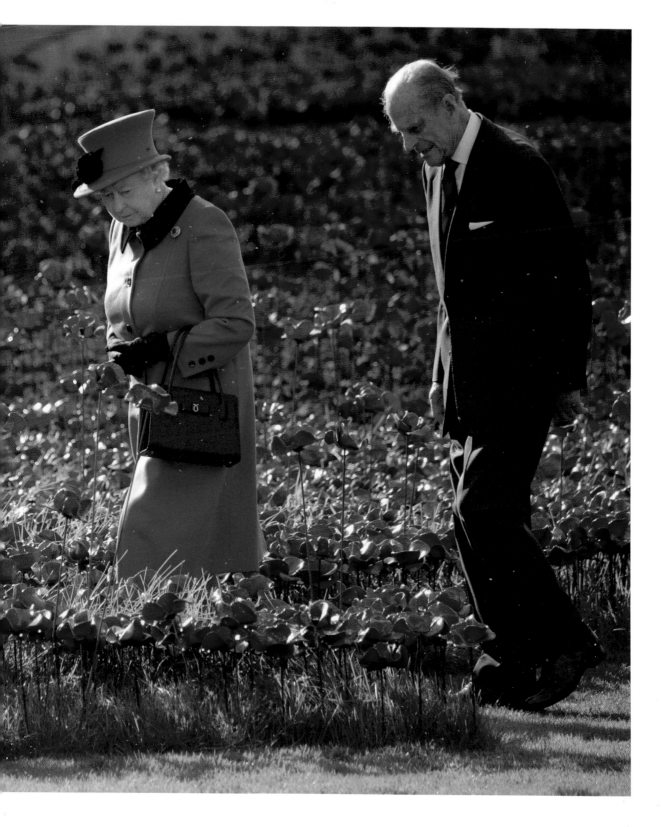

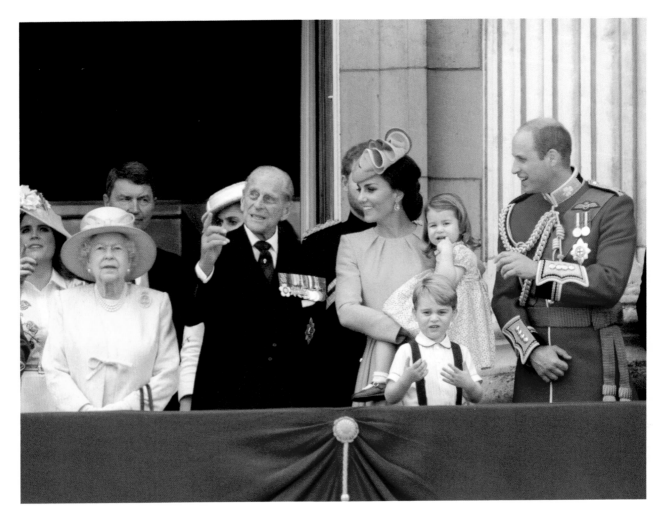

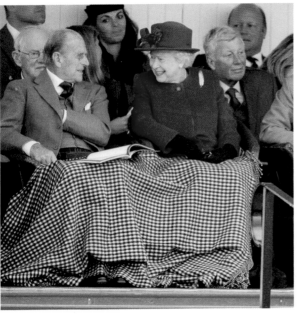

◀ **Blankets at Braemar, 2015**

The Queen and Prince Philip keeping warm at a chilly Braemar Gathering, the biggest event of the Highland Games. The Queen first went in 1933 as a seven-year-old and the royals have continued to be regular attendees at the event just down the road from the Balmoral Estate.

▲ **Family flypast, 2017**

Prince Philip sharing a moment with the then Duke and Duchess of Cambridge on the balcony of Buckingham Palace following the Trooping of the Colour. Charlotte and George look on at the RAF flypast.

### ▲▶ Changing of the guard, 2021

The Duke of Edinburgh handed over his role as Colonel-in-Chief of The Rifles. In a unique ceremony the Prince, who retired from public duties in 2017, handed over his role to the then Duchess of Cornwall. At the time, Camilla was almost 100 miles away at her Highgrove home in Gloucestershire, in order to comply with social distancing rules during the Covid-19 pandemic. This was the last time I photographed the Duke.

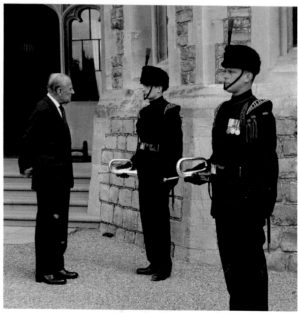

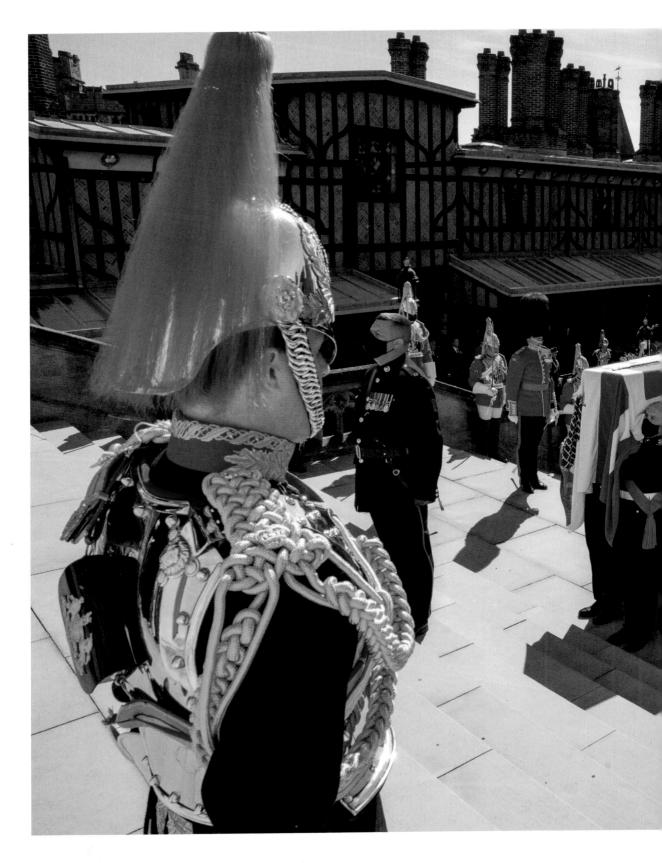

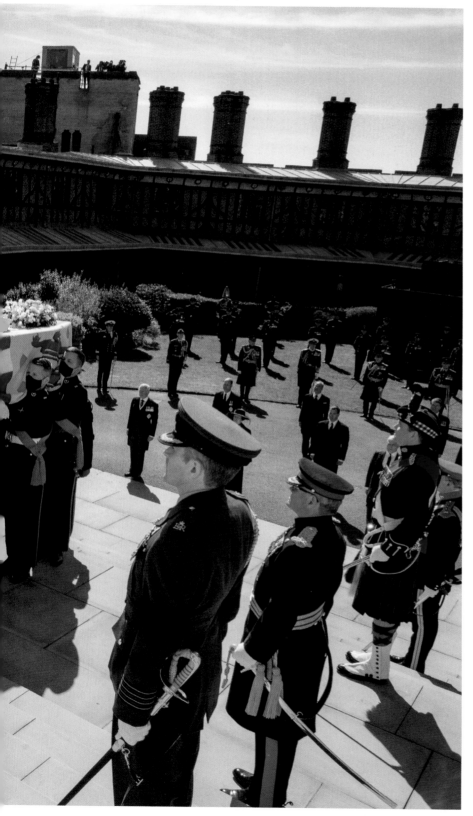

Prince Philip's funeral was one of those days in this job where you just have to raise your game. The Queen Mother's funeral was tough, Diana's funeral was awful, but the Duke of Edinburgh's was, in many ways, different. I was positioned in a special 'hidey-hole' pillar on the steps outside St George's Chapel at Windsor Castle. I was looking through a sort of letterbox and I was sitting in there for three hours. The Palace were very kind, they laid on a cushion for me to sit on and they also provided me with a packed lunch. I got pictures of soldiers fainting because of the heat – it was a very warm day. I was able to get the full view as the Marines walked up the steps with the coffin. They stood there for a minute's silence and they were absolutely brilliant. The soldier here on the left in my picture with his gleaming helmet wrote to me afterwards asking for a picture, and I was pleased to send it to him. A big day, but great, if sad, memories.

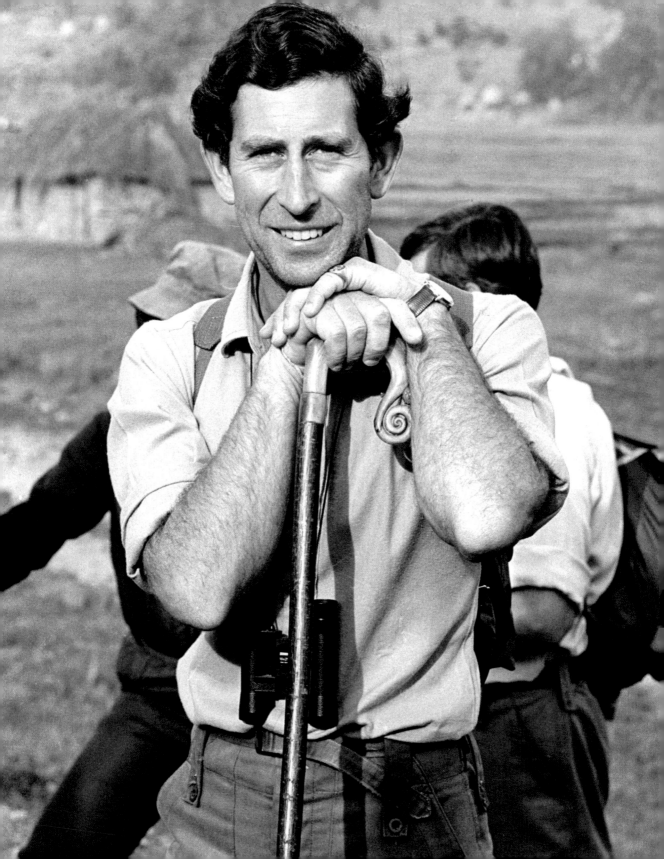

# King Charles III

## Early Years 1975–1997

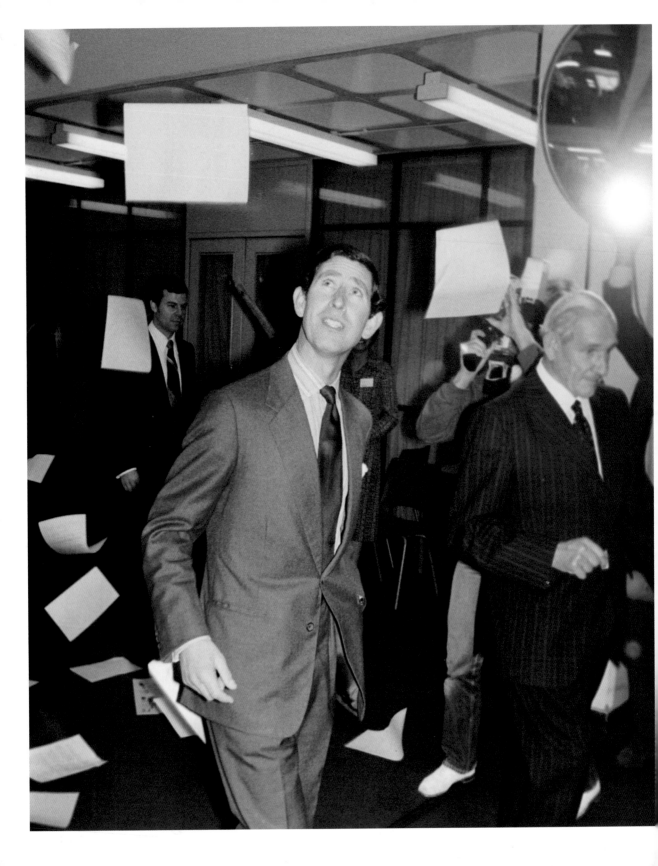

# King Charles III

In the Silver Jubilee summer of 1977 Prince Charles – nearing 30 – declared it was a good year to marry. The then-editor of the *Sun*, Larry Lamb, decided it was also a good year for me to become a full-time royal photographer. The hunt was on to get the first pictures of the woman who would become Charles's bride. I must have gone to 200 polo matches at England's grandest country houses before Lady Diana Spencer came on the scene. In those days I was pretty aggressive and intrusive in my pursuit of the Royals; I needed the picture. I would get furious reprimands from the heir to the throne in my attempts to get it. So when Charles and Diana announced their engagement, myself and *Sun* reporter Harry Arnold sent the Prince of Wales a telegram of congratulation, saying, 'We hope you'll be very happy.' To my surprise, Charles wrote back, 'I hope you won't be made redundant.'

◄◄ **A relaxed-looking Prince Charles in the Himalayas, 1980**

On his first visit to Nepal since attending the Coronation of King Birendra and Queen Aishwarya in 1975, Prince Charles ventured out on a three-day trek in the foothills of the Himalayas. It's customary not to shave during treks. I asked the Prince if we could get a picture before he removed his three-day growth and it was published on page one of the *Sun*.

◄ **An unusual welcome at the Polytechnic of the South Bank, 1980**

Prince Charles taking everything in his stride as he walks through flying paper on arrival to present the Girl Technician of the Year Award. It was the Bakery School at this college that helped make a silver wedding anniversary cake for King George VI and the Queen Mother in 1948 and a christening cake for the infant Prince Charles.

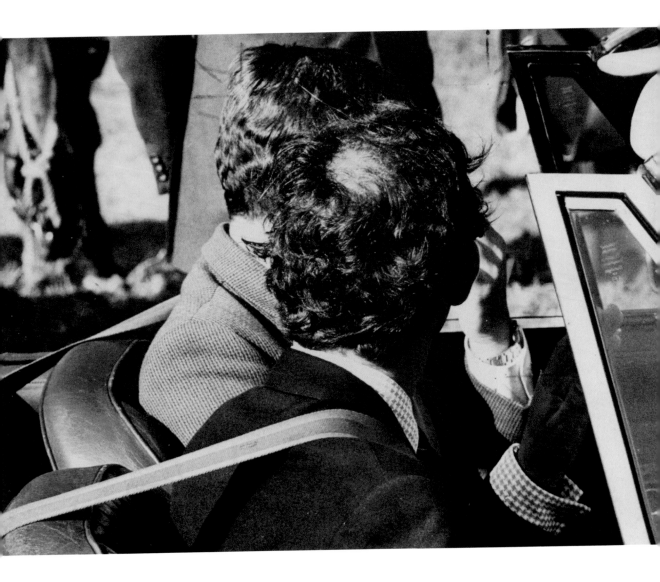

**▲ An unfiltered view of Prince Charles, 1977**

The first time I spoke to His Majesty was in the Queen's 1977 Jubilee year. I took a photo of him that showed he was losing his hair. We ran on it page one under the headline 'There's a patch in your thatch!'

The following week I was at a polo match in Cirencester, Gloucestershire, and his copper warned me the Prince wanted a word. Charles looked at me and said: 'Are you the man who photographed my bald spot?' I said: 'Yes, have you been getting some stick about it?' He replied: 'Not really. Anyway, who saw it?'

I told him how many papers we sold every day and the shocked Prince said: 'Three million. Oh my God, that is the reason everywhere I go people have been photographing the back of my head.'

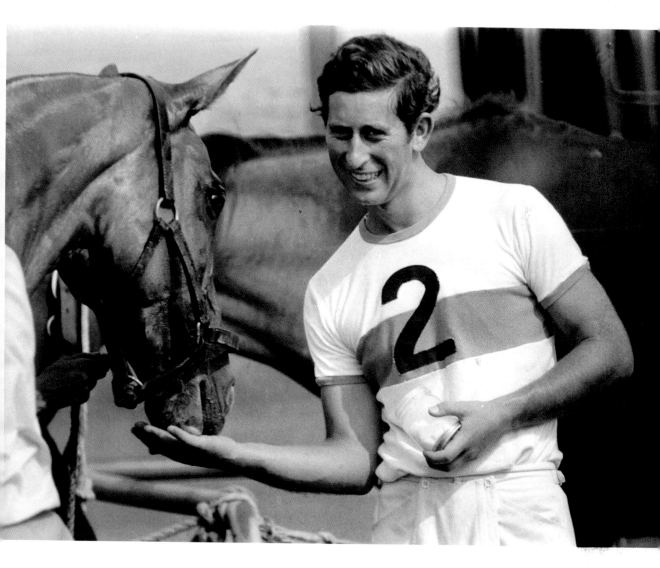

**▲ Charles with his polo ponies at Smiths Lawn, Windsor, 1975**

I took my first royal photo for the *Sun* in 1975. James Whitaker – then a reporter for the paper – asked me if I would go with him to Smiths Lawn where the Prince of Wales was playing polo. I captured this really nice picture at the end of the match of Charles feeding sugar cubes to his polo ponies. This was the picture the Prince and Camilla tweeted to wish me a happy 80th birthday.

'His Majesty has a great sense of humour, and despite the awkwardness about his hair at the time, he saw the funny side of it.'

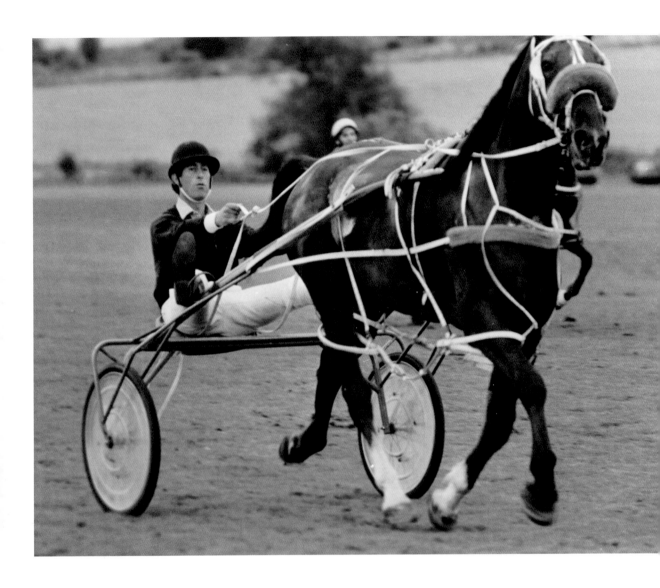

▲ **Happy to try his hand at new
equestrian sports, 1978**

Prince Charles having a go at
harness racing in a 'sulky' after a
polo match in Fife, Scotland, in
September 1978. I rushed straight
to Edinburgh Airport and caught
the shuttle to London to drop off
the film to ensure it made the next
day's paper.

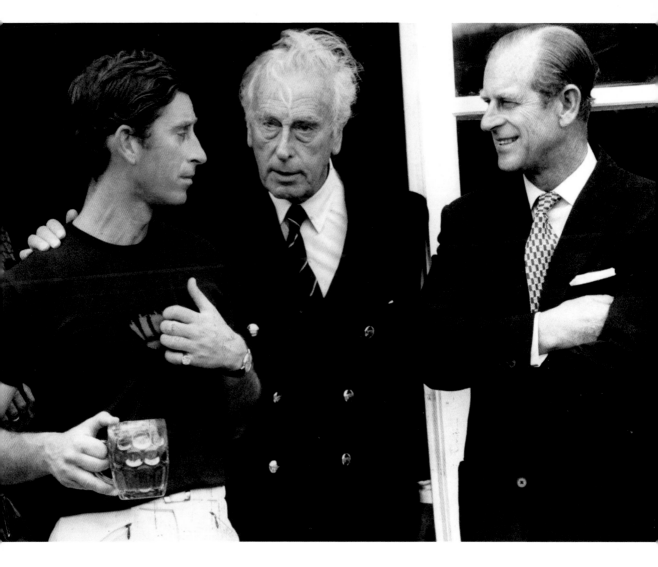

**▲ Prince Charles and his mentors at Tidworth Polo Club, 1978**

Charles shared his love of polo with his father, Prince Philip, and the man he treated like his grandfather, Lord Mountbatten.

Mountbatten's death just a year after I took this photo was especially hard on the young prince. In 2015 he made the emotional journey to Mullaghmore, the village where Lord Mountbatten was killed.

Charles's later poignant words summed up his pain: 'At the time I could not imagine how we could come to terms with the anguish of such a deep loss, since for me Lord Mountbatten represented the grandfather I never had... It seemed as if the foundations of all that we held dear in life had been torn apart irreparably.'

**▶▶Ever charming to friends and strangers alike , 1978**

Charles wins over delighted factory workers in Harlow, Essex, with a flashing smile. During the 1970s the Prince – then the world's most eligible bachelor – would be mobbed everywhere he went. The British public couldn't get enough of him.

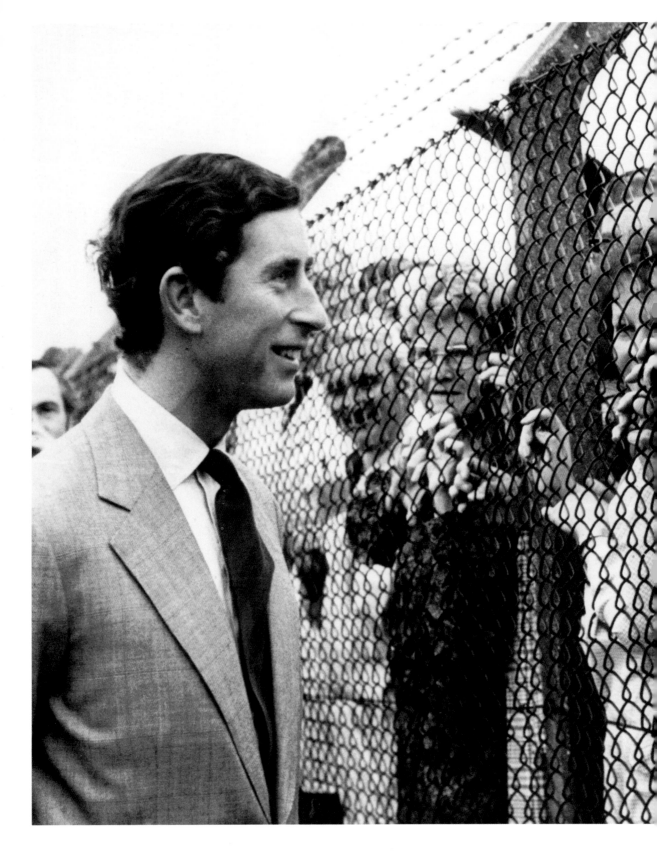

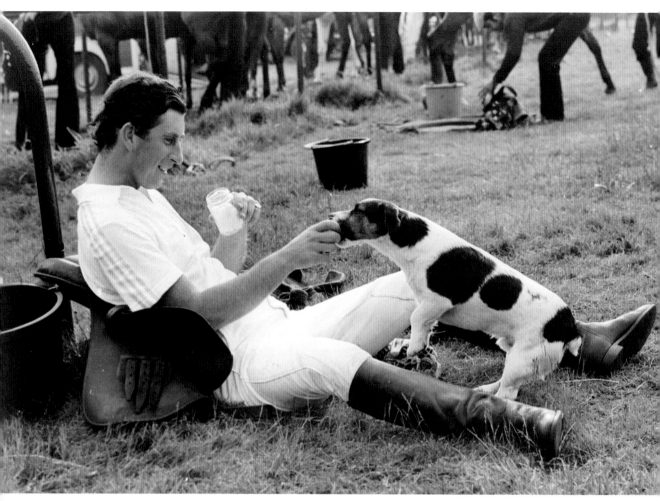

◀ **A compassionate and concerned Charles at Cowdray Park, Sussex, 1978**

It wasn't just the players who got injured during polo matches – and Charles has always been hands on with his horses. At this polo match at Cowdray Park, the Prince stayed with and soothed his pony as it awaited treatment.

◀ **Resting after a polo match with his Jack Russell, 1979**

Prince Charles feeding his Jack Russell, Tigger, after a tough game of polo at Smiths Lawn, Windsor. This is one of my favourite pictures and shows the animal-loving nature of the Royal Family.

▶ **The weight of winning, 1979**

I would follow Charles all over the country covering his polo matches in the hope I would be first to photograph the woman who would one day be his wife. I took this shot one Saturday at a match in the West Country. Charles was presented with this really large trophy and it just collapsed in his arms. I didn't get a picture of any Royal girlfriends that day but this was a cracking image.

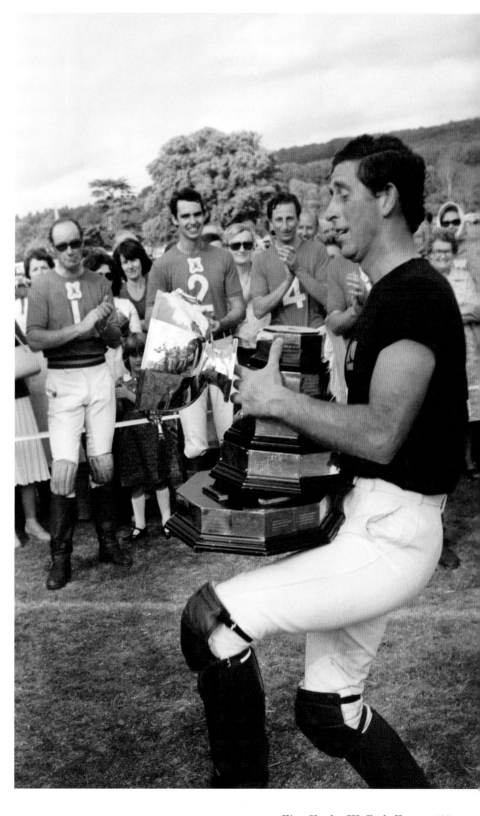

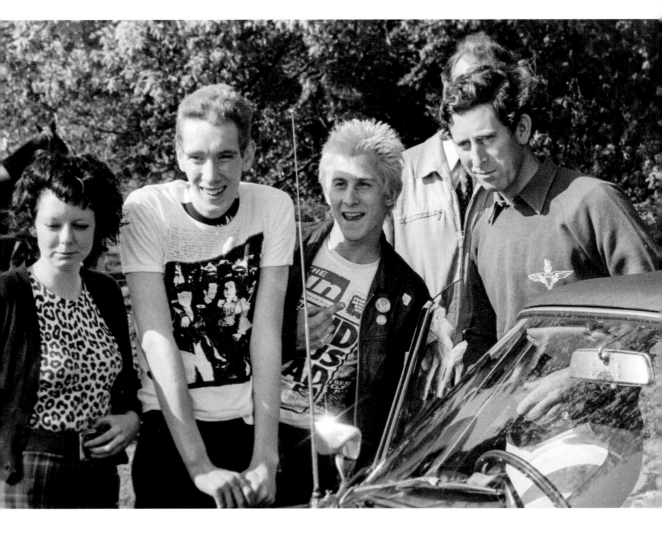

**▲ A prince for all people, 1979**

**▶ The Prince spreads his wings, RAF Benson, 1979**

His Majesty's appeal extends to people with a wide range of interests and from different generations. Punks Anne Wobble, 17, Tony Waterman, 17, and Phil Sick, 19, approached the Prince during a game of polo. When told Phil Sick's name, the Prince retorted: 'Is that the normal spelling?' They had turned up to the game in Windsor to invite the Prince to a rock concert that night, 27 May 1979.

Prince Charles, wearing a Biggles-style flying outfit which he said had been dug out of a museum especially for the occasion, fulfilled a private ambition by flying in a pre-war De Havilland Tiger Moth bi-plane at RAF Benson, in Oxfordshire.

The Prince, who was accompanied by Royal Air Force Cranwell instructor Flight Lieutenant John Hardie, demonstrated his skill as a pilot by taking the controls of the 44-year-old plane for more than an hour. As well as taking off and landing he completed a number of aerial manoeuvres.

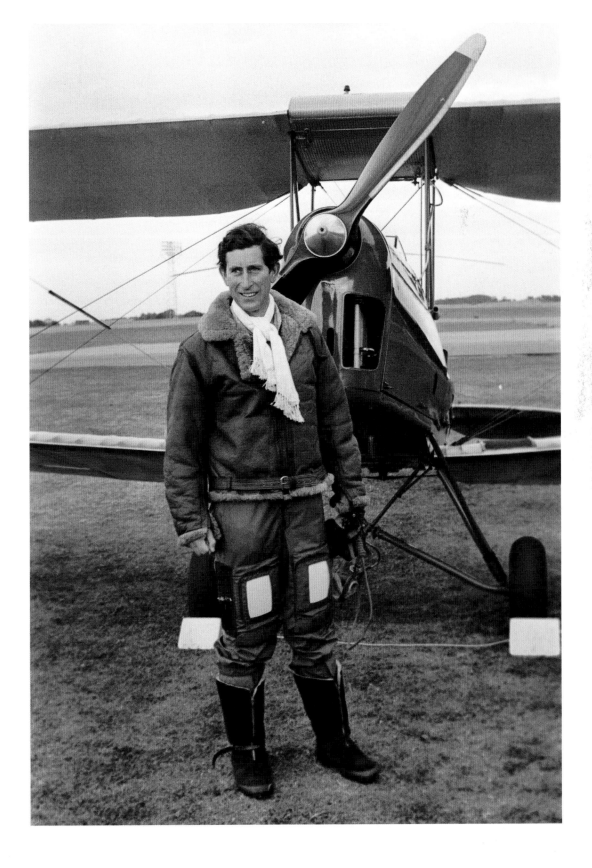

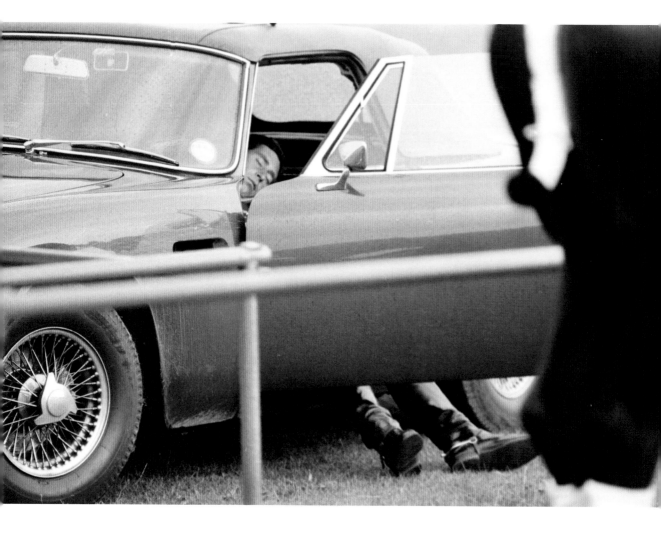

**▲ Charles catching 40 winks, 1979**

Prince Charles sleeping in his Aston Martin DB5 Volante sports car after a polo match at Cowdray Park Polo Club. The car was a gift from his mother on his 21st birthday.

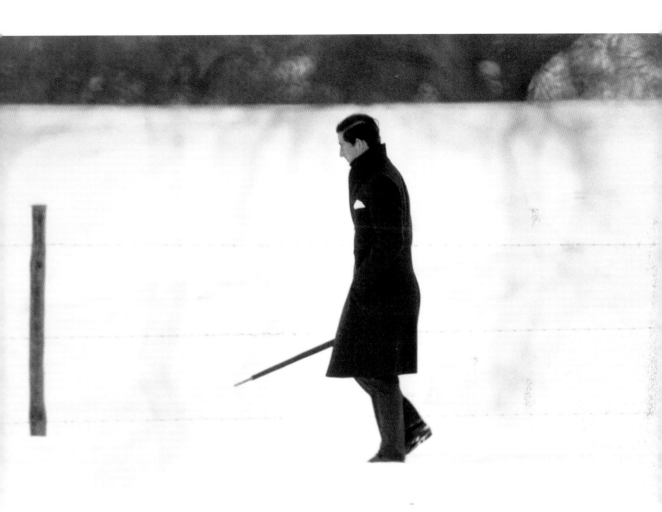

**▲ A stroll in the snow at Sandringham, 1979**

Every year the Royals congregate at Sandringham for Christmas. Here Charles takes a break from the festivities to spend some time alone walking around the estate.

'In the late 1970s I actually began to like Prince Charles and appreciate what he was doing. He just never stopped working for others and I started to change my way of thinking about the Royals.'

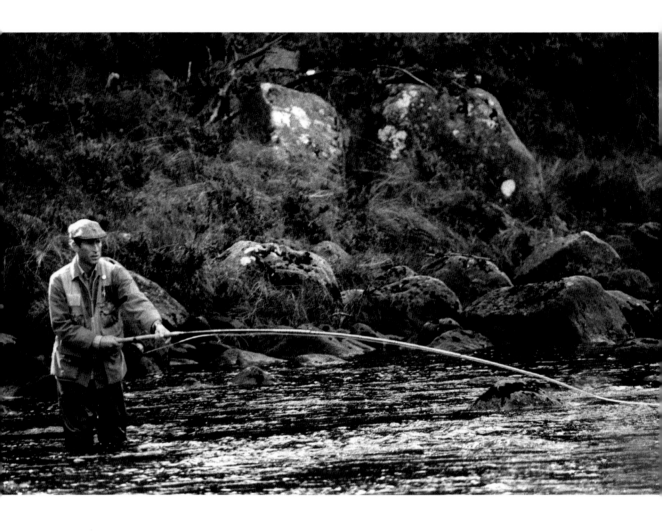

**▲ Catching a break at
Balmoral, 1980**

Prince Charles took Lady Diana
Spencer on this weekend break to
Balmoral. He looked relaxed fishing
on the River Dee, on the banks of
which, the following year, Charles
and Diana spoke to the press for
the first time after their marriage.

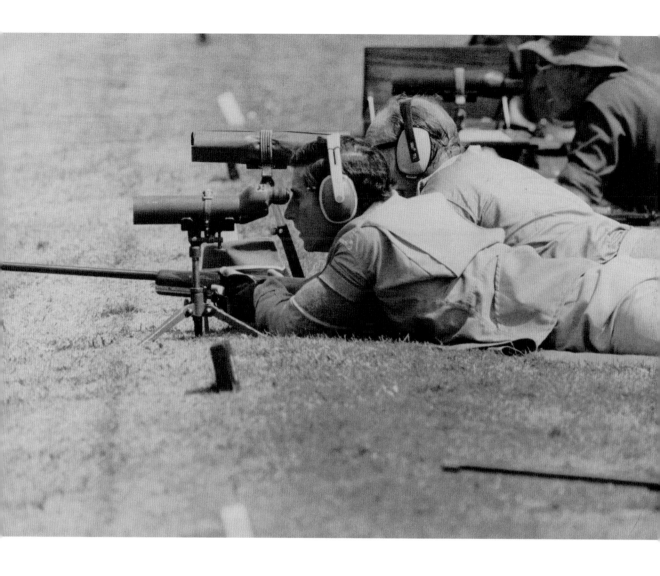

▲ **Prince Charles showing his sharp eye at Bisley, 1980**

His Majesty is a crack shot and can be seen here shooting for the House of Lords team in the annual match against a team from the House of Commons. In his capacity as President of the National Rifle Assocation, he was the first Royal to shoot at Bisley, in Surrey, one of the world's most famous rifle ranges.

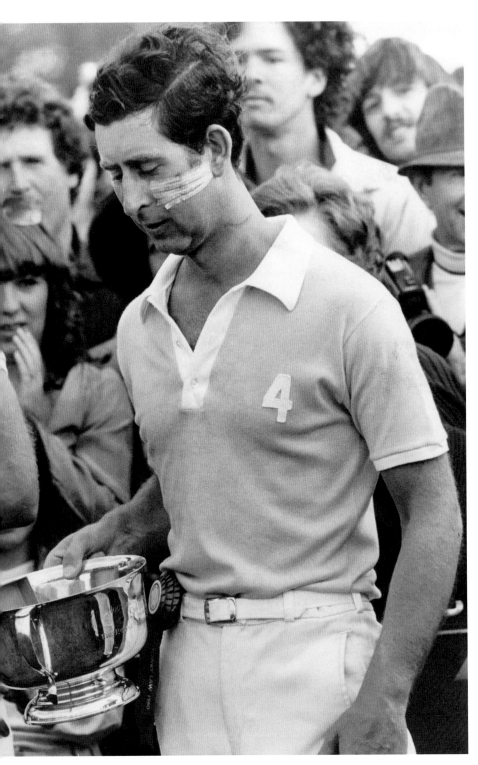

In 1980, the Prince was thrown and kicked by his pony during a polo match at Windsor and needed six stitches.

He carried on playing despite the injury and my picture of him presenting the trophy afterwards made the front page. A two-inch crescent scar on his left cheek bears witness to his narrow escape to this day.

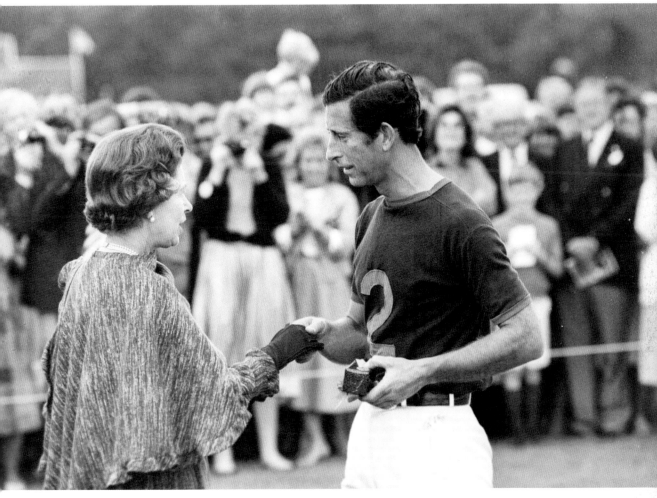

**▲ Thank you, Ma'am, 1980**

A formal encounter between mother and son as the Queen presented the Prince with his winner's medal.

**▶ Cooling down, 1986**

Temperatures of over 30 degrees weren't enough to stop Charles playing his beloved polo - helped here by a quick half pint between rounds.

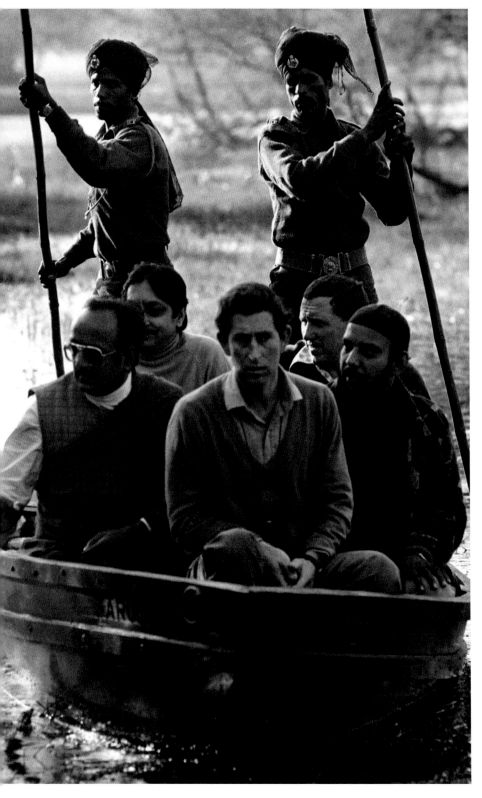

▶ **Charles gets on the road, Bharatpur, 1980**

In 1980 we went on this massive tour of India and Nepal with the Prince. We were away for a month and we went everywhere with him. It was an incredible experience.

◀ **Birdwatching in Bharatpur, 1980**

His Majesty has had a lifelong commitment to conservation. While his predecessors enjoyed tiger hunts on their trips to India, Charles preferred birdwatching at a wildlife sanctuary.

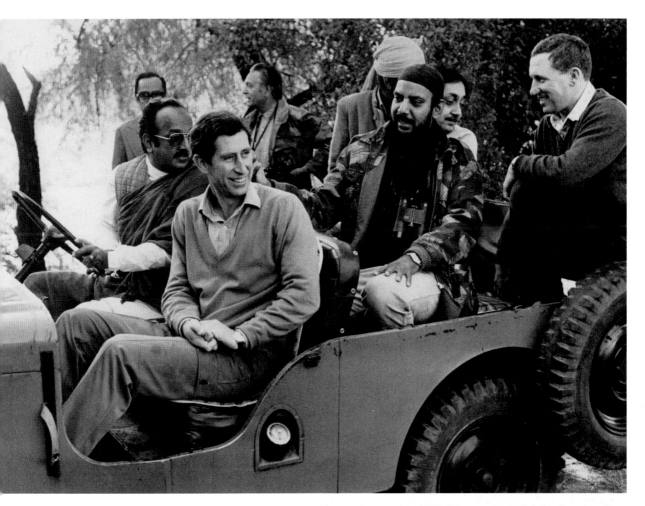

▶ **Embracing Indian culture in Bombay, 1980**

Bollywood star Padmini Kolhapure made headlines around the world after she greeted Prince Charles with a garland and a peck on the cheek during his trip to India in 1980. The Prince visited a film studio where the young actress was shooting a movie. Excited to meet the future monarch, she rushed over to greet him and planted a kiss on his cheek.

However, their meeting instantly caused a furore in the Indian and the UK papers, as at the time Charles was one of the world's most eligible bachelors.

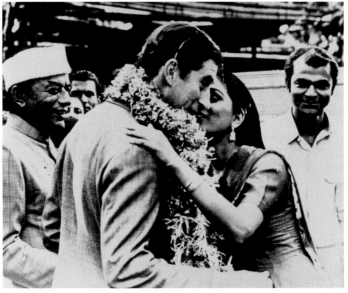

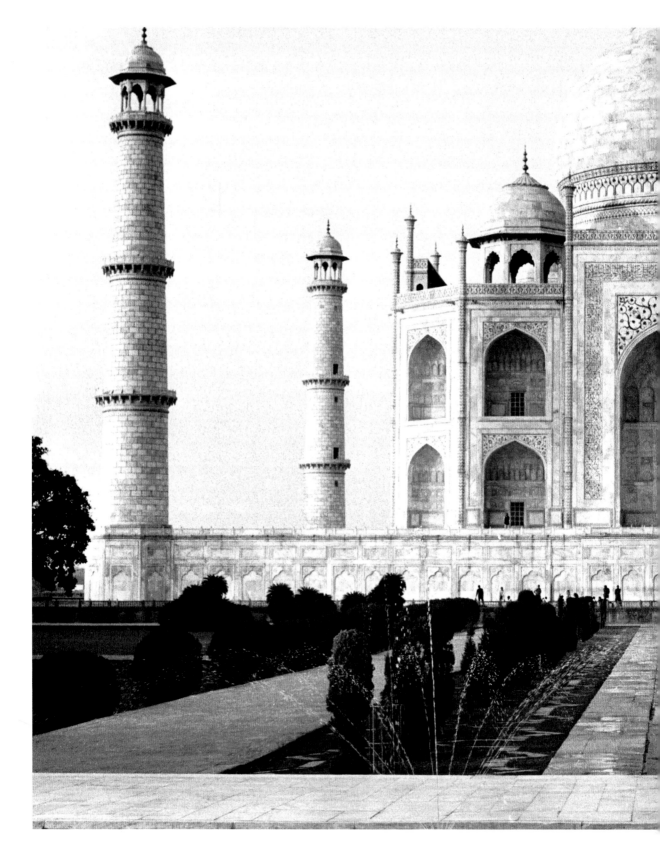

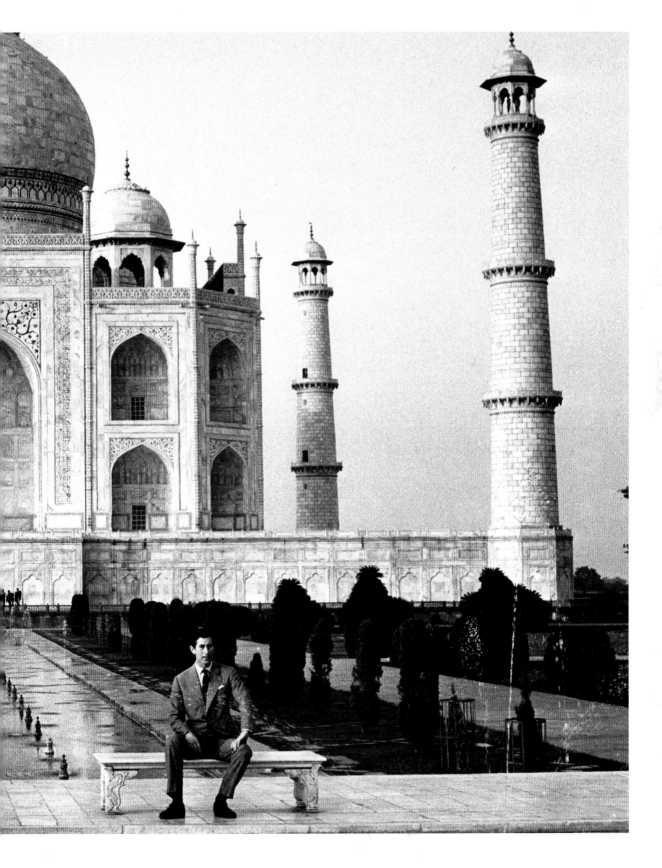

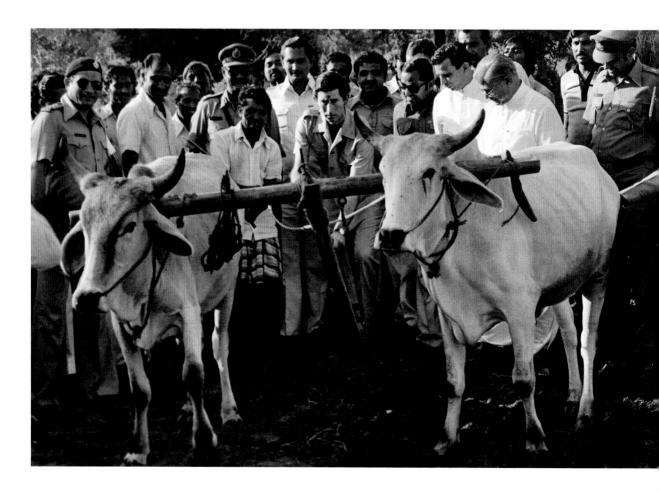

### ◄◄ Taking a moment in Agra, India, 1980

Prince Charles sitting outside the Taj Mahal, in Agra, that world-famous monument to love, during his tour of India. Twelve years later Princess Diana would be famously photographed sitting alone in front of the same building, which many saw as a signal that she and Prince Charles were drifting apart. The Royal couple announced their separation nine months later.

### ▲ Ploughing through his Indian tour, 1980

His Majesty has often shown his willingness to try his hand at new things, in this case ploughing the traditional way with oxen.

### ► Mother Teresa makes a lasting impression, 1980

I shook hands with Mother Teresa during the India tour. Prince Charles was due to meet her so I went down the day before. I knocked on the door and there she was! I told her why I was there and she ran through what was going to happen when the Prince arrived, including where they were going to pray. There's one thing you can't do with the Royals: when they're praying you can't photograph them! She was an amazing woman and she charmed the Prince when they met.

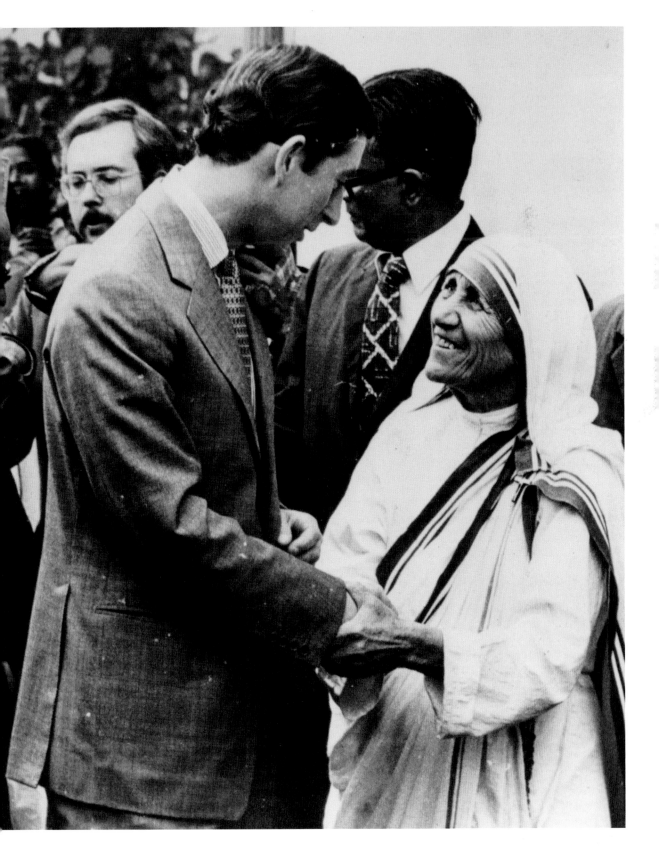

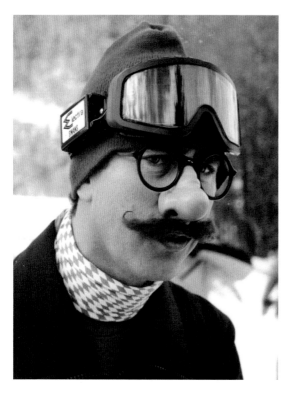

▲ Guess who! Klosters, Switzerland, 1980

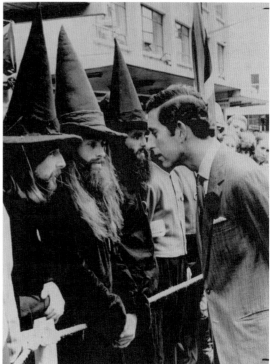

▲ A wizarding walkabout in New Zealand, 1981

One morning, in Klosters in 1980, Charles's host Patti Palmer-Tomkinson told us, 'My uncle Harry will be joining us for skiiing this morning.' It was a joke – when 'Uncle Harry' emerged, it was the Prince wearing a false nose, glasses and moustache.

The photographers were like sharks after red meat. Several fell over on the slopes trying to get a picture of the slapstick Prince and many missed it. He had the get-up on for less than a minute and it was the last we ever saw of it!

You never quite know who you'll bump into on a Royal trip. In this case Charles seems to be taking a keen interest in three men dressed as wizards on a visit to Dunedin, New Zealand, in 1981. He first visited the country in March 1970, as a 21-year-old, and was there last in 2019 with Camilla, so far having visited the country ten times.

◀ Sloping off, Klosters, Switzerland, 1980

I was walking back to the hotel after seeing Prince Charles safely back into his chalet after skiing all day, and suddenly remembered I'd left my camera bag outside his residence. I walked back to the chalet only to come across the Prince going down the slope on a kid's sledge! I got a picture and it ended up on page one. I still remember the headline: 'Prince Whizz'.

**▲ Prince of Wheels, Lambourn, 1981**

Always happier on a horse, Charles would occasionally swap his steed for a bicycle to keep fit. Here he was on a visit with Princess Diana to racehorse trainer Nick Gaselee's stables at Lambourn, Berkshire, in March 1981. The bike had no seat to toughen up his legs as he prepared to ride as an amateur jockey.

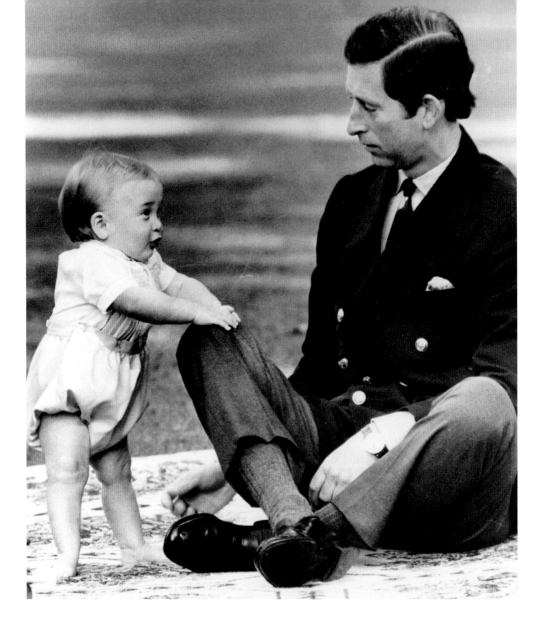

**▲ Father and son, 1983**

This is a lovely shot of Charles playing with William at a photo opportunity in the grounds of Government House, Auckland, during the 1983 Royal Tour of Australia and New Zealand.

Prince William joined his parents on the six-week trip at Diana's insistence, a move that broke years of Royal protocol, which stated that two heirs should not travel together on the same trip, to protect the line of succession.

**▶ William steps up, St Mary's Hospital, London, 1984**

Charles and William were the first visitors after Prince Harry was born at St Mary's Hospital, Paddington, in September 1984. The Palace would announce his name that day: Prince Henry of Wales, to be known as Prince Harry.

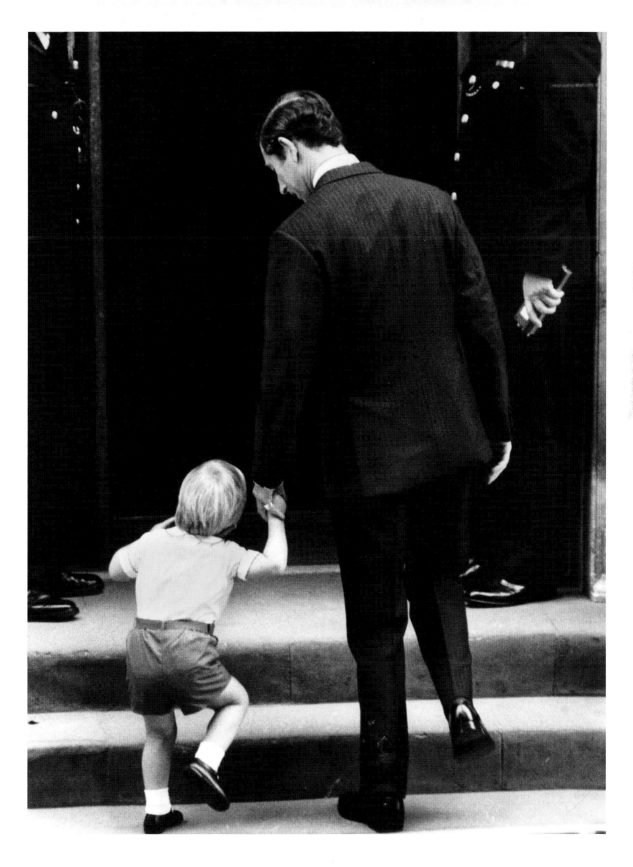

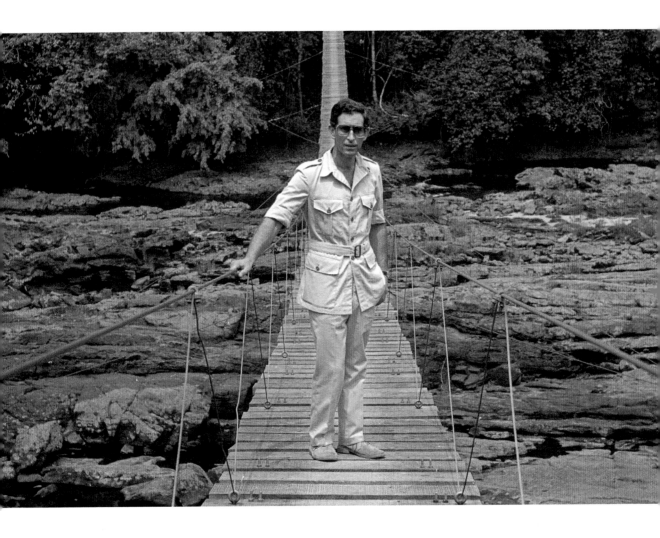

▲ **Living the high life, 1990**

Prince Charles on a suspension
bridge over the River Mana, in Korup
Rainforest, in the West African nation
of Cameroon in 1990.

▶ **A bad break, Cirencester, 1990**

In a very Royal injury, the Prince
broke his arm after falling off his
horse during a game of polo. Charles
later required a second operation
after the fracture failed to heal.
I snapped the Prince and Diana
leaving Cirencester Hospital in
Gloucestershire.

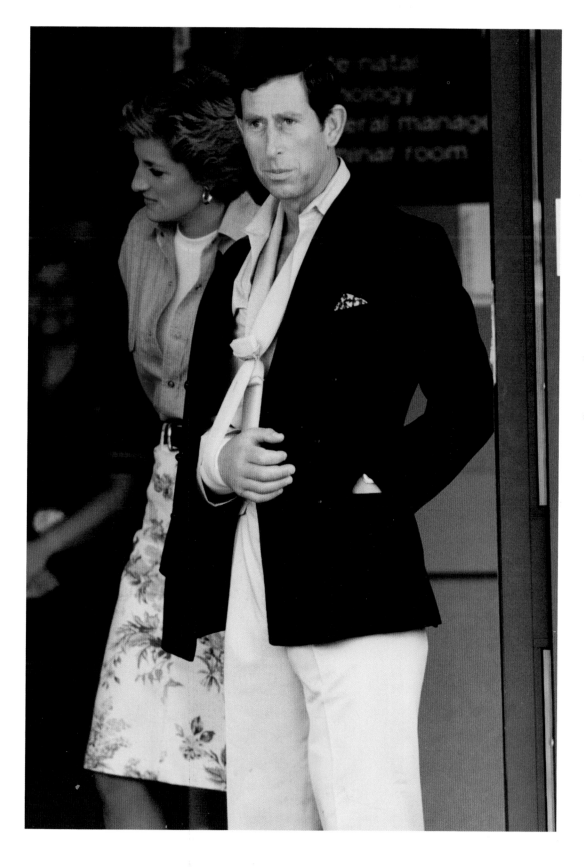

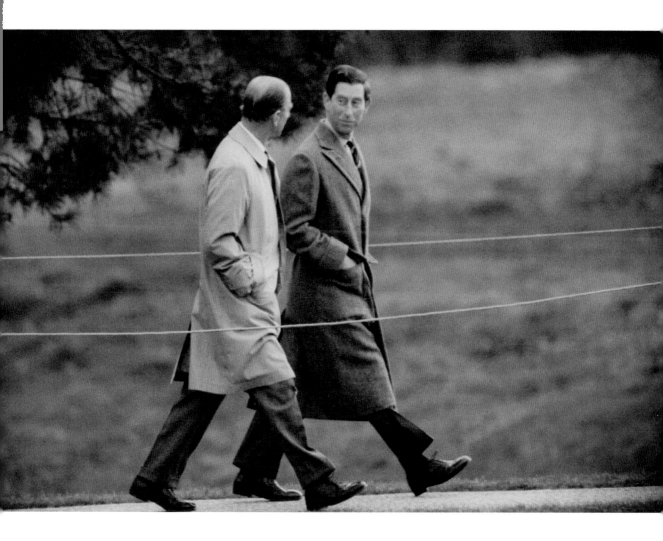

◀ **All smiles at the Sandringham Flower Show, 1991**

Charles looking very dapper as he attends the Sandringham Flower Show in 1991, an event at which he has been a regular visitor over the years.

▲ **Father and son, 1993**

Charles in deep conversation with his father during a walk at Sandringham. Prince Philip handed over control of the 20,000-acre estate to his eldest son in 2017.

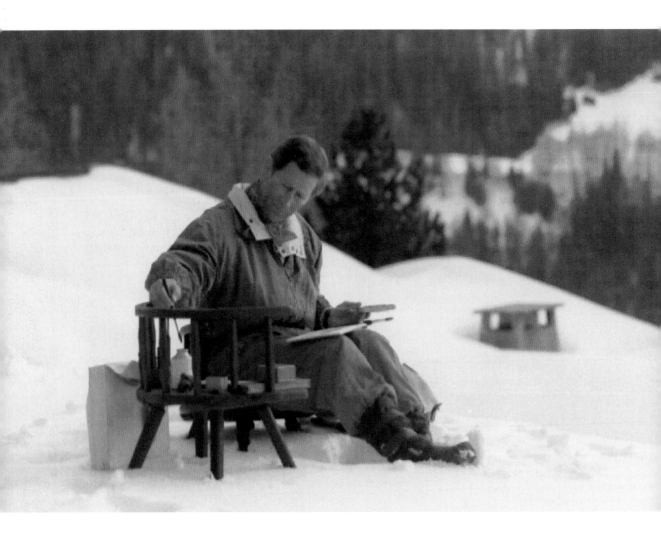

▲ **Taking down the view at Klosters, 1994**

Never without his sketchbook, even on the slopes, like I was never without my camera! King Charles started painting in the 1970s. He works exclusively in watercolour, and his paintings were first exhibited in Windsor Castle in 1977. His Majesty, who has donated all profits from his artwork to The Prince of Wales's Charitable Fund, prefers to paint outdoor scenes, especially the area surrounding Balmoral. His works have featured on stamps and even on a Swiss ski pass.

'Everything His Majesty does is for the benefit of others, never himself. You can't even pay him a compliment. He won't accept it, he just dismisses it because he feels he has so much else to do.'

**▲ Not-so-secret patrol, New Zealand, 1994**

Charles gets up close and personal with members of the NZDF's SAS regiment. That year, 1994, was when Prince Charles admitted to his affair with Camilla Parker Bowles, the future Duchess of Cornwall, in a BBC interview seen around the world.

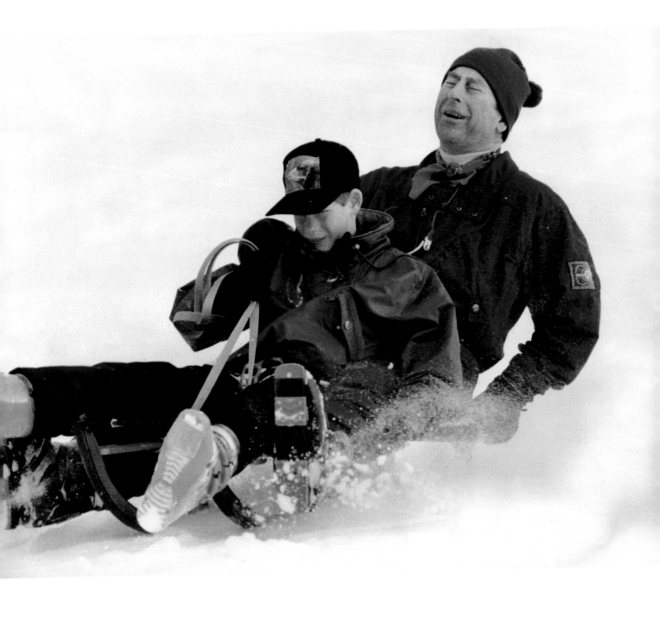

▲ **Harry's game! Klosters, Switzerland, 1997**

I think His Majesty always regretted doing this photocall with his young son, Harry. Just before the pair came to a halt, the sledge hit a chunk of ice and the Prince, who had a well-documented bad back, was in agony. I think it will be the last time he tries something like that!

▶ **Family fun before tragedy strikes, Balmoral, 1997**

William and Harry spent the month leading up to their mother's death – August 1997 – at Balmoral with their father. This photo was taken a little more than before two weeks before Diana died.

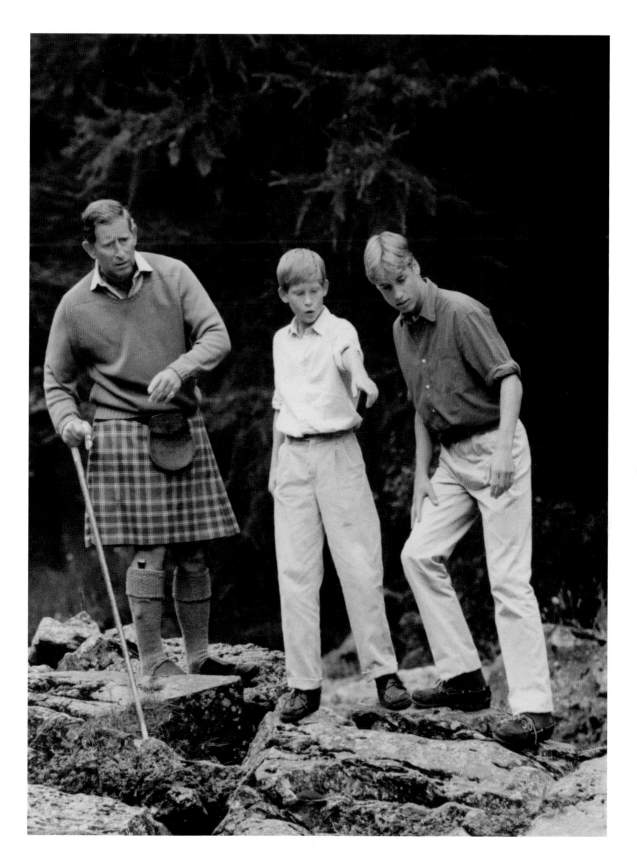

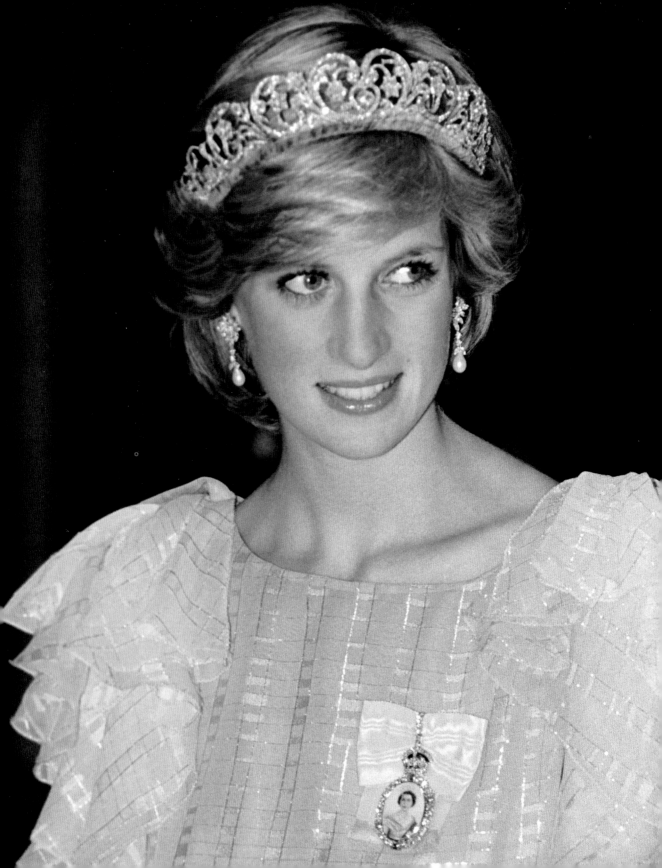

# Diana

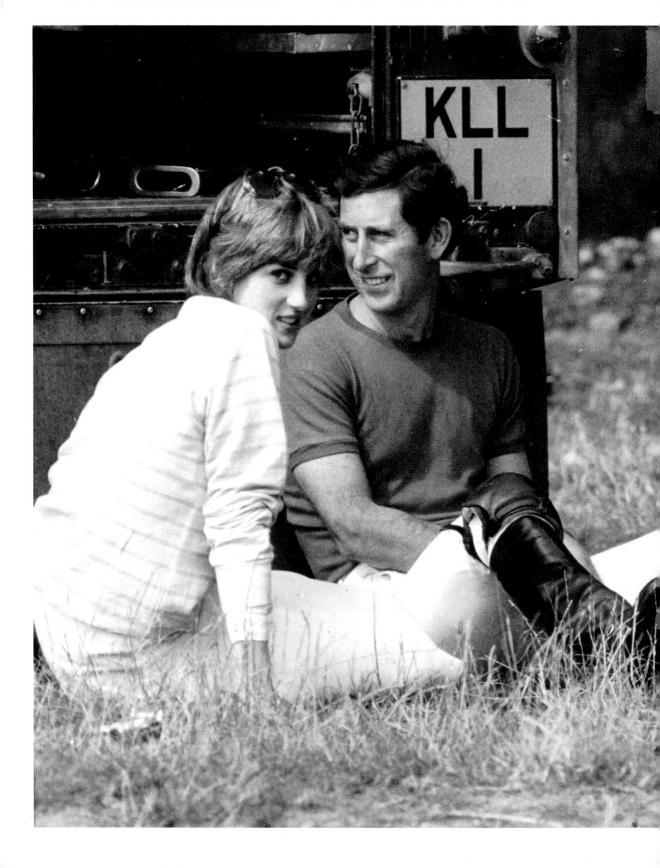

# Diana

Diana was a breath of fresh air when she joined the Royal Family. She changed everything. I followed her across the globe as she carved out a humanitarian role meeting lepers in Nigeria, Aids orphans in Brazil and landmine victims in Angola. We got on well, and she would look down my lens knowing she would get a great picture published the following day. She had a wry sense of humour, too. In 1990, shortly after being fined for speeding, Diana visited the Honda factory in Tokyo and was shown Formula One ace Ayrton Senna's racing car. I piped up: 'They would never catch you on the M4 in that Ma'am.' She replied, deadpan: 'I'll do the jokes, Arthur.' Another time I got an attack of the Delhi Belly in Cairo and Diana sent her doctor to see me. At a photocall the next day she joked: 'That's done wonders for your figure.'

◀◀ **Courting Canada, 1983**

A regal and elegant Princess Diana on the tour of Canada in 1983, winning admirers the world over.

◀ **Summer of love, 1981**

Looking relaxed but ever aware of the camera. Two weeks before their wedding, Lady Diana Spencer supported Prince Charles in his match at Smiths Lawn Polo Club, Windsor, July 1981.

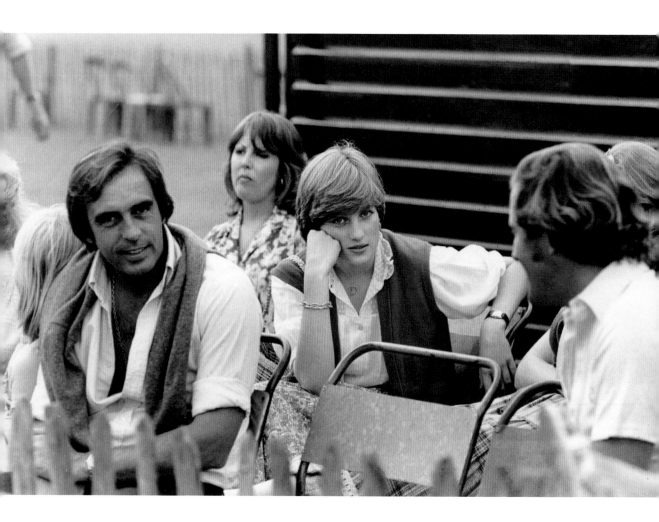

**▲ Finding the elusive new girlfriend of Prince Charles, July 1980**

'My remarkable working relationship with Lady Diana Spencer began exactly a year and a day before her wedding. This photo has a special place in my heart as it was the first I ever took of Diana. It was the start of a 17-year run of covering this amazing woman.'

I got a tip that Diana was at the polo match at Cowdray Park at Midhurst, West Sussex. My contact said Charles had turned up with a woman called Lady Diana Spencer, but no one know what she looked like. The only description was 'blonde'. So I walked around the polo pitch and I came across this very pretty looking girl and she had a necklace with a D on it. I said, 'Excuse me are you Lady Diana Spencer?' She said yes and posed for my picture. I filed that photo, doubtful that Charles was running around with a teenager, and it only got published when the relationship was confirmed.

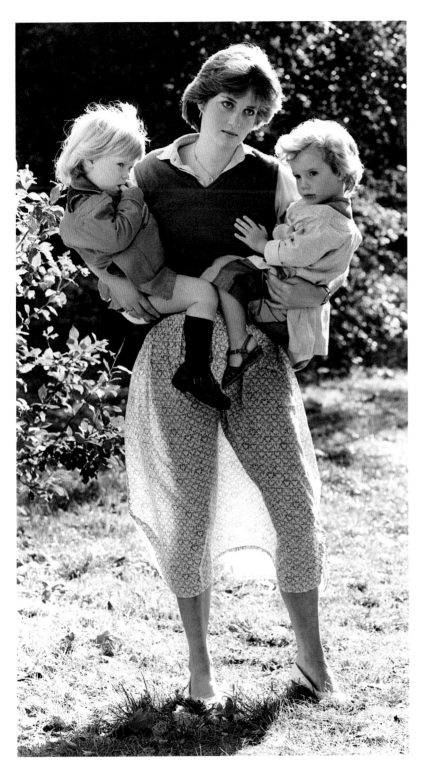

I went to the nurseries around London to find out where Diana worked. When I finally found her, I asked her to pose for a photo in a nearby park. The see-through look was never intentional – I would never do that to a lady – but as she was standing there, the sun came out. It was a sensational picture and I remember going back and showing it to the night editor, Roy Patilla. He went 'Oh my God' and put it straight on page one with the headline 'Charlie's girl'. I still get asked about this picture to this day.

▲ **A great catch, 1980**

In September 1980 I was driving along Deeside, near Balmoral Castle, on my way to the Braemar Games when I saw Charles fishing in the river. I slammed on the brakes and dashed over. I saw someone else with him who was dressed in waterproofs, hat and waders. I first thought it was his ghillie. But it was Diana. She saw me and hid behind a tree. Then suddenly she made a dash through the trees and I got pictures of her running for their car. Charles angrily packed up his fishing gear and off they went. That fishing excursion was the clue that Diana was someone special.

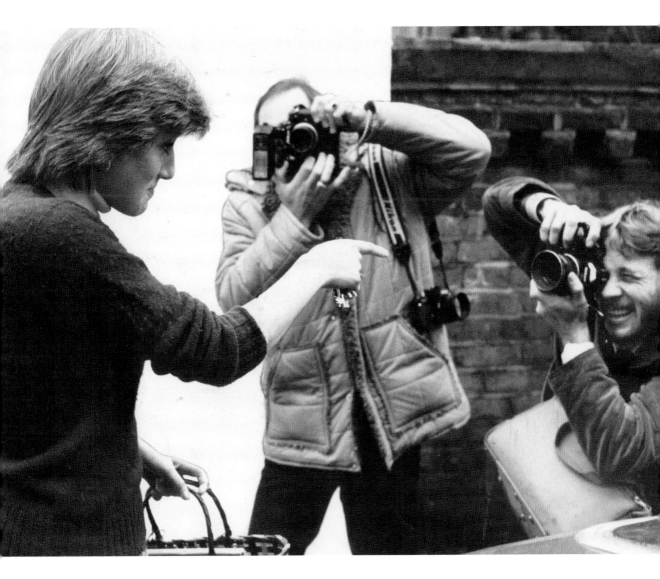

**▲ Catapulted into a new world, 1980**

Every day the Press would go to the lovely flat Earl Spencer had bought Diana and take pictures of her leaving for work and coming home. One day, she stopped me and asked: 'Why are you so interested in me?' I said: 'You know why, you seem the perfect girl with no past.'

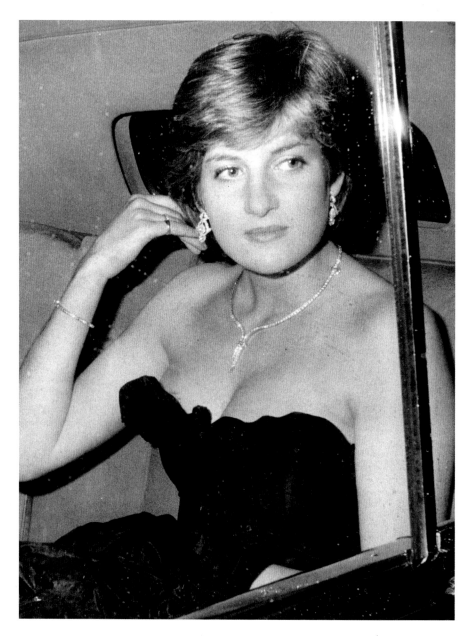

◀ **Causing a sensation on her first appearance with Prince Charles, 1981**

This was Diana's first big event after her engagement to Prince Charles. They attended Goldsmiths' Hall, London, where Princess Grace of Monaco was reading poetry. I was with the Press pack waiting outside and when Charles got out of their car, he said, 'Wait til you see what's coming next!' And she came out with this off-the-shoulder dress by designers the Emmanuels. She looked a million dollars.

It was a fabulous dress. And I remember this portrait of DIana looking out the car window looking very pensive. It was the start of Diana-mania.

'I watched Diana turn from a shy, teenage nursery school assistant into the most famous woman in the world.'

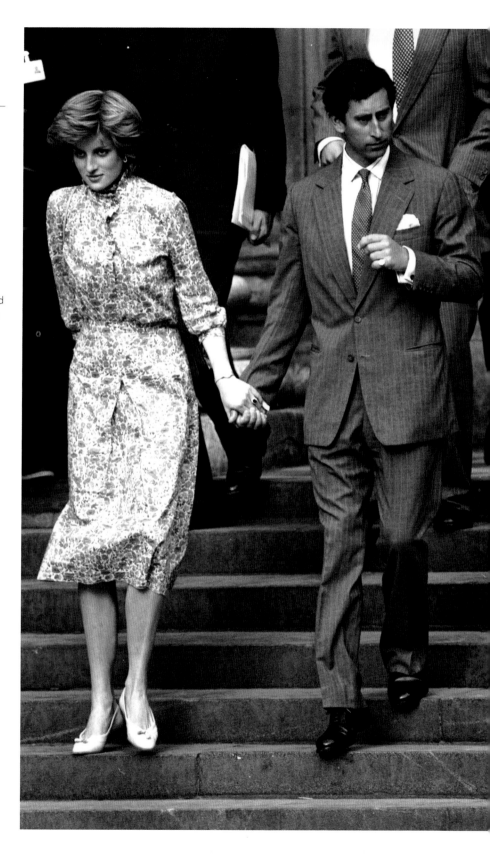

**▶ Picture perfect for their big day, 1981**

Two days before the Royal wedding, I was driving past St Paul's Cathedral on the way to *The Sun*'s office when I spotted Prince Charles's car. So I pulled up sharply, left my car on a double yellow line and grabbed my cameras. As I reached the steps of the Cathedral, Charles and Diana emerged after their wedding rehearsal. Diana saw me and reached out and held the Prince's hand. It was a page one picture. By this time she was painfully thin, and I remember thinking, 'Please Diana, don't lose any more weight'.

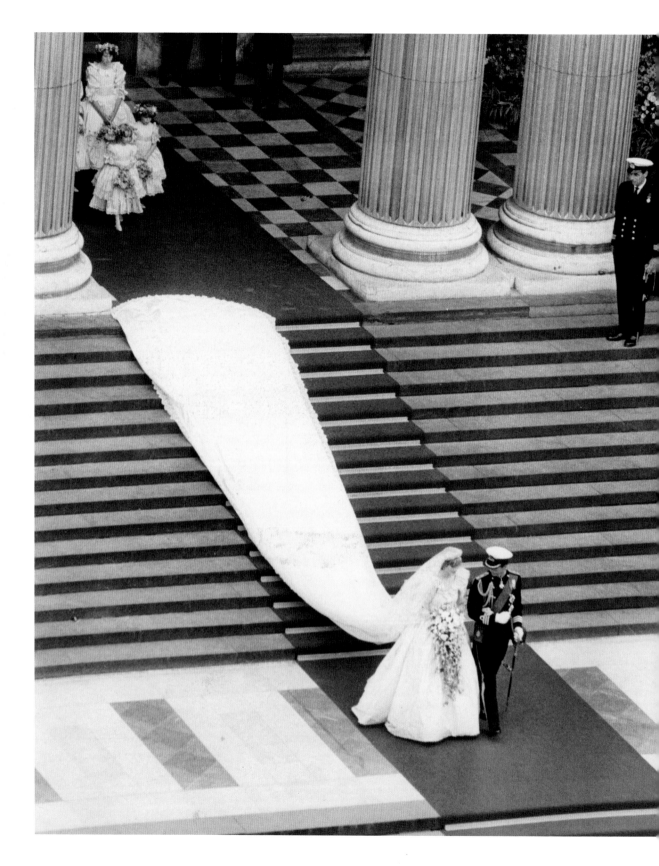

**◄ The train now standing at St Paul's, 1981**

**▲ The people's princess in training, 1981**

Unusually, I was in the wrong position on the day of the wedding – I should have been outside Buckingham Palace, because that's where Diana and Charles kissed, which made it on to page one. But I chose to go to the Cathedral because I thought the dress was the story – however, my photo appeared on an inside page. Still, the picture of the wedding dress was an historic image. It had the longest train ever for a Royal bride. I think this is a beautiful picture. A brilliant *Sun* subeditor came up with the headline: 'The train now standing at St Paul's'.

After their engagement was confirmed, official duties began. On 9 May 1981, Prince Charles and Lady Diana Spencer opened a special exhibition at Broadlands, the home of the late Lord Mountbatten, and met the delighted crowds.

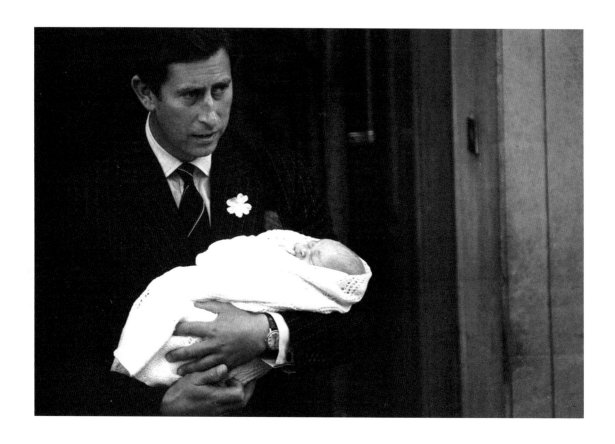

**▲▶ The birth of the new generation, 1982**

On 21 June 1982, Prince William became the first future monarch to be born in a hospital. But that was not the only break with Royal tradition: Prince Charles was present at the birth of his first and then later second son – previously unheard-of amongst the Royal Family. The Prince later wrote to his godmother, Patricia Brabourne: 'I am so thankful I was beside Diana's bedside the whole time because by the end of the day I really felt as though I'd shared deeply the process of birth and as a result was rewarded by seeing a small creature which belonged to us. Even though he seemed to belong to everyone else as well!'

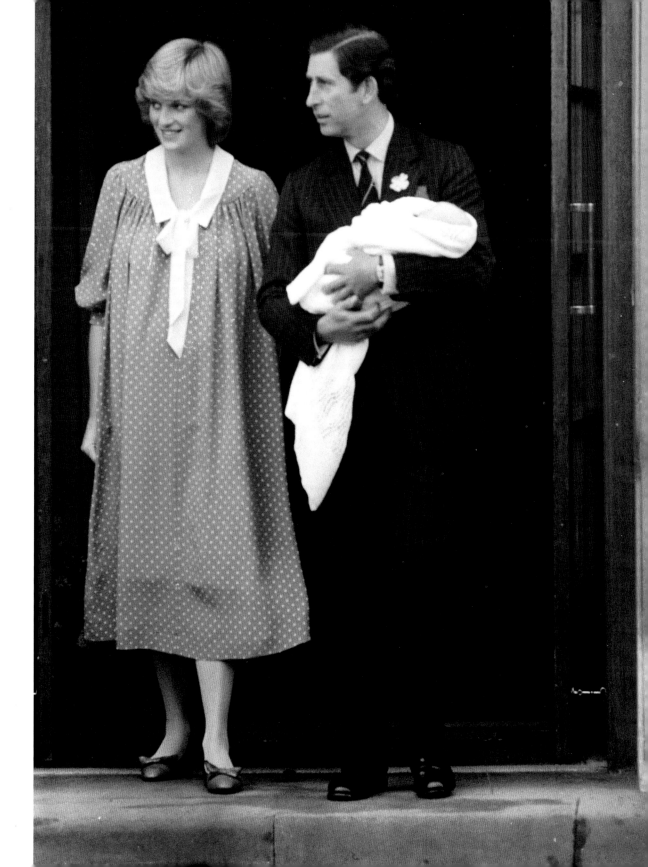

**◀▲ Winning hearts in Australia and New Zealand, 1983**

The crowds were huge on this tour and my pictures were flying into the paper. It was like The Beatles had just arrived rather than a Royal couple. In Brisbane they had to shut the city – they couldn't fit another person in. The crowds were 30 deep in places.

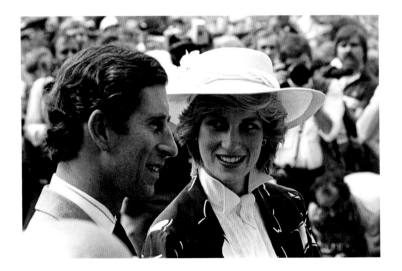

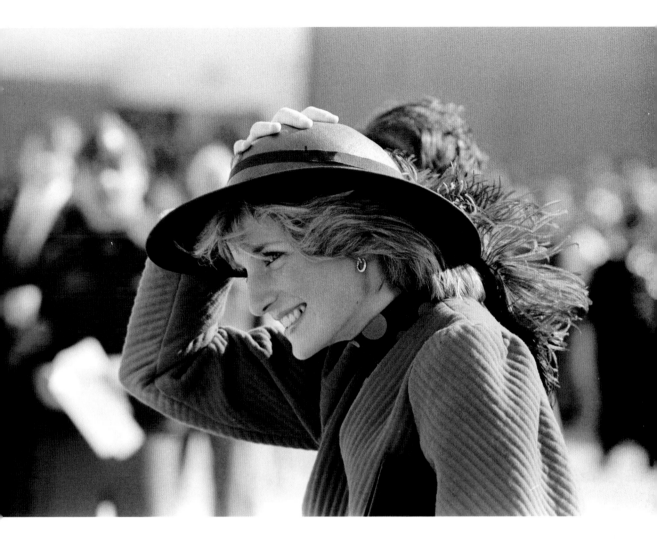

**▲ Tour of Canada, 1983**

Diana celebrated her 22nd birthday
in Canada on the country's national
day. She was greeted by adoring
crowds, with many bringing along
birthday cards for her.

'It was Diana-mania. No one seemed
to care about the Prince. They only
cared about her.'

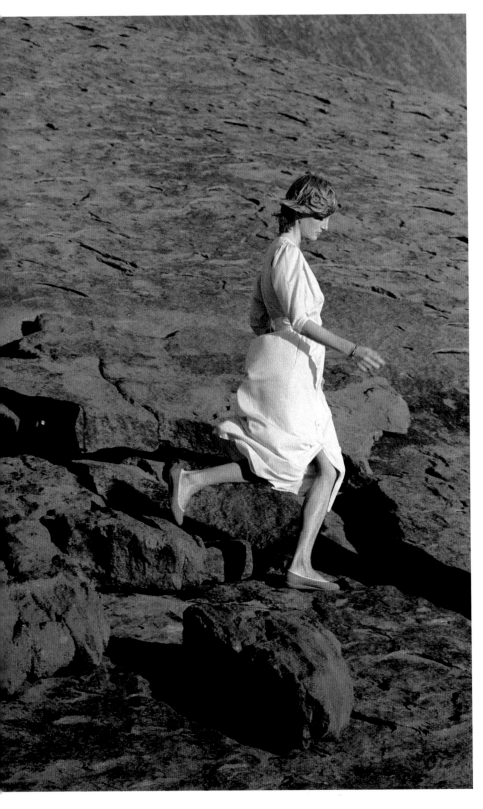

◀ **Exploring Indigenous Australia, 1983**

Today visitors aren't allowed to climb Uluru – the sacred Aboriginal site in Australia's Northern Territory. But back then Diana was allowed to scale the peak.

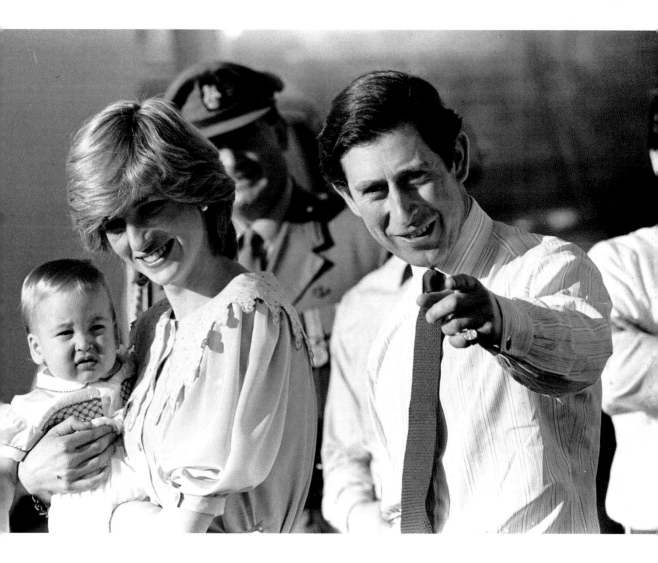

**▲ 'Look at the camera, Wills!',
Alice Springs, 1983**

Prince William joined his parents
on the antipodean tour of 1983,
and we all got an insight into the
family behind the Royal protocol –
it was also when we first heard his
parents call him 'Wills'.

'William was a lovely little boy.
It was a joyous time to observe him
with his doting parents.'

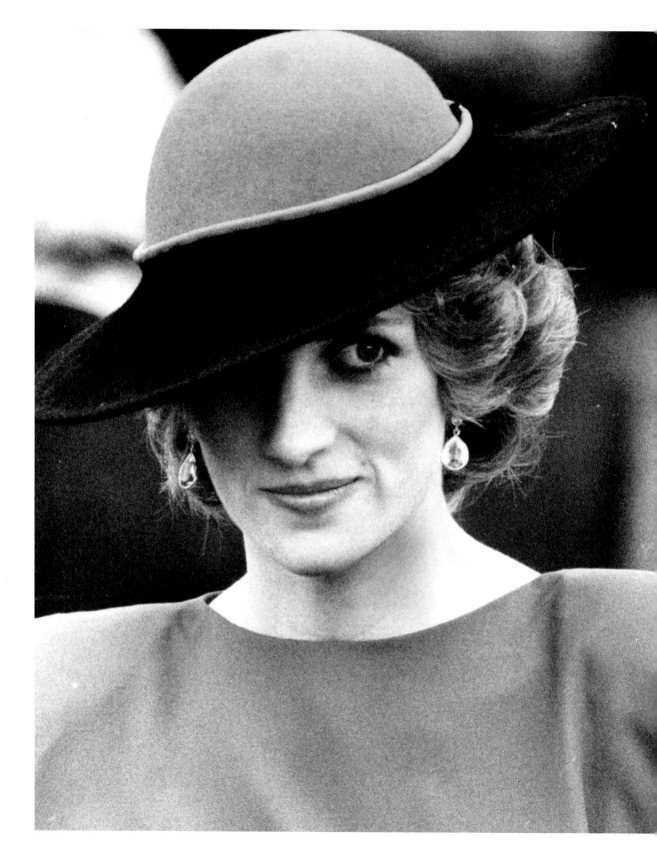

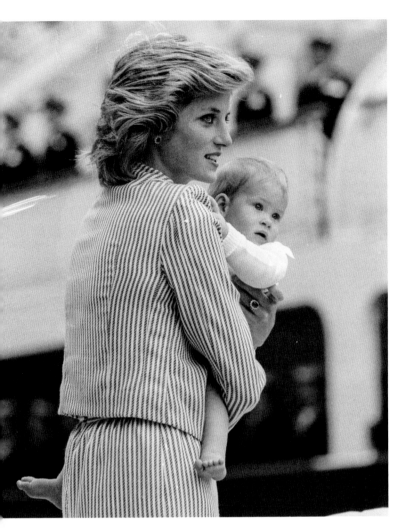

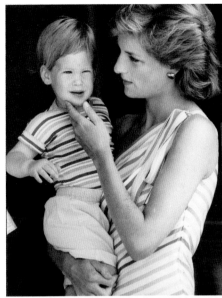

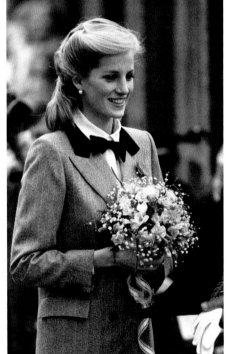

◀ **Wedding belle, 1985**

One of my favourite pictures I took of Diana, at a friend's wedding in Norfolk. I love the styling of the tilted hat and the fabulous diamond earrings.

▲▶ **Changing faces of Prince Harry**

The boys were her world and she took them with her whenever she could.

▶ **Visiting Dr Barnardo's Intermediate Centre, 1984**

Diana became known – and much copied – for her bob in the 1980s, but I like this rare shot as it shows her experimenting with a very different hairstyle.

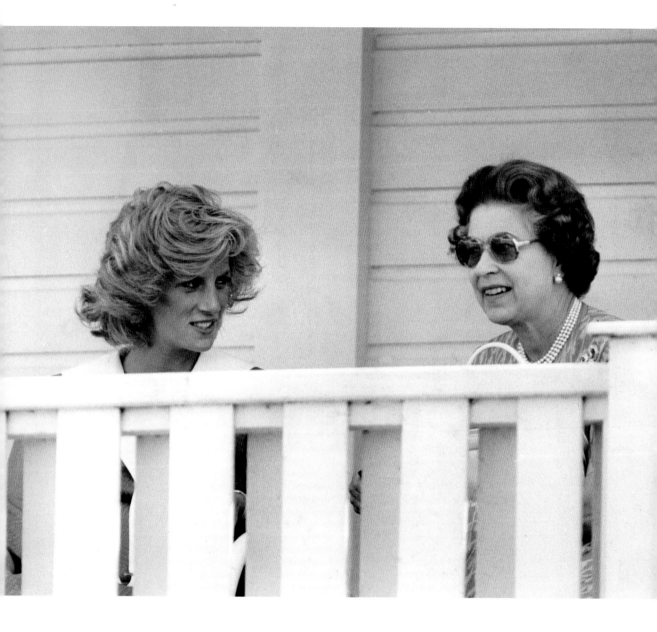

**▲ A day out at the polo, 1984**

Diana's hair blew in the wind but the Queen – as ever – didn't have a hair out of place.

**▶ All smiles at Clarence House, 1987**

Diana joined the Queen to wish the Queen Mother a happy 87th birthday.

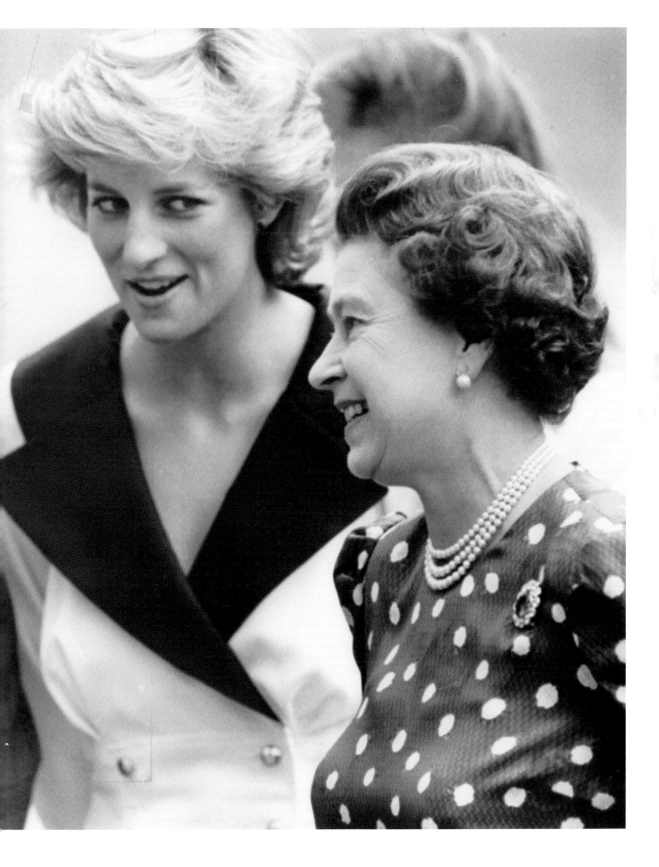

**▲ A nice touch, 1983**

People say that Charles and Diana didn't love each other, but I don't believe that because on that first tour to Australia and New Zealand they couldn't keep their hands off each other. They were very tactile and loving. I've got some really lovely pictures from that visit, but it was the one I took at the last engagement in Gisbourne, New Zealand, that ended up on the front page. The Royal couple were saying goodbye to the Maori Chiefs and Charles had his hand on Diana's bottom. This was the last picture I sent from the tour and it made the splash with the headline, 'Charles gives Diana a pat down under'.

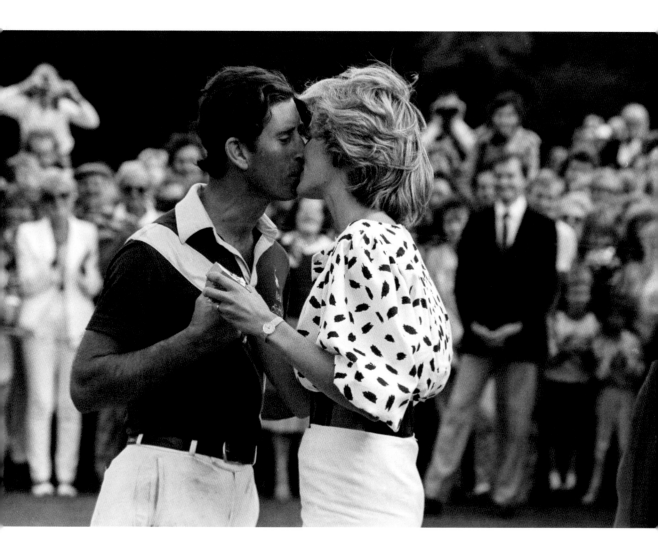

'The tour to Australia and New Zealand was six weeks long. My wife had to reassure our children that we hadn't divorced and that their father was still away working.'

▲ **The kiss that didn't miss, Smith's Lawn, Windsor, 1985**

In contrast to the later kiss that missed in Jaipur, India, in 1992, after another polo match, this one hit the mark in the happier days of their relationship.

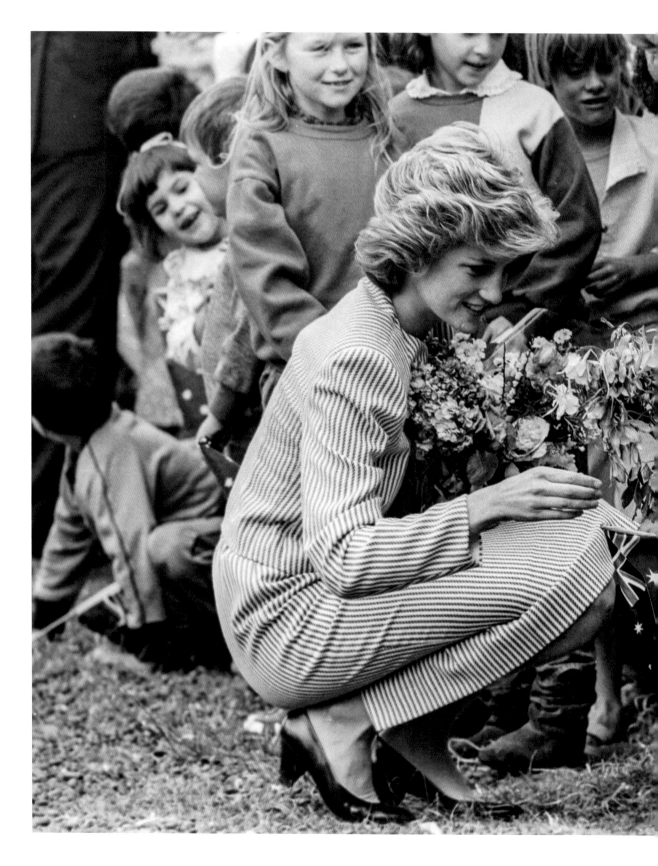

◀ **Going walkabout in Australia, 1985**

Diana loved children – she would squat down towards kids on walkabouts so she was on their level. It made for amazing pictures.

### ◀ The Princess and the King, 1987

A great advocate of British designers, Diana wore a Catherine Walker cream wool suit to greet King Fahd of Saudi Arabia on his three-day state visit.

### ◀ Ahead of the trend, 1986

While most girls watched polo in a summer dress and pearls, back in June 1986 Diana kept things casual with a sweatshirt, bandana and out-of-shot Converse trainers.

### ◀ Window on the world, 1988

An unusual picture of the Princess arriving in a snow-covered car at the upmarket Swiss ski resort.

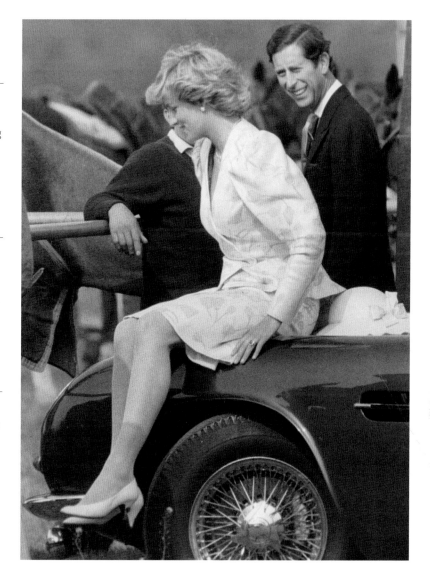

'For 17 years she was the only member of the Royal Family that mattered. Even in jeans and an old shirt or a jumper she looked great. She had the figure of a supermodel and she made any dress look fantastic.'

### ▲ Making an impact, 1987

Charles smiling through his polite request to Diana to get off the bonnet of his Aston Martin Volante – a 21st birthday present from the Queen. She caused only a small dent.

Prince Harry was an
early visitor to his father's
polo matches, igniting a
passion for the game that
he still has today.

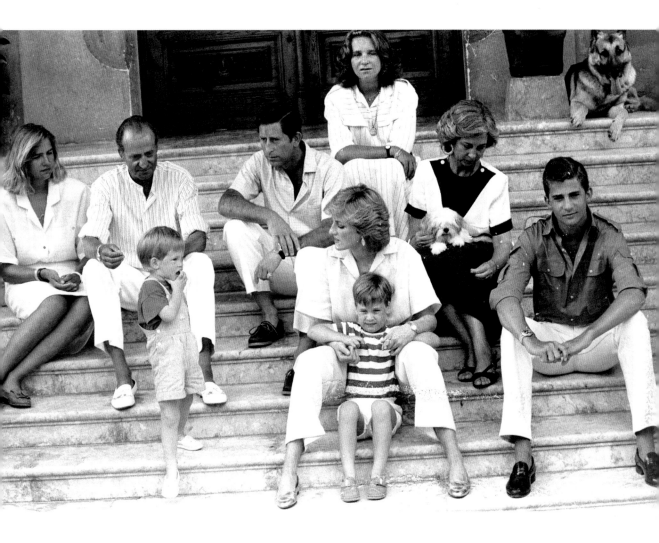

**▲ On holiday in Majorca, 1987**

A family holiday to Majorca as guests of the King of Spain. This picture caught a more relaxed moment in the photocall on the palace steps.

**▶ Perfect Prince, Smiths Lawn, 1987**

William getting a hug and sitting on Diana's knee at a polo match after he got a telling off from his nanny for straying too close to his father and the horses.

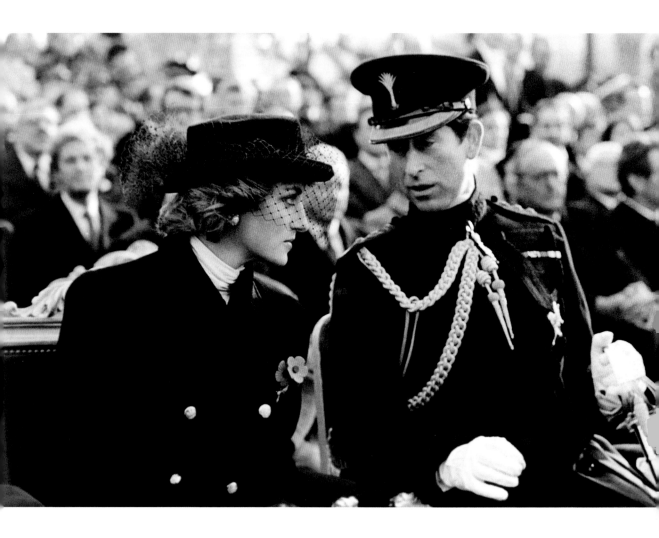

**▲ Paying their respects , 1988**

Diana and Charles attend a
Remembrance Day service at the
Arc de Triomphe in Paris.

**▶ A Royal appointment at Victoria
Station , 1988**

Diana waiting with the Prince of
Wales to greet the Turkish president
on his arrival for a state visit.

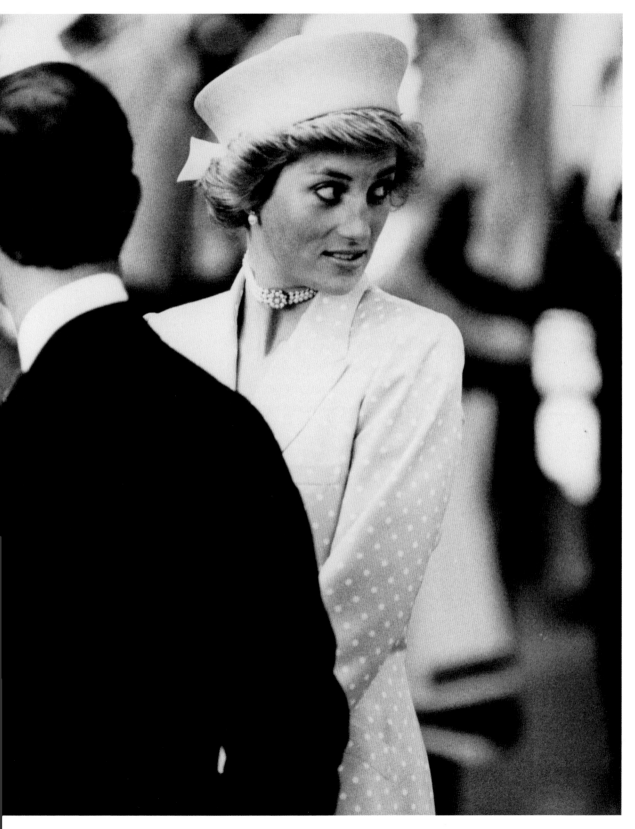

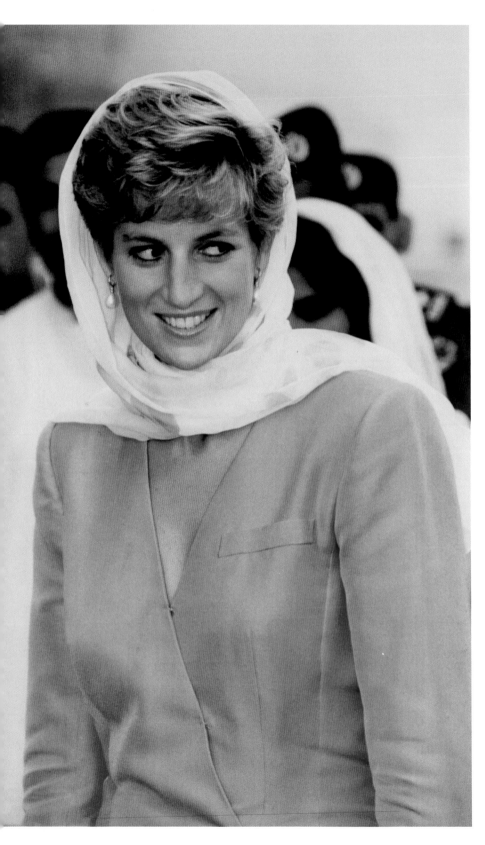

**◀ Visiting a mosque in Lahore, 1991**

Always elegant and always respectful of religious and cultural traditions, Diana looked stunning and demure in this coordinating headscarf.

**▶ Dressed to kill on the beach, 1991**

Diana had a strong sense of style – even on the beach. Here, she was strolling by the sea while on holiday with the children on Sir Richard Branson's Necker Island.

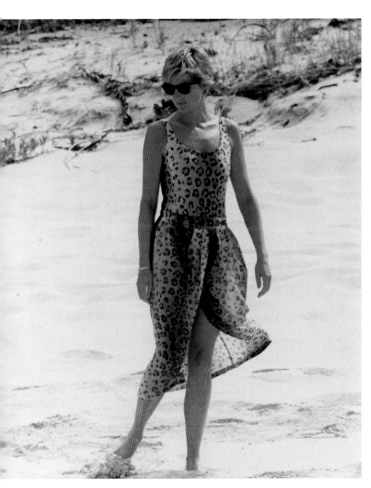

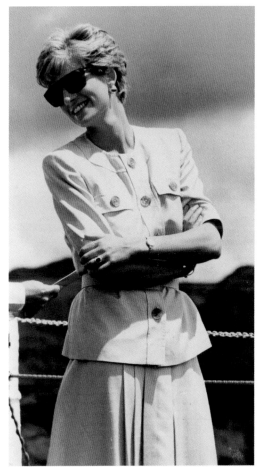

**▶▲ The great giggler**

Diana was different.
For instance, you could
have a conversation with
her. She would giggle a lot,
too - she was great fun.

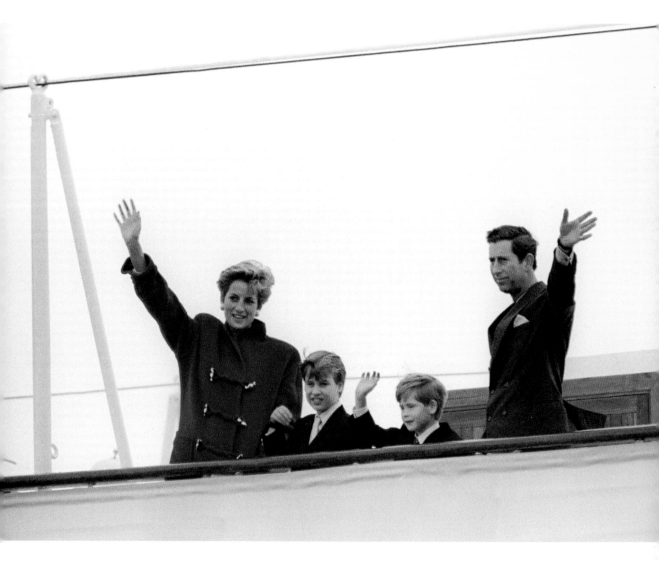

▲ **Making waves in Toronto, 1991**

Prince Charles and Diana took Prince William and Prince Harry on their first Royal engagement, to Canada. They looked like a happy family waving to the cheering Toronto crowd from aboard the Royal Yacht *Britannia*.

▶ **Never a day off, Niagara Falls, 1991**

On the Canada tour, Prince Charles and Princess Diana began to take on more individual engagements, in a further hint that all was perhaps not well between them. This unofficial trip to Niagara Falls couldn't escape attention. Spotted aboard the *Maid of the Mist*, the Princes, aged nine and seven, stole the show.

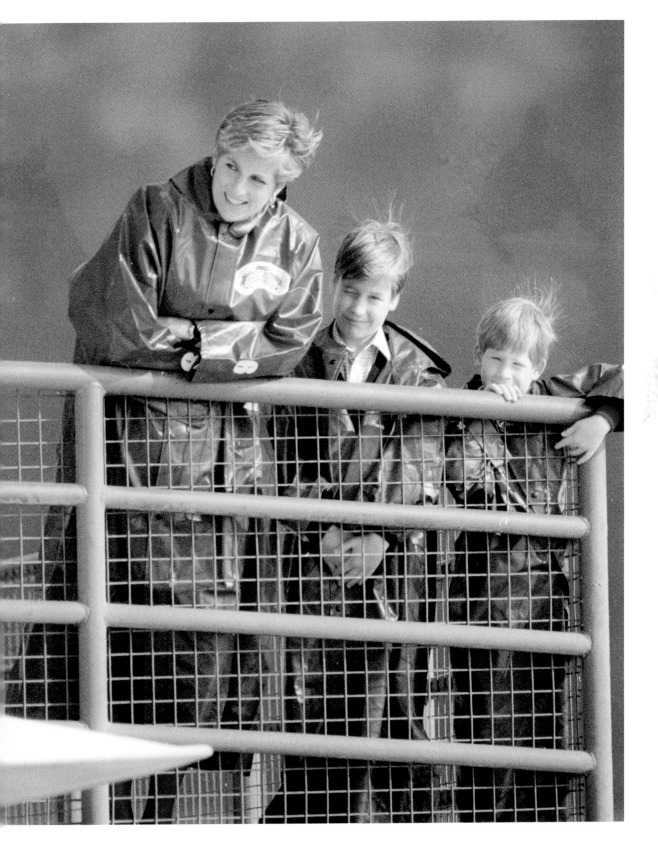

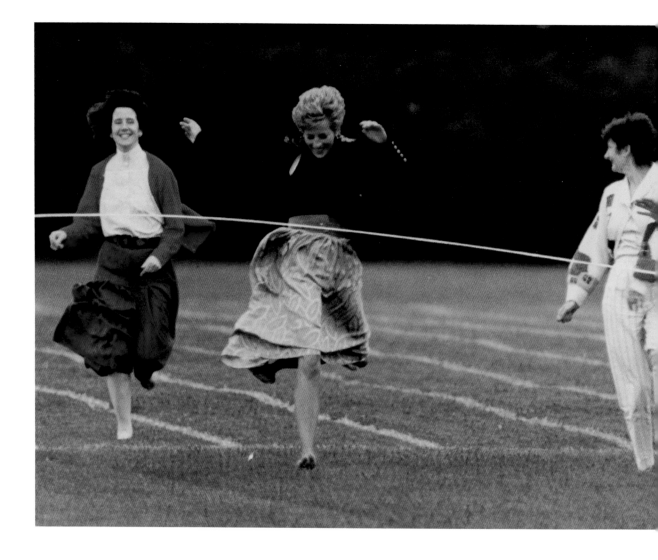

### ▲ Always a winner, 1991

Very few women could outrun Diana in the style wars ... but mum Carolyn Hall still beat the Princess in the mother's race at Wetherby School, London, in 1989. Diana is shown here raising her arms in triumph but the victory really went to her rival, just out of shot in this picture.

### ▶ Breaking down boundaries, 1991

One of the great things Diana did was singlehandedly take away the stigma of HIV and Aids. At that time nobody quite knew about this illness, and everybody was nervous about it. I covered the engagement when Diana was visiting the HIV Ward at the Middlesex Hospital.

She shook hands with the patients and sat and talked to them, comforting people who were suffering. She was just incredible the way she embraced issues like AIDS – probably against all the advice from the suits at the Palace. She went ahead and did these things her way.

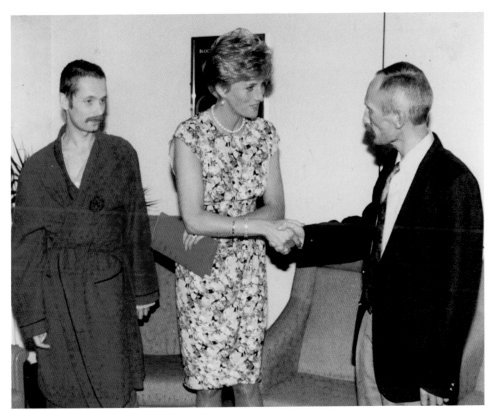

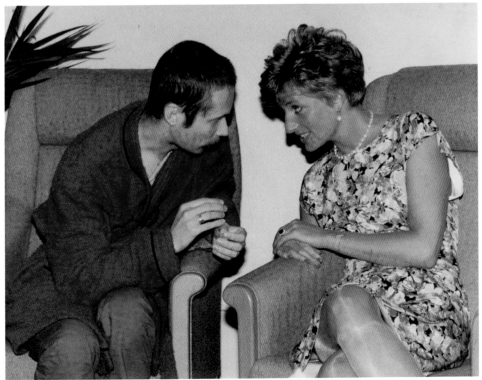

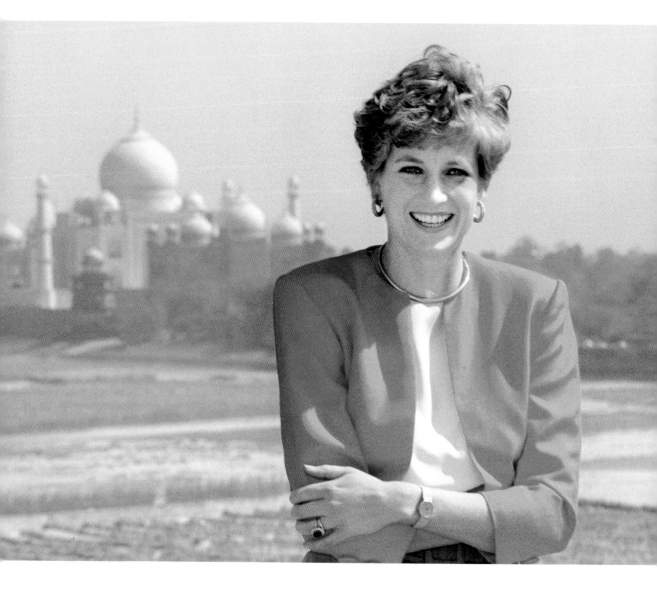

'I was the only photographer there that day — just me and Diana. I got a great picture. I still love that picture today.'

▲ **A different take on the Taj, India, 1992**

All the other photographers went straight to the Taj Mahal thinking it would be the best shot of the day. I went to the Red Fort with Diana and I've never regretted it. When we reached the top of the building you could see the Taj Mahal shimmering in the distance. Diana said to me, 'Where do you want me, Arthur?' And I said, 'I want you just there in front of the Taj.' This was my best picture of the tour.

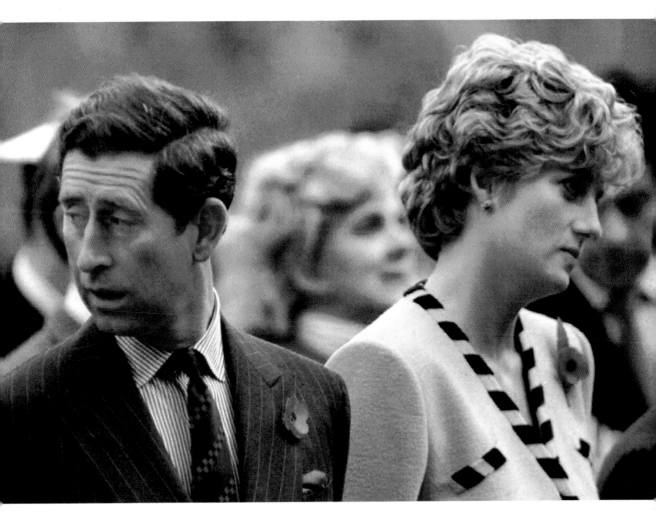

▲ **Going in different directions, Korea, 1992**

This was the last tour that Charles and Diana did together. It was clear to all there that cracks were appearing in their marriage. They didn't really want to look at each other at this memorial service for those who died in the Korean War. Later that year the Prime Minister, John Major, announced they were separating.

**▲ Tragedy on holiday, 1992**

Diana leaving the ski resort of Lech,
in Austria, the day after learning of
the death of her father, Earl Spencer.

## ▶ The 'revenge' dress, 1992

The world was rocked when Prince Charles admitted adultery in a TV interview with Jonathan Dimbleby. That very same evening, Diana stunned onlookers at the Serpentine Gallery summer party, arriving in a plunging Christina Stambolian dress and choker. It became known as 'the revenge dress'.

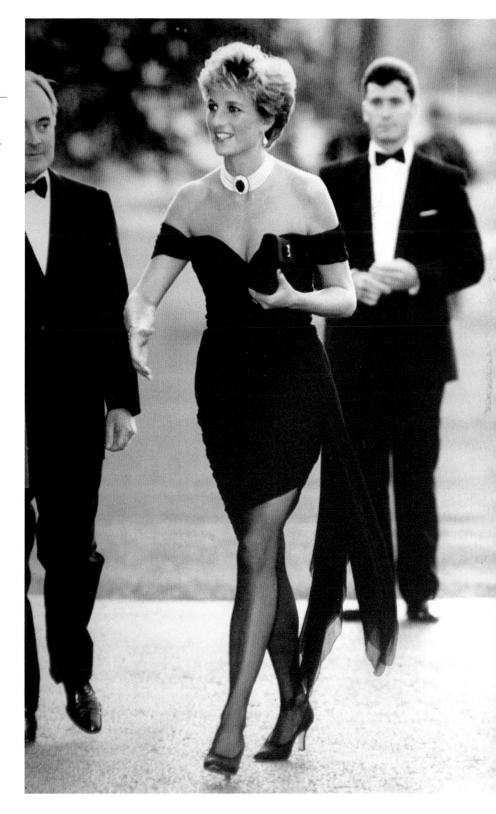

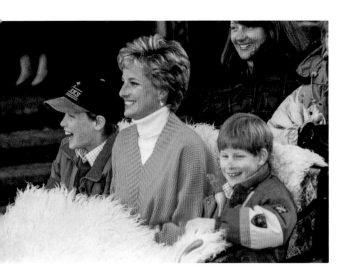

**▲ Swapping skis for a sleigh, Austria, 1994**

A happy, joyous photo of Diana and her boys on a sleigh ride in Austria in March 1994.

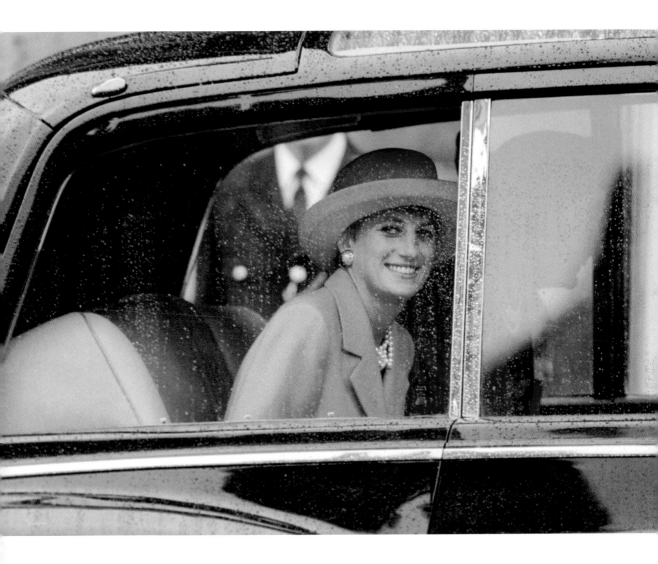

**◀ All smiles Stateside, 1996**

Diana visits Northwestern University in Chicago for a gala dinner. Look at that smile!

**▲ Purple reign, 1990**

Diana arrives at the Garter Ceremony at Windsor Castle.

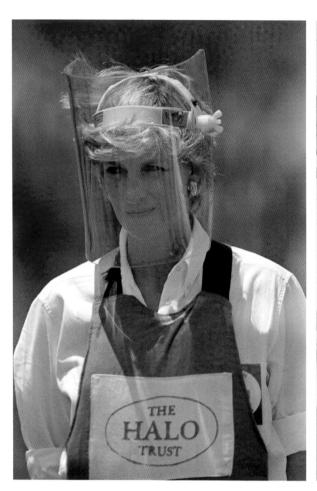
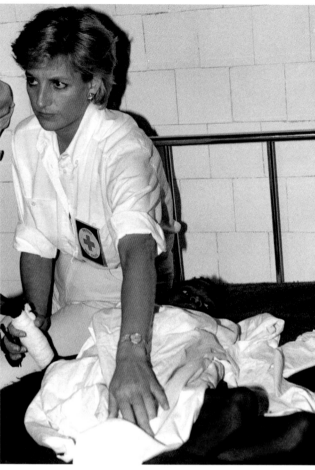

## ▲ Walking a new path, 1997

Princess Diana visited Angola in January 1997 to highlight how landmines laid during the country's civil war were maiming children. It was a tragic situation. Some of these kids had legs or arms missing. Many argued that Diana was getting too political, but she didn't care. She was there to shed light on the terrible suffering of these young people. We went to this hospital and there was a little girl in bed who wasn't covered from the waist down. Diana saw me coming to take a picture and put her hand up to ask me to pause, then she adjusted the covers so the child was decent. I took this picture of Diana holding her bandaged arm. The Princess had tears in her eyes as the nurse was telling her that the child had been blown up. Later Diana went to a minefield that had recently been cleared, where I photographed her in all the protective equipment.

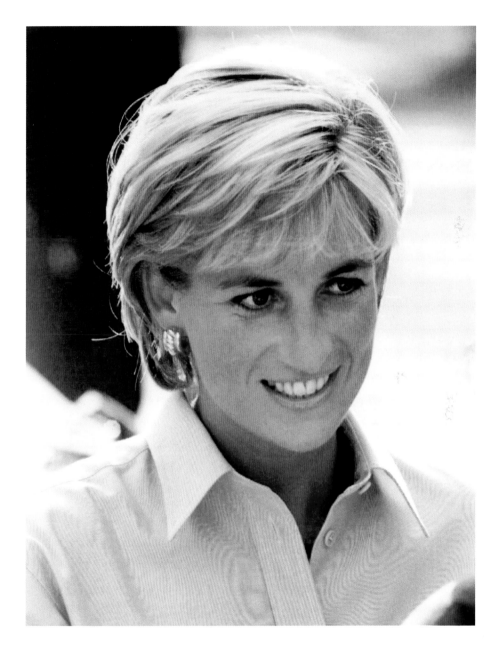

**▲ My last portrait, 1997**

Diana was on another landmine crusade – this time in Bosnia – and it was the first time I used a digital camera. I took this photograph as the sun was setting in Tuzla and it was a beautiful portrait. The next day Diana returned to Britain and I looked out the window as her convoy went past from my Bosnian hotel. She was sitting in the car looking very pensive. That was the last time I saw her. The following month, she died in Paris. At least 100 people wrote to the paper for a copy of this picture. It was such a powerful image of her.

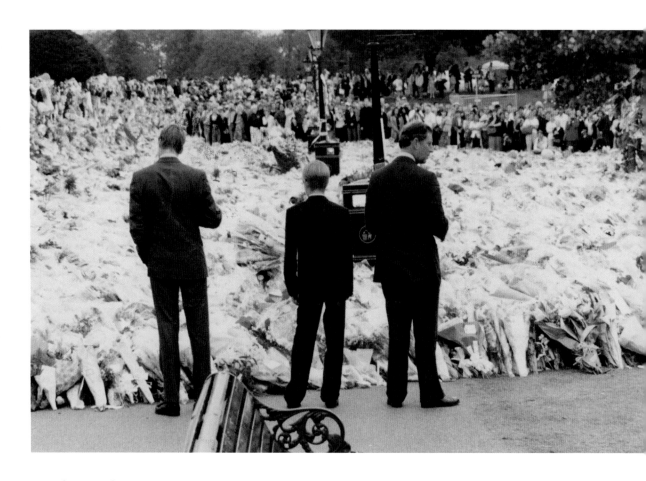

'I don't know how they did it. I really don't.
They were just kids — they were heartbroken,
but they were very, very strong.'

▲ **Paying their respects at Kensington Palace, 1997**

Prince Charles brought the boys down to London to see the tributes to their mother outside Kensington Palace. I've never forgotten it. It was unbelievable seeing these young men reading the heartfelt tributes to their mother. Harry's face was contorted with pain and tears. It was amazing how the boys conducted themselves in such traumatic circumstances. Their father led them gently through it. There were a few photographers there but it was very, very respectful, everybody was quiet. And then the family spoke to a few people in the crowd. The public showed such love for them.

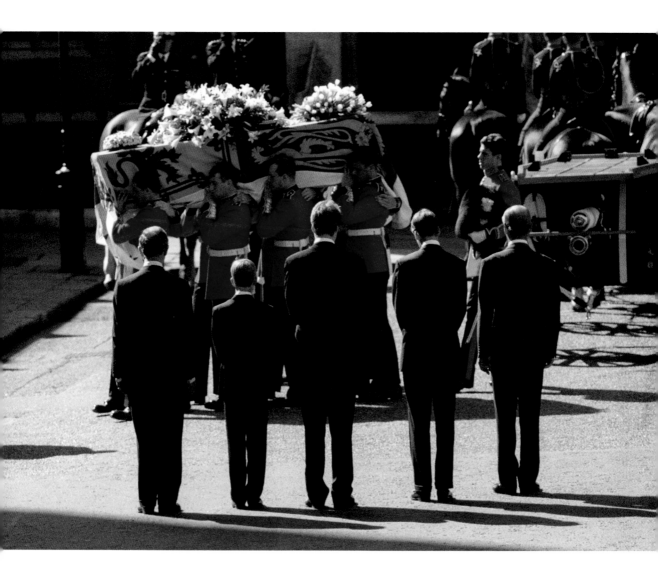

**▲ The final goodbye, 1997**

I still look at this picture and remember that moment like it was yesterday. I'll never forget it as long as I live. I was outside Westminster Abbey for the Princess's funeral. I heard the sound of people sobbing over the clip-clop of the horses in the funeral cortege. A woman I had photographed for 17 years was in that coffin and I was just so upset. People to this day love her so much and every year they make a pilgrimage to Kensington Palace to lay flowers. She wasn't perfect – no one's perfect – but her campaigns against landmines and for greater understanding of AIDS were amazing. Even after she was divorced and no longer a member of the Royal Family, she still had amazing influence, influence that she only ever used for the good of others.

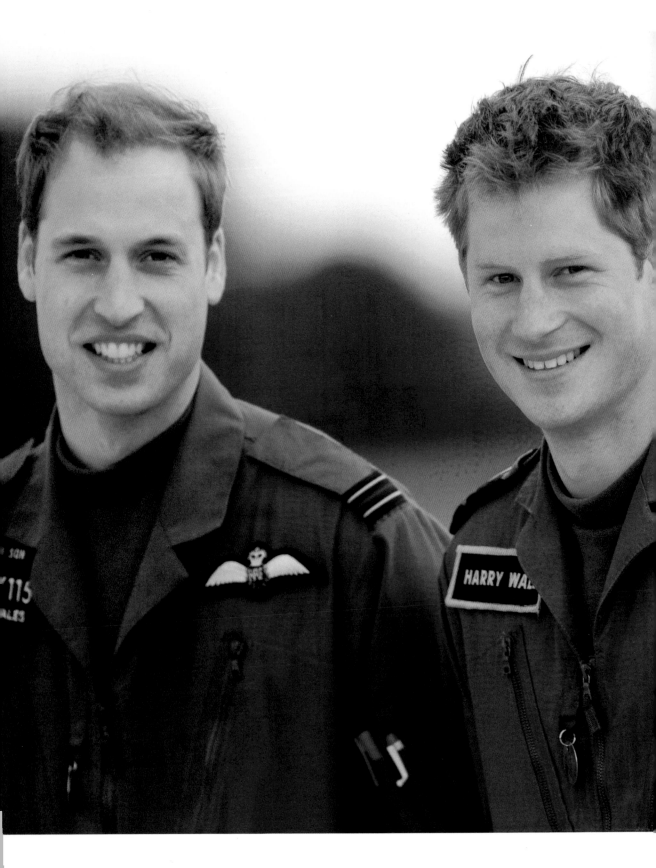

# William
# & Harry

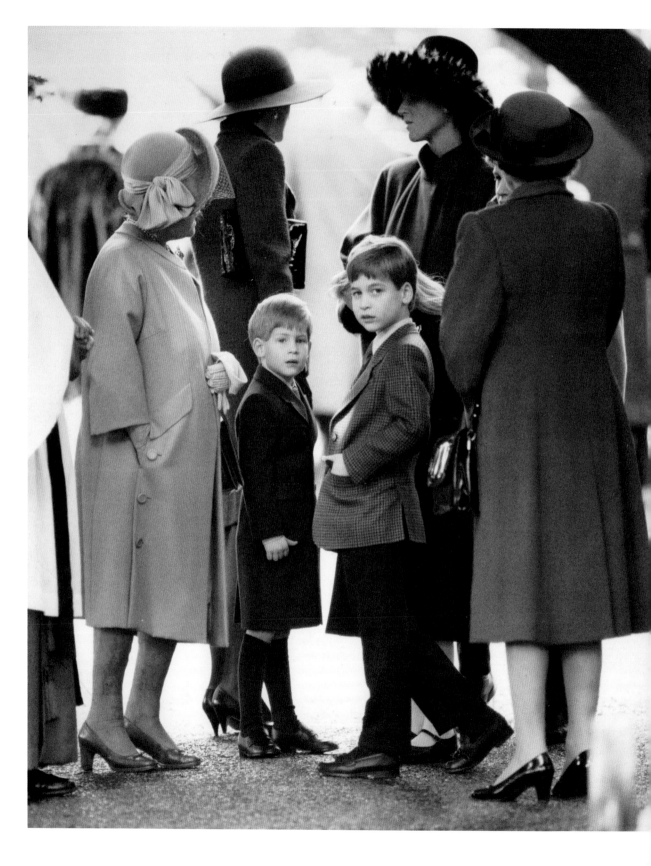

# William & Harry

Once, you wouldn't have got a cigarette paper between William and Harry; they were so close before their relationship fractured. I watched them grow up together; Harry was the joker while William – as future king – was more serious. I was there when they learned to ski together and when they learned to fly. The bond seemed unbreakable. *Sun* readers loved seeing Harry larking about with sprinter Usain Bolt, playing rugby with street kids in Brazil or making a sick child smile in a Barbados hospital. He was always laughing and joking. William has a great sense of humour too; in 2019 our flight with him hit severe turbulence over Pakistan. William walked to the rear of the plane afterwards and asked the terrified Press pack: 'Does anyone need a change of underwear?' He added: 'No, it wasn't me flying.' It calmed everyone down and showed the measure of the man. I would love to see these two brothers shake hands and laugh together again.

◄◄ **William and Harry Wales, 2009**

As thick as thieves, while training for their helicopter licences at the Defence Helicopter Flying School near RAF Shawbury, Shropshire, WIlliam and Harry lived together in a rented cottage.

◄ **Family Christmas, 1989**

A Royal Family tradition is to be at Sandringham for Christmas and to attend church on Christmas Day. I was pleased to capture the generations from the Queen Mother down to the youngest members of the family.

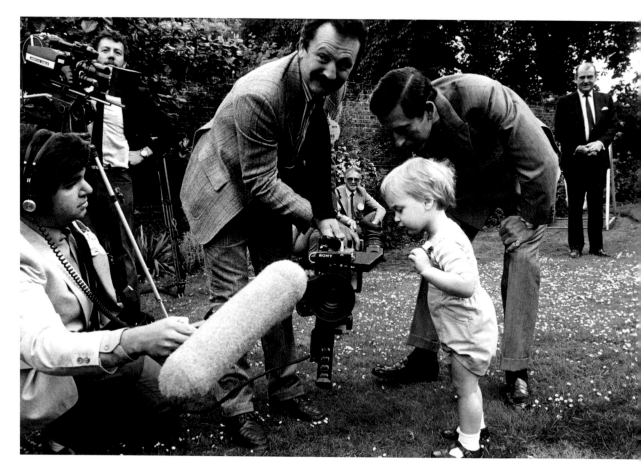

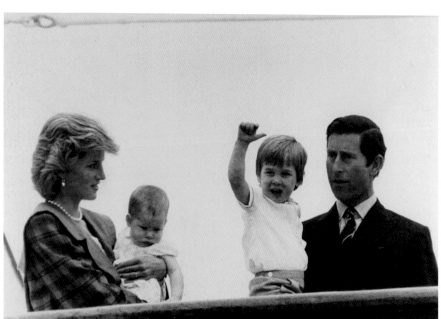

◀ **Ciao Italia!, 1985**

Waving to the crowds in Venice when Charles and Diana were reunited with their children after an exhausting tour of Italy.

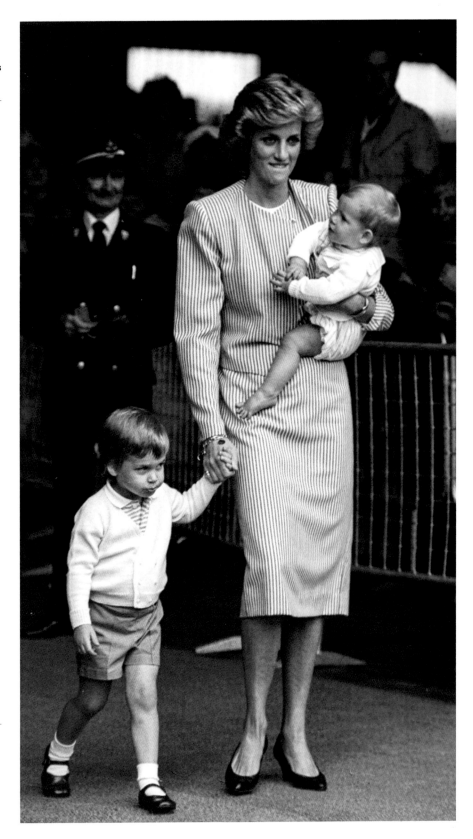

◄ **Prince William inspects the Press, 1984**

Princess Diana invited the media to Kensington Palace to photograph Prince William, who had recently begun talking. He charmed us all by checking out our cameras while playing with his parents.

▶ **All aboard once more, 1985**

Diana boarding the Royal Yacht *Britannia* with her boys at Portsmouth on another family trip.

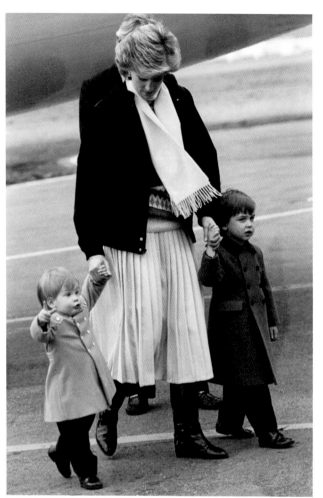

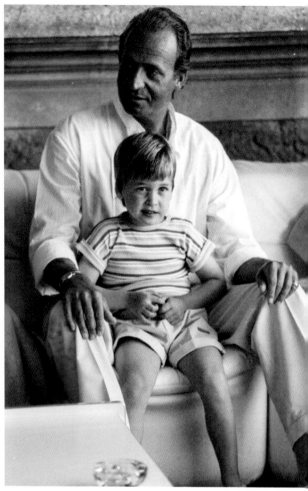

**▲ Bonny lads in Bonny Scotland, 1986**

Diana and the boys arrive in Aberdeen at the start of their holiday at Balmoral Castle in Scotland.

**▲▶ Royal Family holiday in Majorca, 1986**

That summer the family were guests of King Juan Carlos of Spain and his family. I got some lovely pictures at the Press photocall.

**▶ Stomping around Sandringham, 1987**

Prince William looks every inch the country gentleman in this sweet snap, clutching his flat cap.

**◀ Off to school, 1988**

It was important to Diana that her boys had some normality in their very abnormal lives, and that included being a hands-on mother taking them to school.

**▶ Firm friends, 1988**

In the early years, Diana and Sarah Ferguson were great friends within The Firm, joining the family at similar times and finding their way through their roles together.

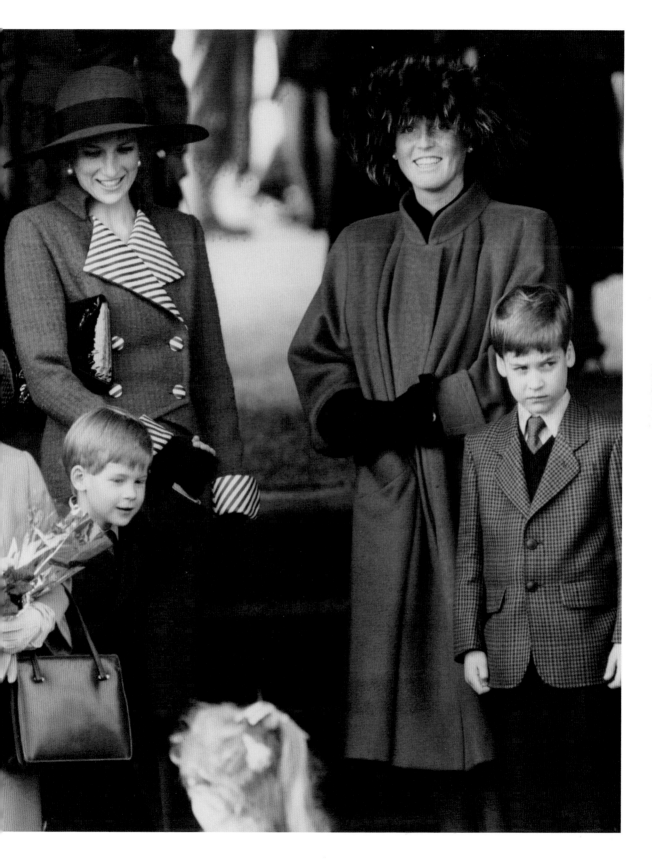

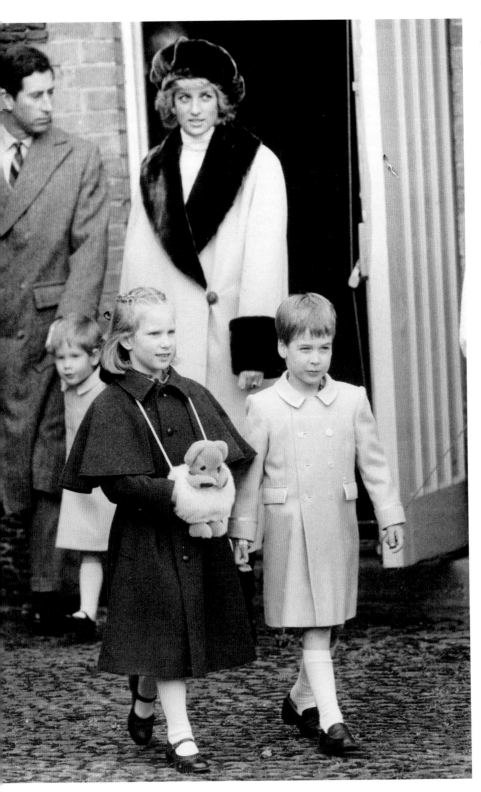

**◄ Buddies from birth, 1988**

I love this picture of the young cousins William, Zara and Harry together at Sandringham. It's even more lovely to know that they are all still close today.

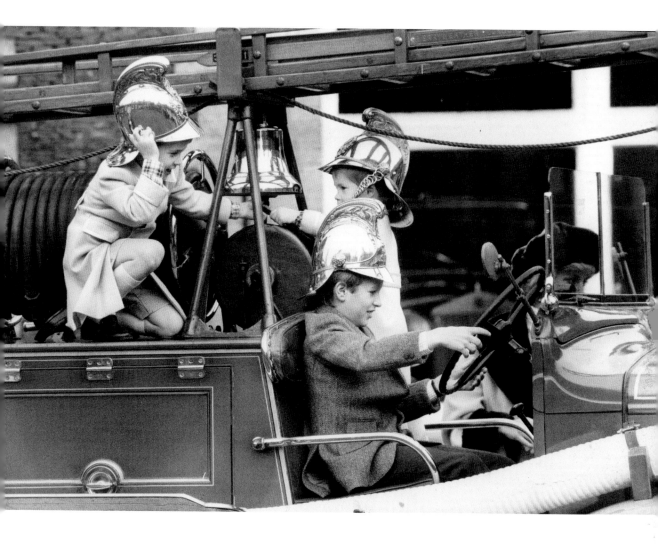

**▲ Where's the fire?, 1988**

I took this picture at the Old Fire Station at Sandringham on Emergency Services Day. I loved seeing the delight on the children's faces as William and Harry rang a fire engine's bell and Peter Phillips sat in the driver's seat. Diana watched on proudly.

'Princess Anne's children, Peter and Zara, have been firm friends with William and Harry since they were all tiny.'

William

◀ **Father and son, 1988**

Prince Charles and Prince William taking a stroll around the Sandringham Estate together.

▶ **Harry's first day, 1989**

Prince Harry looks so proud to be with his big brother on his first day at Wetherby Shool, Notting Hill. I love the smiles on Diana and William's faces, too.

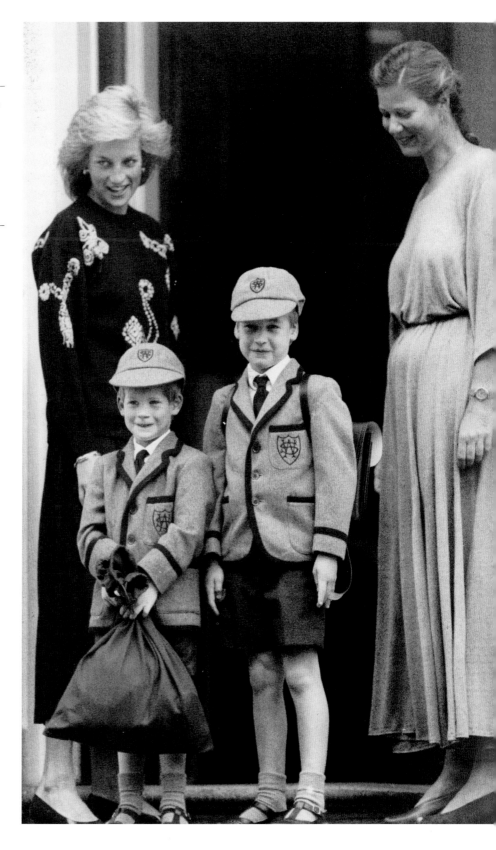

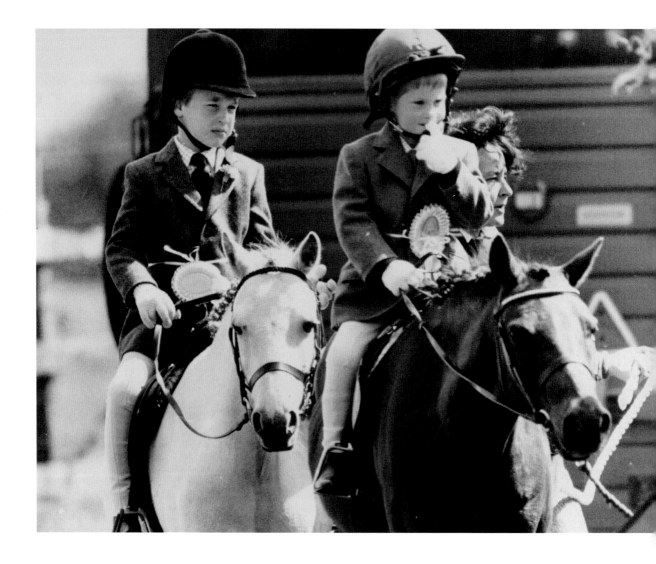

**▲ Just a couple of kids and their ponies, 1989**

The young Princes entered a horse show under false names. Here they are proudly wearing their rosettes. It was not the only time that they would change their names to try to go incognito, with Harry taking the surname of Wales in the military.

**▶ Day out at the show jumping, 1989**

Diana nurtured Princes William and Harry's love of horses, including trips like this one to the International Horse Show at Olympia.

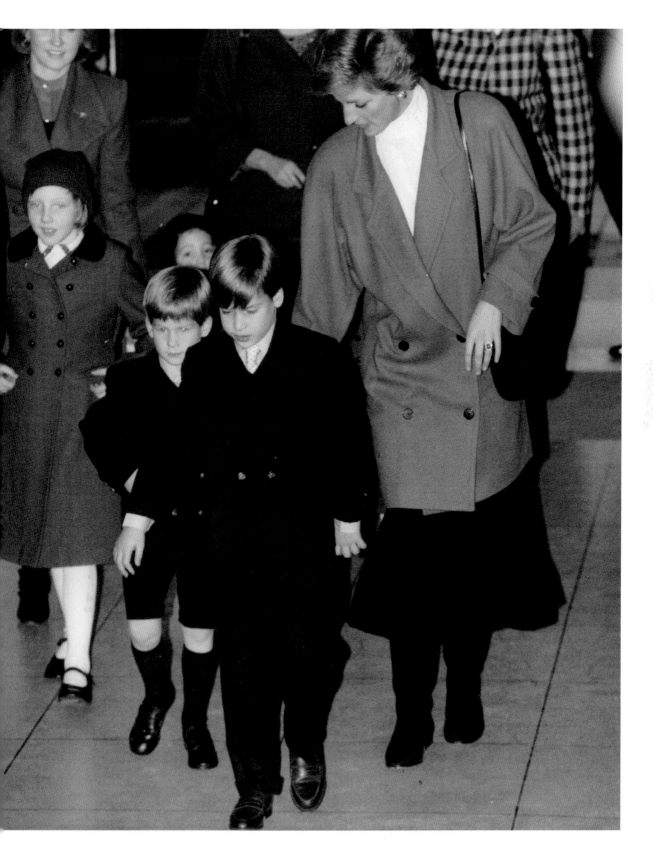

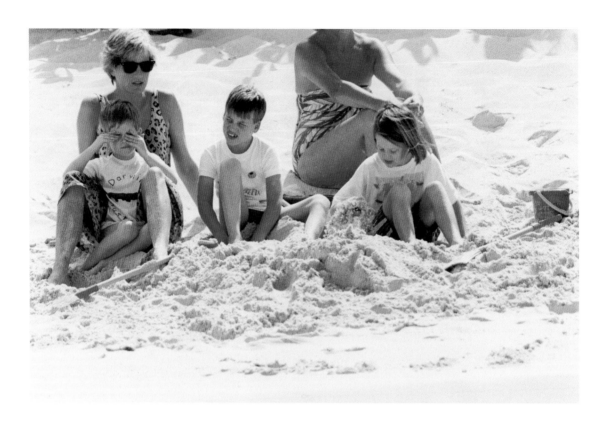

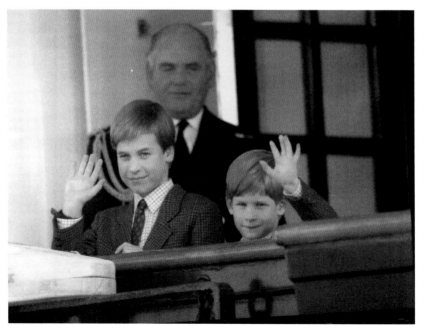

**◀▲ The Princes off duty and on**

From a young age the two Princes have played a formal role in the Royal Family. But Charles and Diana always ensured that formality was mixed with fun.

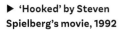 **Happy memories, 1992**

After the Queen Mother
died, Prince William said
this was his favourite
picture of him and his
great-grandmother
together. Here he helps
her up the steps after the
Easter Day service at St
George's Chapel, Windsor.

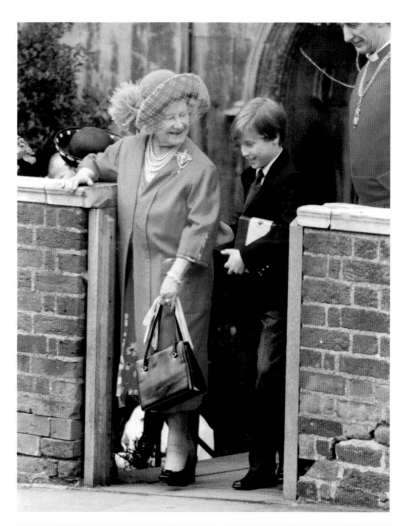

▶ **'Hooked' by Steven
Spielberg's movie, 1992**

Diana was a wonderful
mother; she would take
the boys to the pictures
and to McDonald's, but
she also took them to
homeless shelters to
remind them of the
privilege they had.

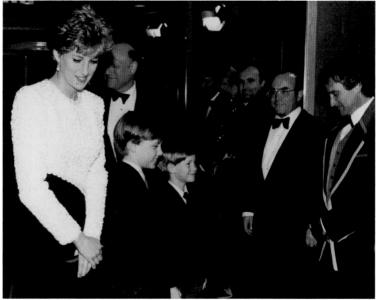

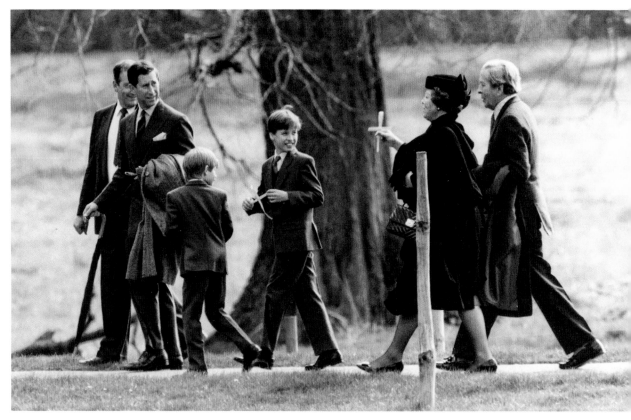

### ▲ Strolling back to Sandringham, 1993

I love this picture. A formal occasion made informal by William's cheeky, smiling face as he chats with Queen Beatrix and Prince Claus of Holland.

### ▶ Dinosaur day out, 1992

Prince William and Prince Harry help to carry gifts after a trip to the Natural History Museum, in London, to see the dinosaur exhibition.

### ▶▶ Showing Dad the ropes, 1994

Charles, William and Harry confidently hitting the slopes on their annual trip to Klosters.

'The Princes were inseparable, solid for one another. They looked so relaxed, having fun together, on that summer holiday in Balmoral when I took these photos.'

▶▶ **Happy times before the storm, 1997**

William and Harry relaxed and happy, skimming stones in Balmoral with their father while on their summer holidays. It was at this apparently carefree time that they learned the shocking news of the death of their mother.

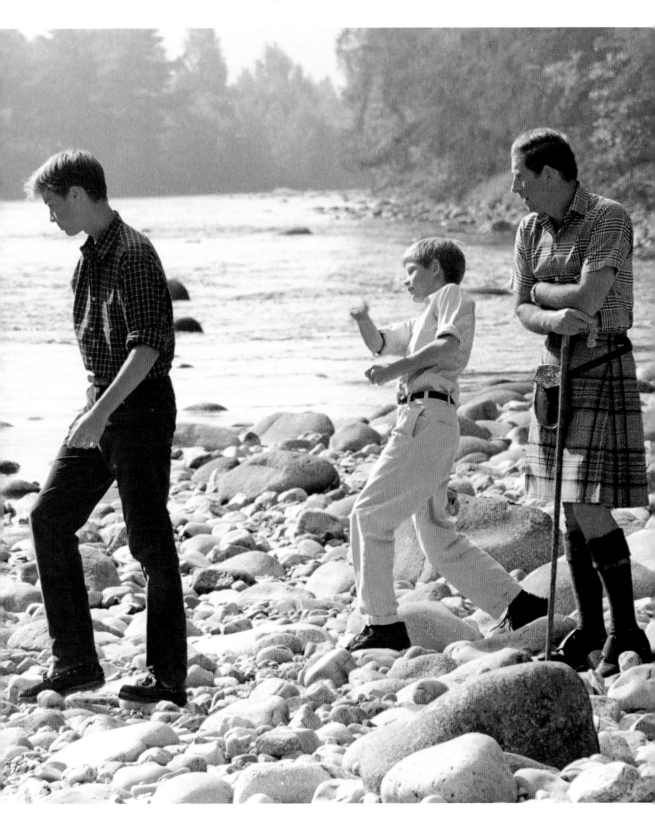

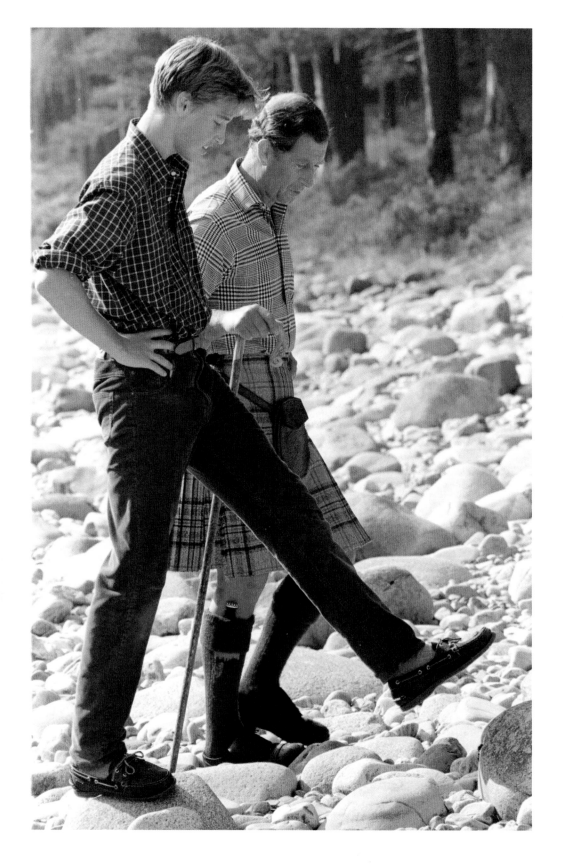

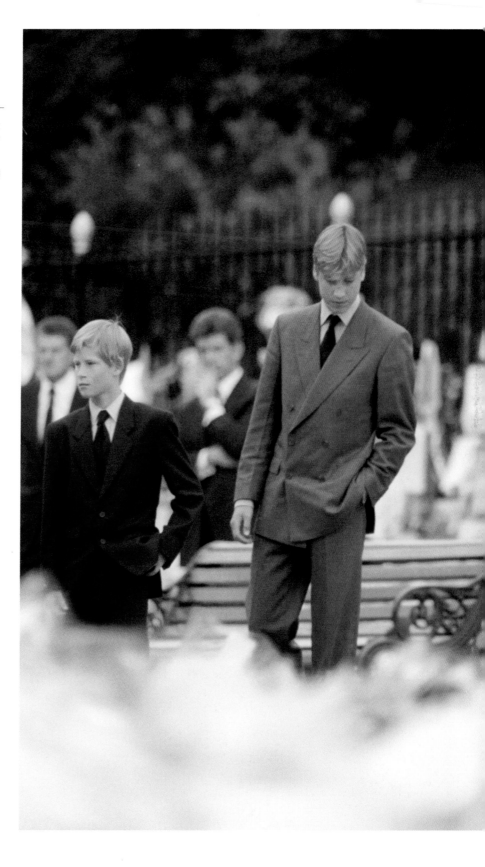

**▶ Outside Kensington Palace, 1997**

This is one of the saddest pictures I've ever taken of William and Harry. While looking at the flowers and tributes to their mother, just three days after she had died, they showed amazing fortitude for such young men.

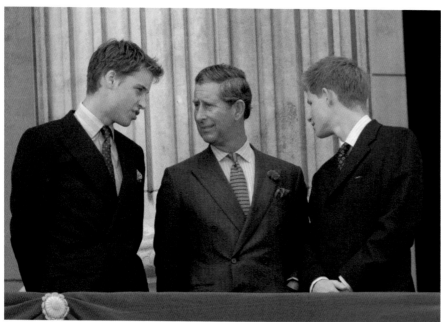

**◄ Queen Mother turns 100, 2000**

Father and sons celebrating the Queen Mother's historic birthday on the balcony of Buckingham Palace.

**▼ Klosters, 2000**

I love this picture, you can see the bond between them all and how relaxed they are to be together.

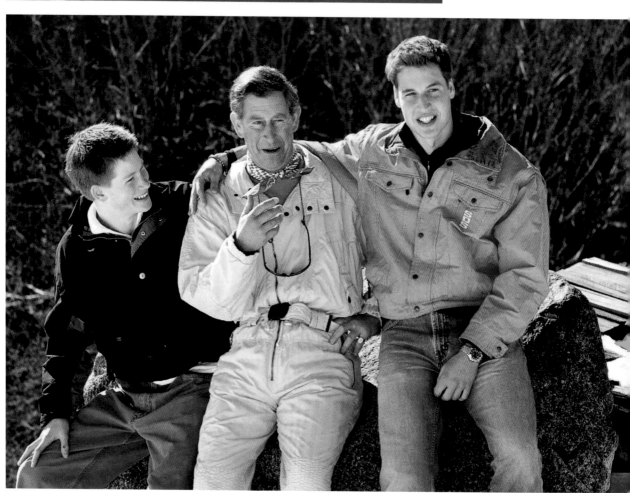

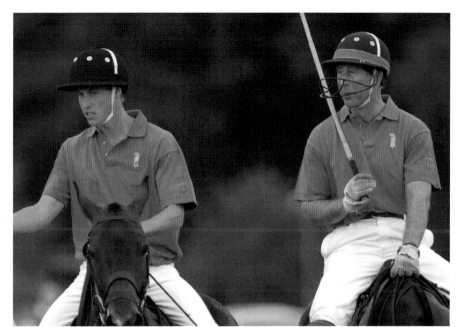

▶ **On the same team, 2001**

Prince Charles and William playing for the same team at Highgrove, sharing a passion for polo, and a competitive edge.

▼ **Party at the Palace, 2002**

The brothers enjoying the Golden Jubilee concert at Buckingham Palace.

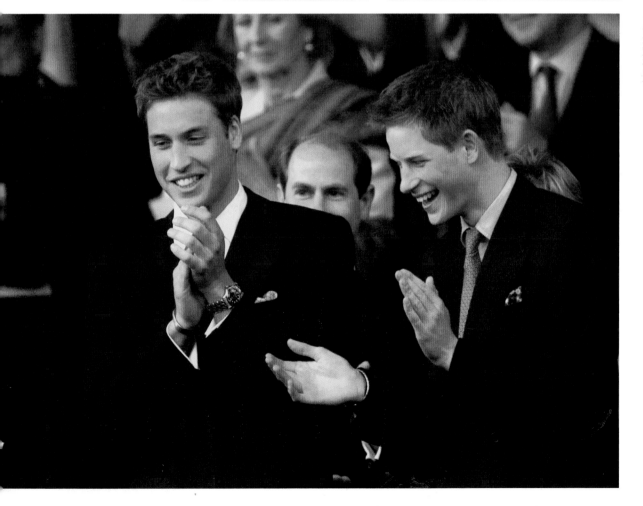

## ▶ Brothers in arms, 2006

Harry passed out at Sandhurst, which was the culmination of a childhood dream to be a soldier.

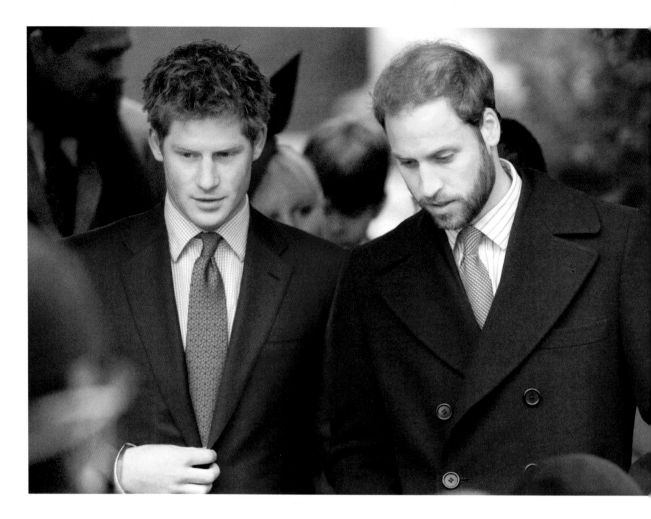

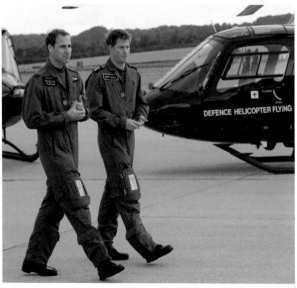

### ◀ Going head to head, 2009

The brothers in step as they trained to fly helicopters together at RAF Shawbury, in Shropshire. Once trained, Harry flew on missions in Afghanistan and William piloted RAF search and rescue helicopters and later air ambulances.

### ▲ A new look on Christmas Day, 2009

Prince William showing off his new beard to the family at Sandringham. He shaved it off soon after. Shame, I quite liked it!

### ▶ William gets his wings, 2012

After a brief training, at which he excelled, William joins 22 Squadron, based at RAF Valley, Anglesey, as a search and rescue pilot.

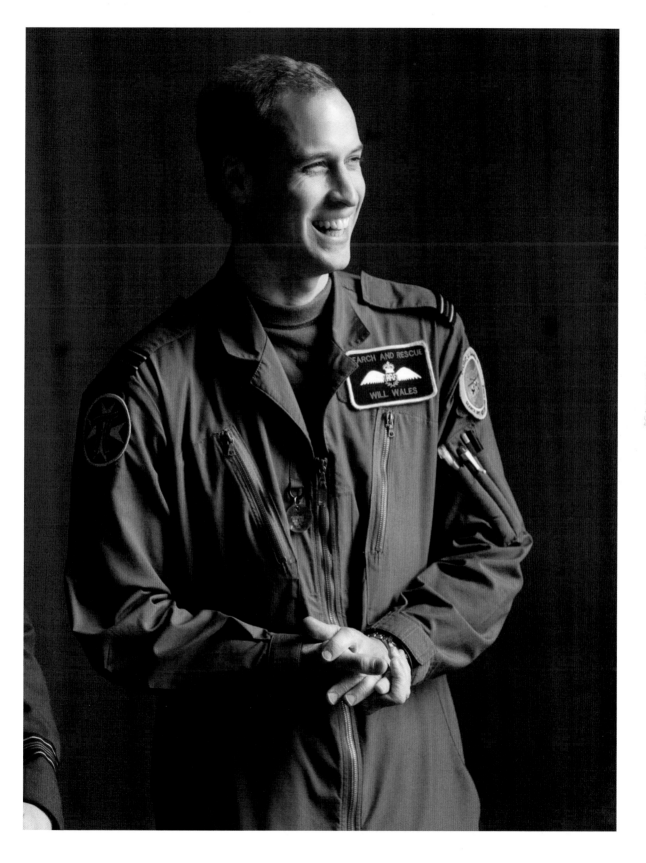

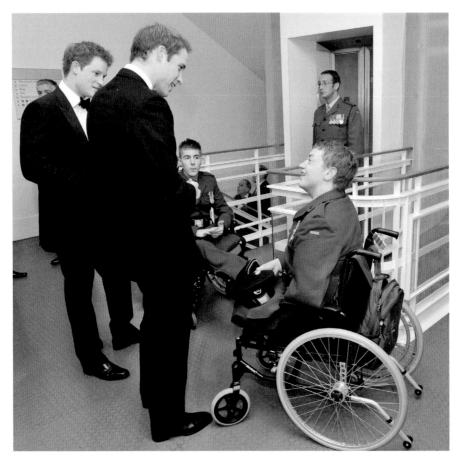

◀ **Meeting the heroes at the *Sun* Millies Awards, 2009**

The two Princes are great supporters of our military heroes, and chatted to injured service personnel at the *Sun*'s annual awards. Harry would go on to take this a step further with his Invictus Games for wounded and injured soldiers from different parts of the world.

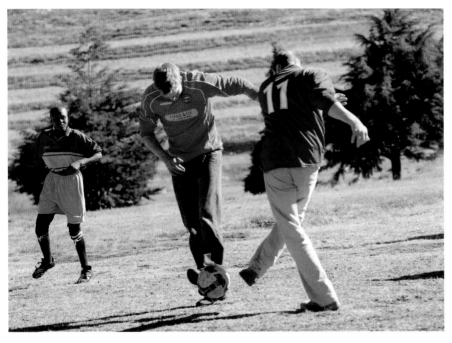

**◀ Man of the match, 2010**

William tackles Harry in a football game with the herd boys of Lesotho. No one knew the score but everyone had a good laugh.

**▲▶ Supporting the Semonkong Children's Centre, 2010**

Princes William and Harry ride together in Lesotho, southern Africa. William saw the great work Harry had done to help these young lads to get an education.

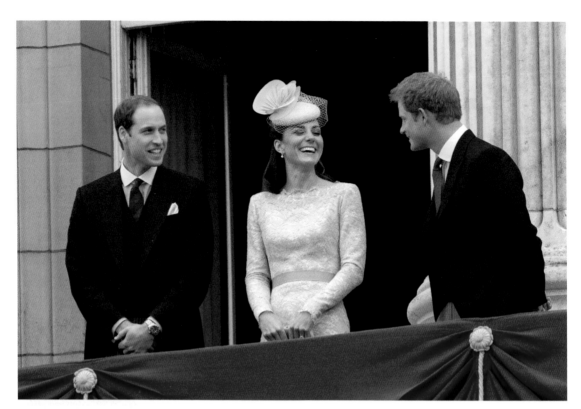

**◀ A rose between two thorns, 2012**

Catherine sharing a joke with her brother-in-law on the balcony at Buckingham Palace during the Diamond Jubilee celebrations. For a long time they were a hugely supportive trio and the Duchess was a rock for both brothers.

**◤ Seriously suave, 2017**

Prince Charles, William and Harry attend the ceremony to mark the centenary of the Battle of Vimy Ridge. They looked serious as such an event demands, but also presented a very modern face of the monarchy.

**▼ Remembering their mother, 2017**

William and Harry pay tribute to their mother's memory. With parallels to the scenes 20 years earlier, the brothers came to see the flowers and candles lit for their mother before marking the milestone privately, away from the public gaze.

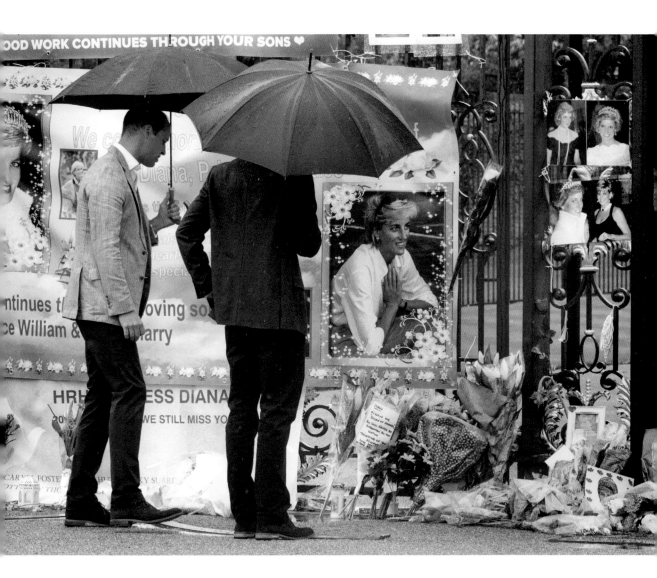

**▲ Blending into the background, 2017**

William and Harry attended the wedding of Pippa Middleton and James Matthews at St Mark's Church, Englefield, but made sure that they blended in and the focus was all on the bride and groom.

This is one of the last photos of the brothers united, as their worlds and bond were about to change.

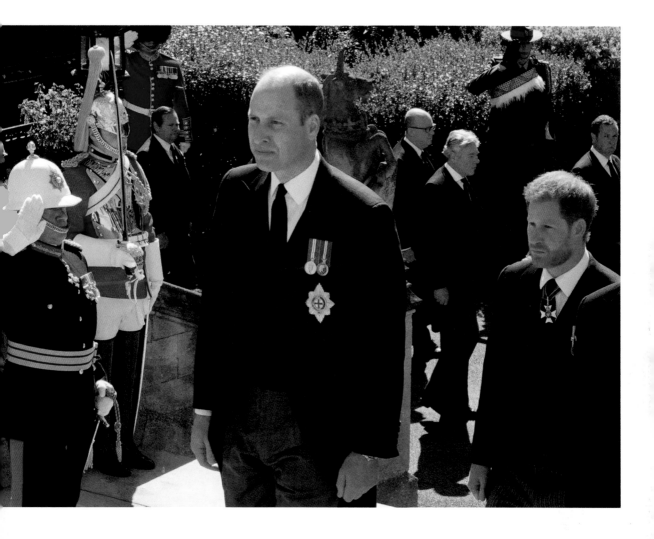

**▲ Goodbye to grandfather, 2021**

The country mourned the death of the Duke of Edinburgh, and despite Covid restrictions did its best to honour his life. The occasion was doubly sad as the two brothers were kept 12 feet apart due to their ongoing rift, although they were seen to share some words after the service. We can only hope that these boys, who have been through so much together, can be united again.

'I was just two yards away from the raw emotion of the Royal Family as they said farewell to the Duke of Edinburgh. For a man who famously wanted "no fuss" and told his offspring to "just get on with it," the Duke of Edinburgh's final journey was filled with sorrow.'

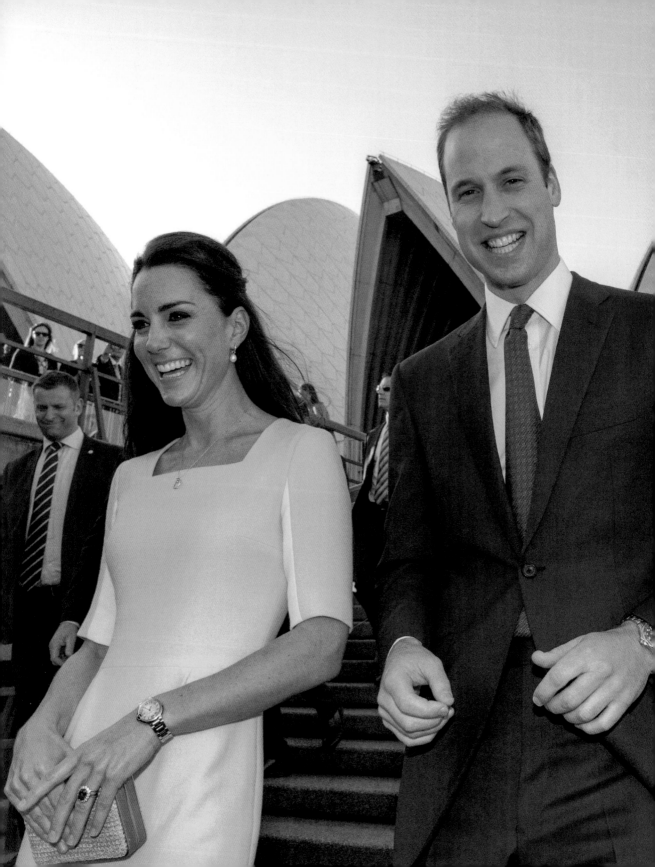

# William
# & Kate

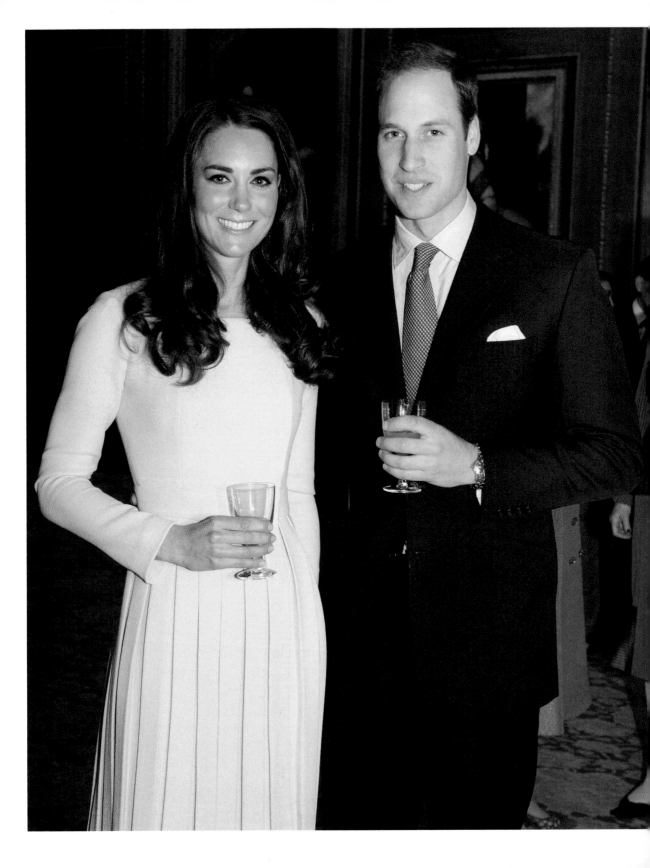

# William & Kate

Illiam has the settled family life that he craved as a boy, and it's all down to Catherine, as she's fondly known to the family. They are very much a double act, a team that shares the pressures of public life, and they closely guard their family time with children George, Charlotte and Louis. After their 2011 Westminster Abbey wedding, they started married life in Anglesey while William worked as a search and rescue helicopter pilot nearby. It allowed them space and time to prepare for the later responsibilities of state. As working royals, they've made raising awareness of the mental health issues that young people face a priority. When they announced their engagement in 2010 I asked William why he had previously broken up with Catherine. He said: 'Well, Arthur, I had to be sure this was the right woman for me because I want this marriage to last forever.' Do you know, William? I think it will.

◀◀ **Duke and Duchess Down Under, 2014**

Just as Charles and Diana had done on their first tour of Australia and New Zealand, the couple took along baby Prince George. The three-week tour was a triumph.

◀ **Welcoming the world's royals, 2012**

William and Catherine attended a lunch at Windsor Castle for sovereign monarchs to commemorate the Queen's Diamond Jubilee.

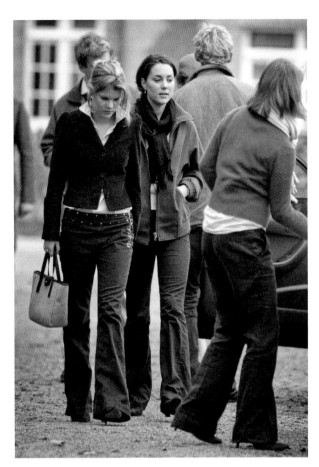

**▲ The picture that never was, 2004**

I took this picture when a group of students from St Andrews was invited to Sandringham by William. I think it was after the church service and I saw them walking out of the side gate, four or five of them. I didn't know about Catherine then, so it was only when I found the picture years later that I realised one of them was Catherine.

**▲ William and Catherine hit the slopes, 2005**

We were in Switzerland covering the couple's ski trip and didn't see Catherine the first day for the official photo call. I did see her the next day arriving at the ski lift. I took a picture and the Palace Press Secretary went crazy. He said, 'You can't do this.' I replied, 'This woman could end up being his wife.'

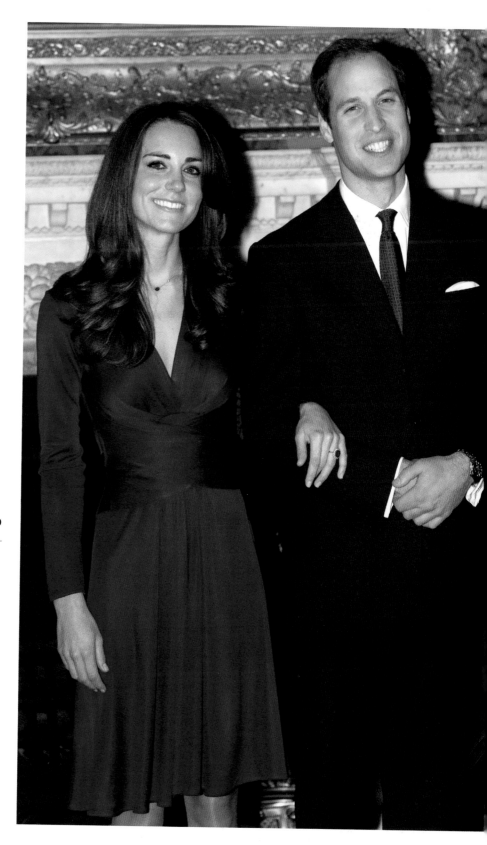

**◀▶ The wait is over, 2010**

The moment everyone
had been waiting for.
Finally the engagement
was announced, with
Catherine wearing
Princess Diana's ring
on her shaking hand.

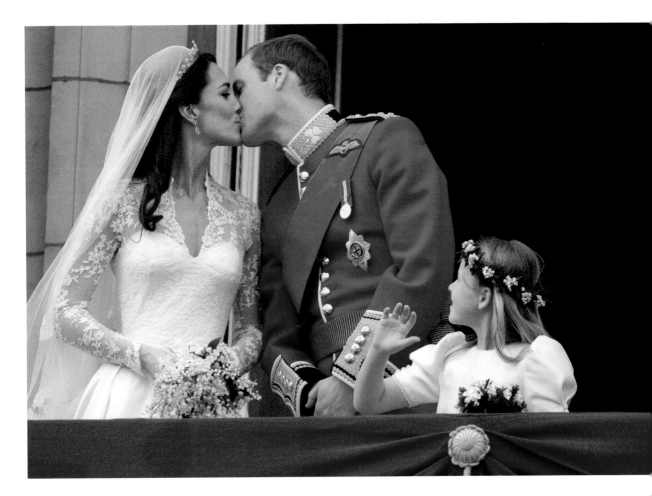

**▲▶ The happy couple, 2011**

The important position for a photographer covering a Royal wedding is to be in place to capture the kiss on the balcony, because that is always page one. So about five days before the wedding I called the Prince of Wales' Press Secretary. I said, 'Look. I don't ask for much and I've worked in this job a long time. Can you get me a pass for inside the Palace?' If I had asked that question ten years before, there'd have been no chance, not even five years before. But for some reason he said, 'Leave it with me. I'll see what I can do.' He came back the next day and said, 'You're in the forecourt.'

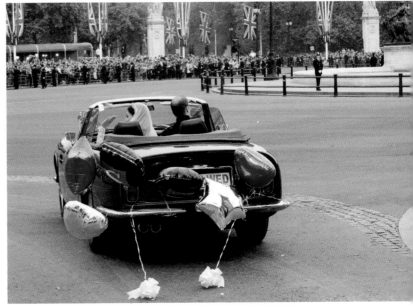

'At a garden party a few months after the wedding I asked Prince Charles, "Did you know he was going to borrow your car then?" "Oh yes," Charles replied. I said, "Why did it stop, start, stop, start like that?" He replied, "Because he didn't take the hand brake off."'

▲ **Making an entrance at the *Sun* Military Awards, 2011**

Catherine stole the show at one of her early red carpet events. She looked sensational in an Alexander McQueen dress, but more importantly she chatted and mixed with the military and was a huge hit.

**▲ A meeting of wives, 2011**

Catherine shared her first
Remembrance Day service at
the Cenotaph with Camilla and
Sophie, Countess of Wessex.
They stood apart from the other
Royals, as protocol dictates for
those who have married into
the Royal Family.

**▶ Always a team player, 2011**

Looking cool in California, William
and Catherine arrive at a charity
polo match in Santa Barbara, at
which the Prince scored four times.

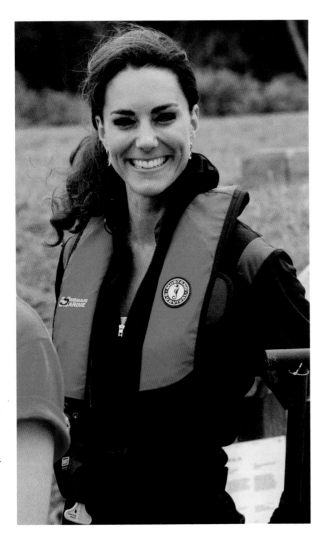

### ◀ Race to victory, 2011

Catherine's all smiles while Dragon Boat Racing at Prince Edward Island, but that didn't prevent her showing her competitive streak as she raced against her victorious husband.

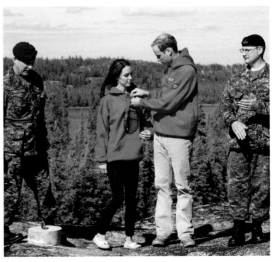

### ◀ Capturing the moment, Canada, 2011

Catherine is a talented photographer and her photos of the family are great. The test of a good photo is if it can bring a smile to your face, and hers certainly do.

### ▲ Team Cambridge, 2011

Prince William and Catherine were gifted matching red Canada ice hockey tops while visiting the Northwest Territories. The hoodies had 'Cambridge' and the numbers one for the Duchess and two for the Duke on the back.

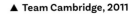

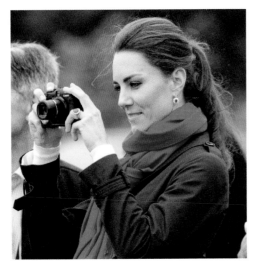

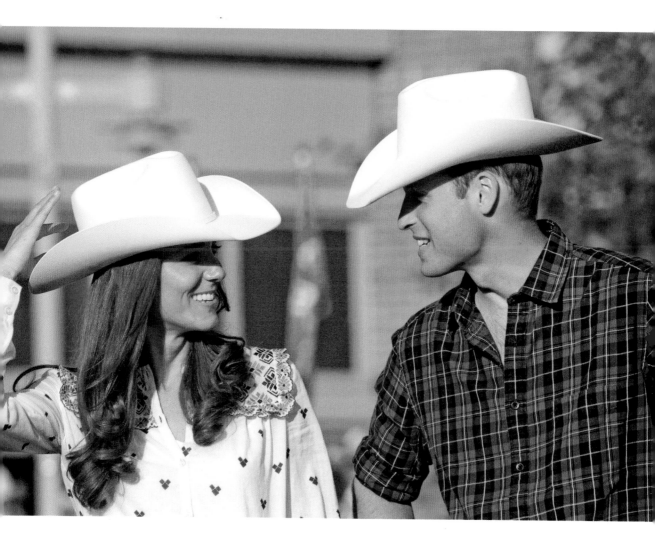

'Canada was one of the first overseas tours that William and Catherine covered following their marriage. It produced amazing pictures.'

▲ **A right royal rodeo, 2011**

The Duke and Duchess of Cambridge enjoying a rodeo in Calgary, both wearing the traditional white cowboy hats that they were given on arrival – a gesture considered a symbol of Western hospitality.

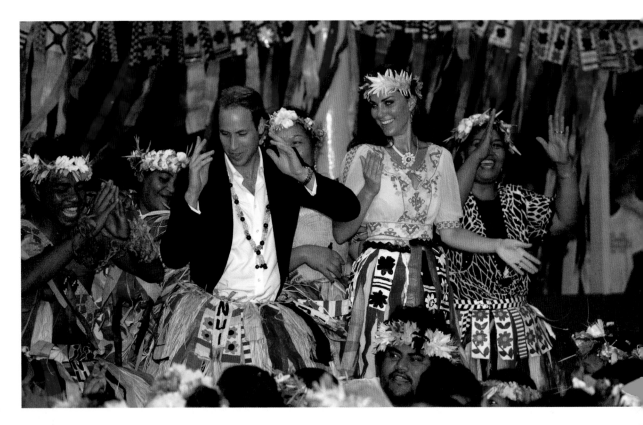

**▲ Shaking a tail feather in the Solomon Islands , 2012**

The couple looked fabulous in grass skirts, but William had taken off the floral headdress that I'd photographed him in earlier. He said, 'Please, Arthur, don't print that. They'll pin it up on my locker back at the air base and write horrible things on it.' I said, 'They can't do that, you're the captain.' He replied, 'That won't stop them!'

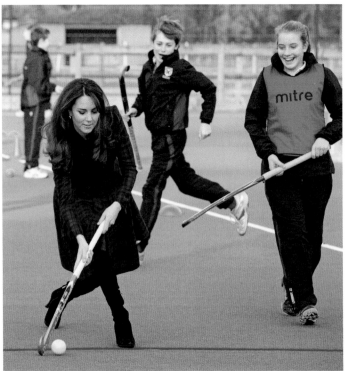

**◀ Face off at Catherine's old school, 2013**

Catherine is a talented hockey player and joined in a game when she visited her old primary school. The Duchess's programme was shortened, which got me thinking. None of us realised she was probably suffering from morning sickness until the pregnancy was unexpectedly announced a few weeks later when she was taken to hospital.

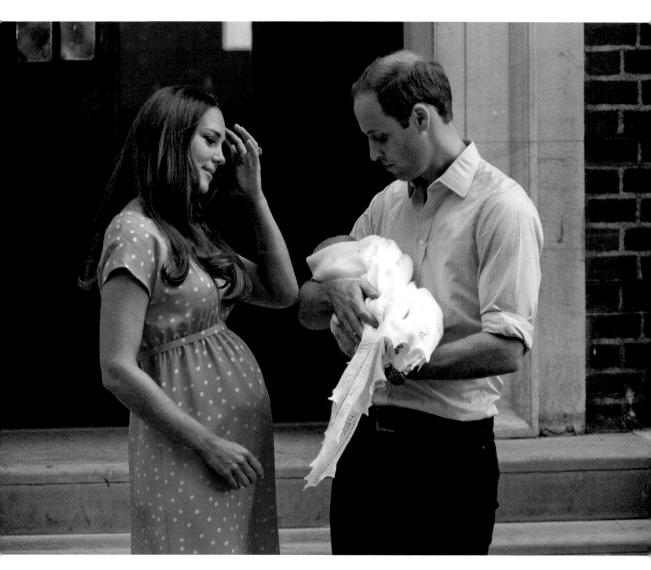

**▲ And baby makes three, 2013**

I staked out my spot early at the Lindo wing of St Mary's Hospital in west London, where Catherine was due to give birth. By the time the Royal baby was born the Press pack was 200 yards long and ten deep. The casually-dressed couple came out with George in William's arms. He then strapped the baby into a car seat, and with Catherine in the car, they drove off. At that moment they resembled any other new parents off to start their family life.

'I remember clearly the day George was born. Catherine went in, gave birth and came out that afternoon. It was amazing and they looked so incredibly happy with their little baby.'

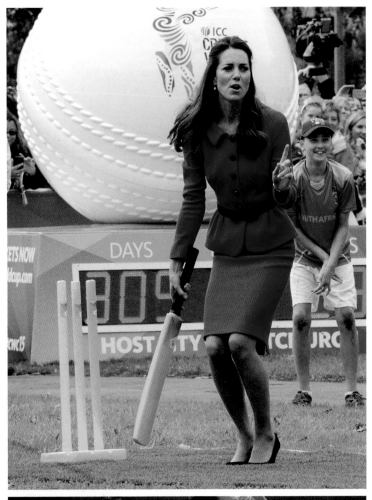

### ◀ Game on!, 2014

Even a close-fitting suit and high heels didn't stop Catherine joining in a friendly cricket match wicket in Christchurch, New Zealand.

### ▶ Head in the clouds , 2014

Always happy in the cockpit, William shares a joke with his wife while sitting in a First World War bi-plane during a visit to Omaka Aviation Heritage Centre, Blenheim, New Zealand.

### ◀ Riding the waves, 2014

William and Catherine were treated to a white-knuckle tourist ride on the Shotover River, and as ever took it in their stride. Travelling at 50mph and spinning at 360 degrees towards the riverbanks, the Prince just shouted 'Go closer!'

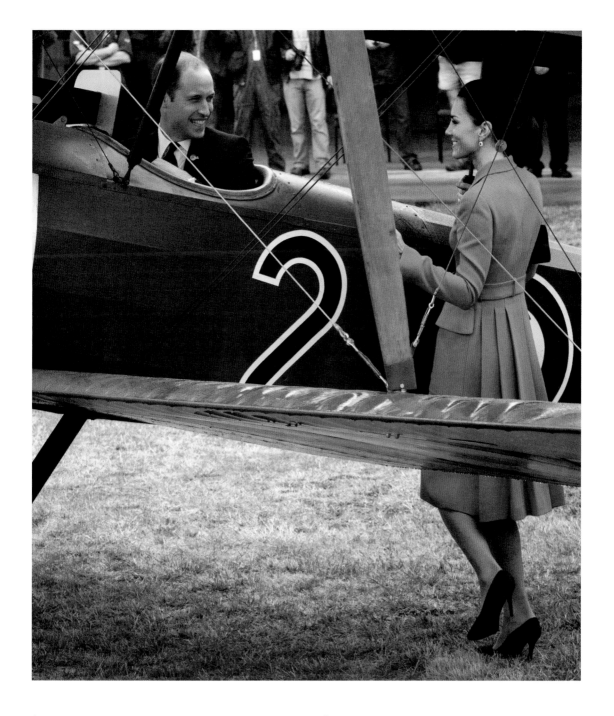

'William and Catherine are Britain's greatest
ambassadors. Wherever they go in the world,
they are met with genuine warmth and enthusiasm.'

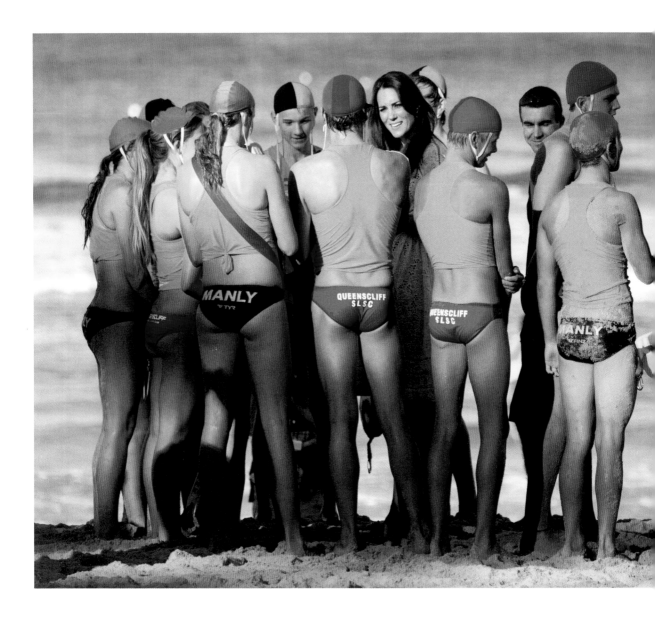

**▲ Afternoon on the beach, 2014**

Meeting young lifesavers from the New South Wales Surf Life-Saving Nippers' club. The couple were presented with a surfboard for Prince George.

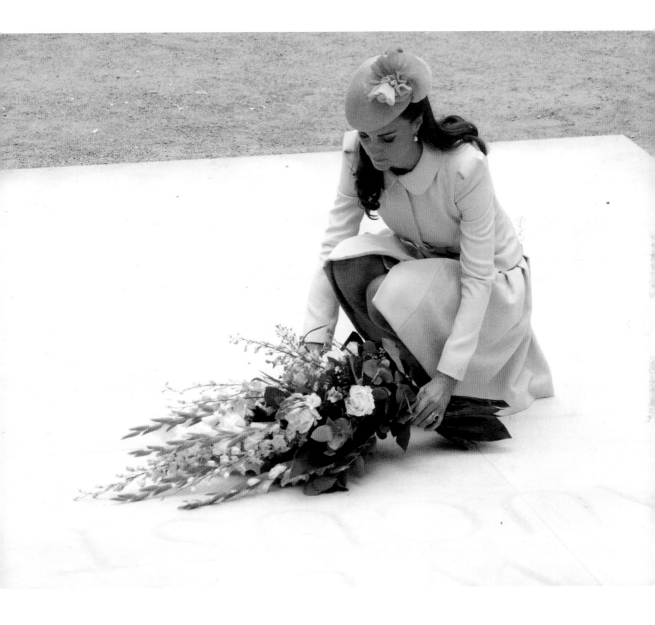

'Whenever you do a job with them and engage with them, whether it's here or overseas, whether it's fun or serious, both William and Catherine give it their very best.'

This was a solemn occasion at St Symphorien Military Cemetery in Belgium as Catherine laid flowers 100 years after the outbreak of the First World War.

### ▲ Queen of the decks , 2014

Prince William played DJ at a homeless centre in Adelaide, Australia, for young people and tried his hand at scratching. He claimed it was harder than flying a helicopter. Catherine, meanwhile, proved to have a secret talent for mixing...

### ▶ Princess Charlotte makes her debut, 2015

Soon after Princess Charlotte was born, William and Catherine came out on to the steps of the hospital to share their joy with the waiting world. They were both magnificent and had a little chit-chat with the broadcasters before heading off to be a family together.

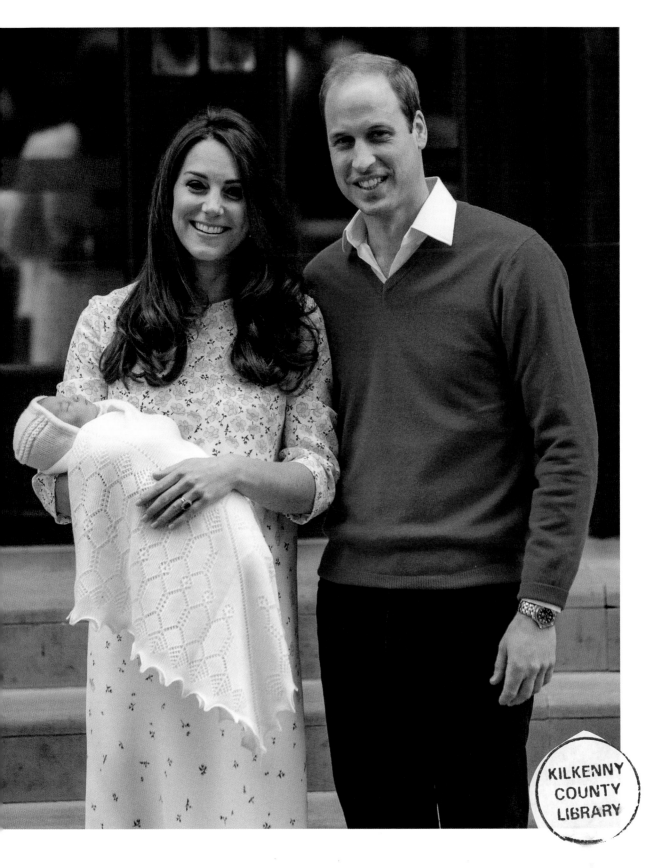

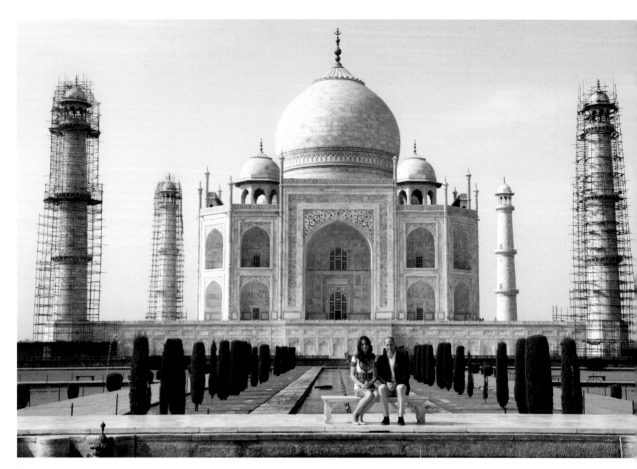

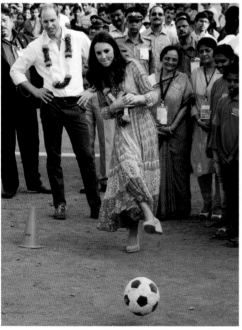

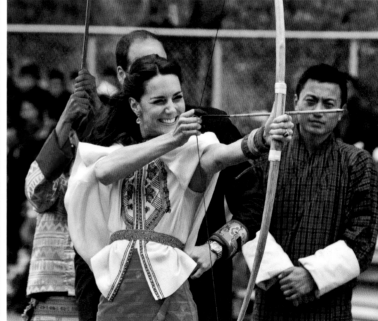

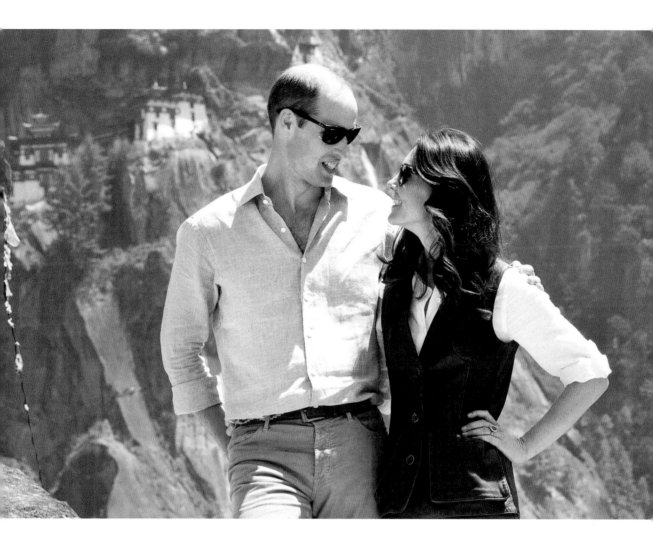

### ◤ Making history once more, 2016

The paper really wanted the shot of William and Catherine sitting exactly where Diana and Charles had separately positioned themselves for pictures at the Taj Mahal that I'd taken previoiusly. I wasn't sure if they would do it, but they did and with such grace. They sat there for a while, so all the photographers got some great pictures.

### ◀▲ Taking it in their stride, 2016

On a visit to Bhutan, the Duke and Duchess of Cambridge completed a three-hour hike to the Tiger's Nest Buddhist monastery that is perched on a mountainside at a height of 3,000 metres. Looking casually smart, they scaled the mountain hand in hand. Good heartedly, Catherine tried her hand at archery and taking penalties on what was a fun tour.

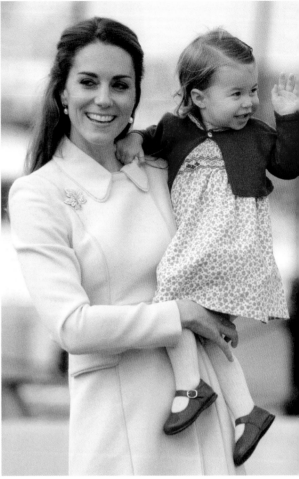

'The Cambridge children
are a delight. When they
make rare appearances on
Royal tours, my job becomes
very easy. The pictures are
always uplifting.'

▲ **Goodbye Canada , 2016**

The Cambridges travelled as a family
of four for the first time on their
tour of Canada. The children stole
the show, with excited waving from
George and a more muted attempt
from little Charlotte.

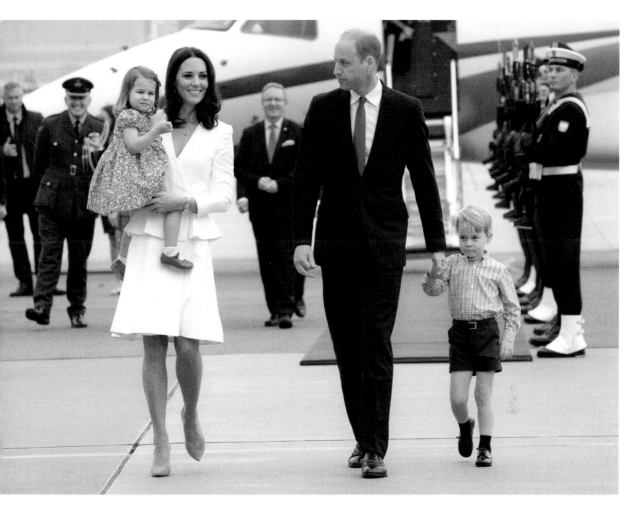

**▲ On the road again, 2017**

The family together again on another official tour. This time it was the couple's first trip to Poland.

**▶ Girl with a Pearl Earring, 2016**

I love this picture of Catherine on her first solo trip, when she visited Mauritshuis gallery in The Hague. The Queen's pearl earrings worn by History of Art student Catherine beautifully mirrors the painting.

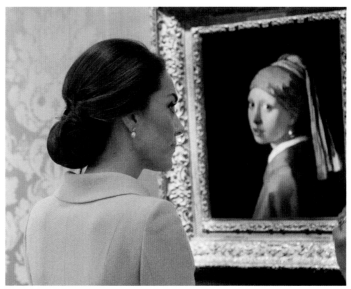

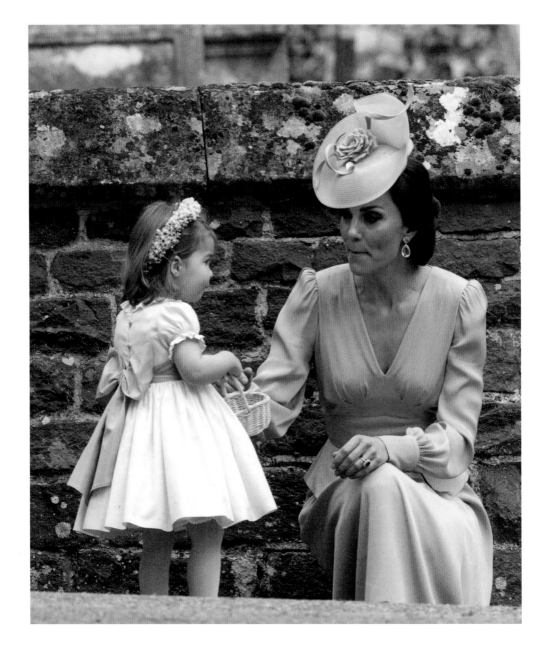

**▲ Beautiful bridesmaid, 2017**

Princess Charlotte looked adorable as a bridesmaid for her aunt Pippa Middleton's wedding at St Mark's Church, Englefield, Berkshire. But I love this picture as a sweet, natural moment between mother and daughter.

**▶ An emotional tour of Berlin, 2017**

The Royal couple shared a moment of reflection alone as they walked through the Holocaust Memorial.

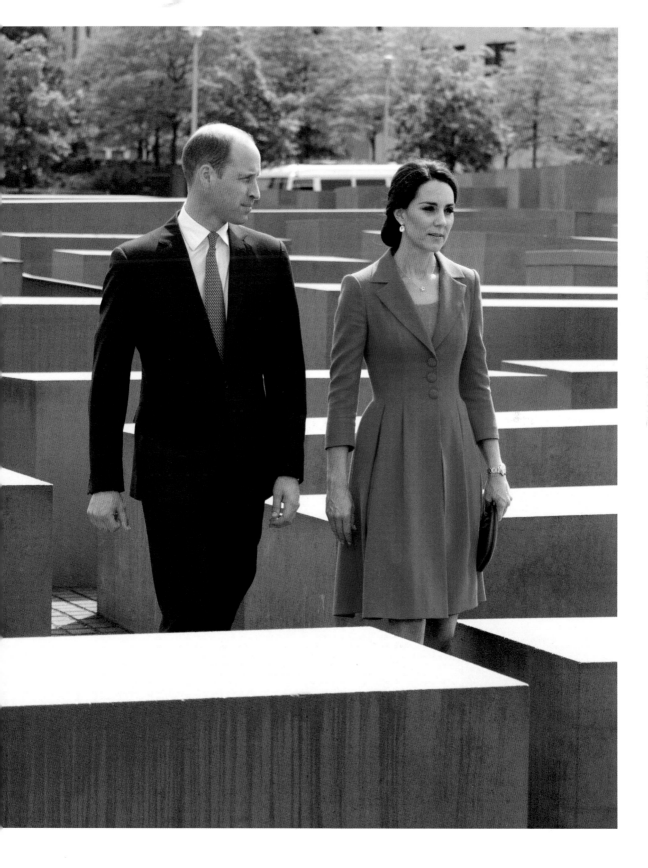

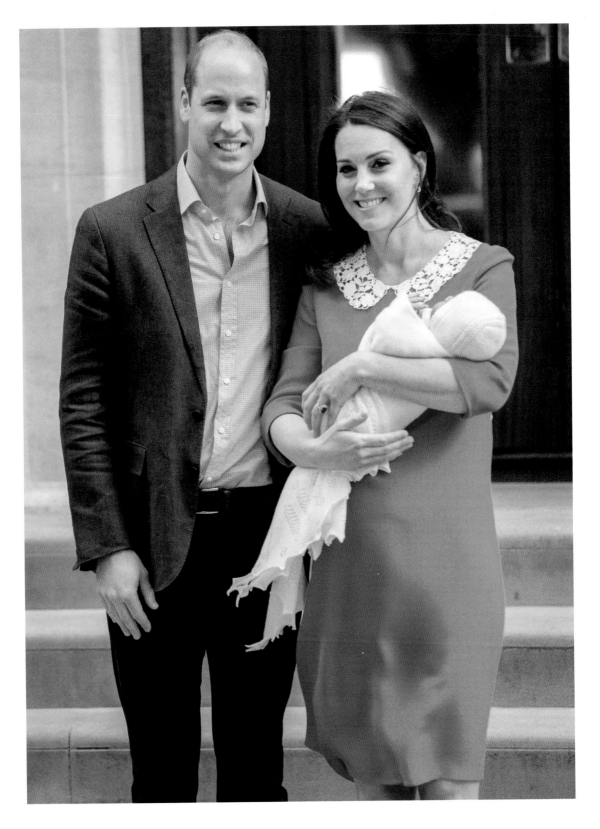

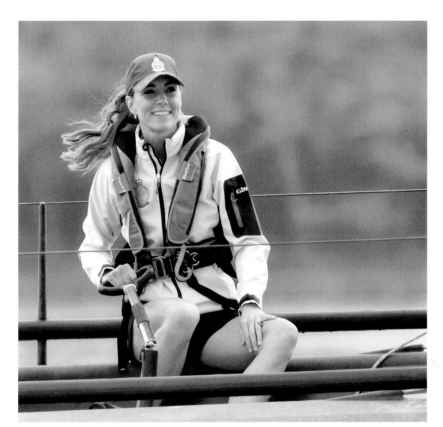

The Cambridges went head to head in a sailing race at the annual Cowes' Isle of Wight regatta.

◀ **William and Catherine complete their family, 2018**

Once more, the proud parents introduced a new baby to the world. It was newborn Prince Louis's turn to face the cameras as he left the St Mary's Hospital in west London. It was tremendous and such a happy moment.

▶ **Cheeky Charlotte greets her grandpa, 2019**

Prince Louis stole the show at the Queen's Platinum Jubilee, but all the children have had their cheeky moments. At the Cowes Regatta Princess Charlotte forgot about the crowds and poked her tongue out at grandfather Michael Middleton when she spotted him in the crowd, much to Catherine's amusement!

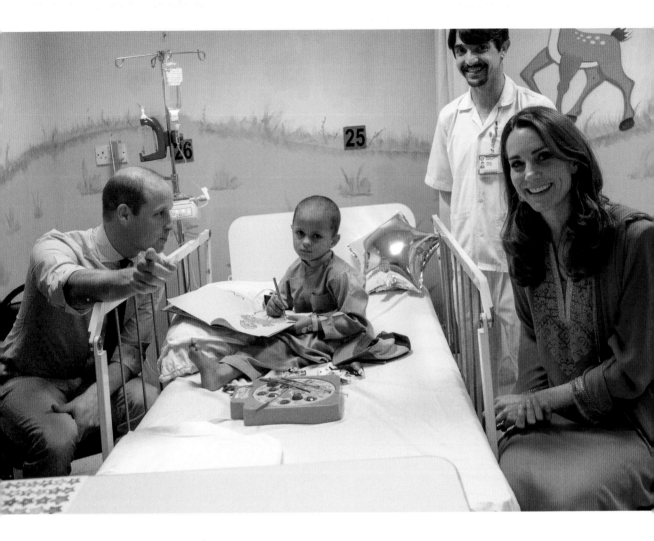

**▲ In his mother's footsteps, 2019**

During their tour of Pakistan, William and Catherine visited Shaukat Khanum Memorial Cancer Hospital in Lahore and spent time with several sick children, including seven-year-old patient Wafia Rehmari, just as Diana had visited the same hospital in 1996.

'On our way to Pakistan, William and Catherine came back to the plane to talk to the Press. The Prince said to me, "Arthur, I just want to tell you, you're very, very welcome on this trip. You're very, very welcome." I'll never forget him saying it.'

**◄ Catherine checks in on student mental health, 2020**

William and Catherine have long been supporters of mental health charities, and just ahead of World Mental Health Day she visited students affected by Covid quarantine and restrictions at university.

**▲ All smiles for the Queen, 2022**

Despite the Queen being unable to attend the service in celebration of her 70 years on the throne, the day was full of smiles at St Paul's Cathedral. The family all came together with dignitaries and other invited guests.

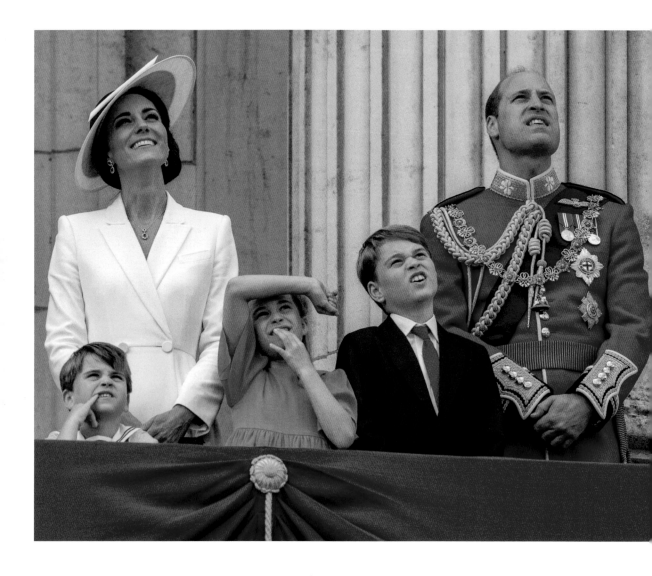

**▲ Joyful Jubilee, 2022**

Undoubtedly Prince Louis stole the show at the Queen's Platinum Jubilee, sharing sweet moments with his great-grandmother and treating us all to an enthusiastic and hilarious array of funny faces.

'I did a few pictures of the faces Louis was pulling – the hands over ears and all that – but by day four, I didn't want to do any more photos of that. I wanted to see pictures of him looking normal. I got some lovely shots, which I sent over to William and Catherine.'

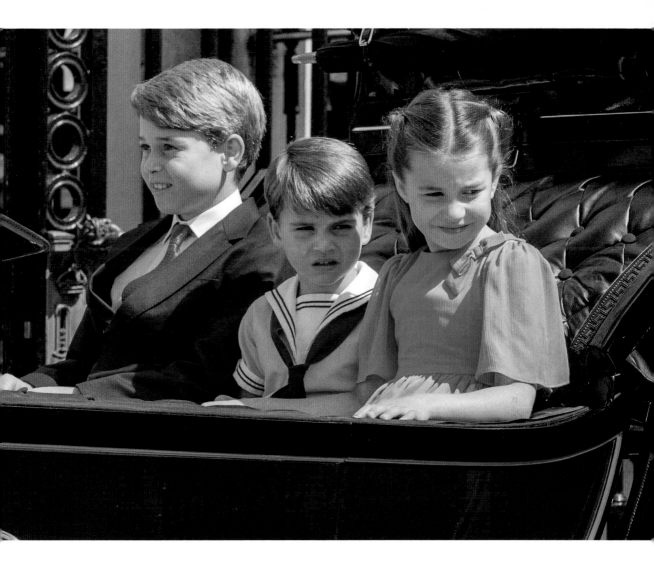

**▲ Sweet siblings, 2022**

Princess Charlotte was the perfect older sister and kept a watchful eye and hand on her little brother Louis in their first carriage ride as part of the Platinum Jubilee celebrations.

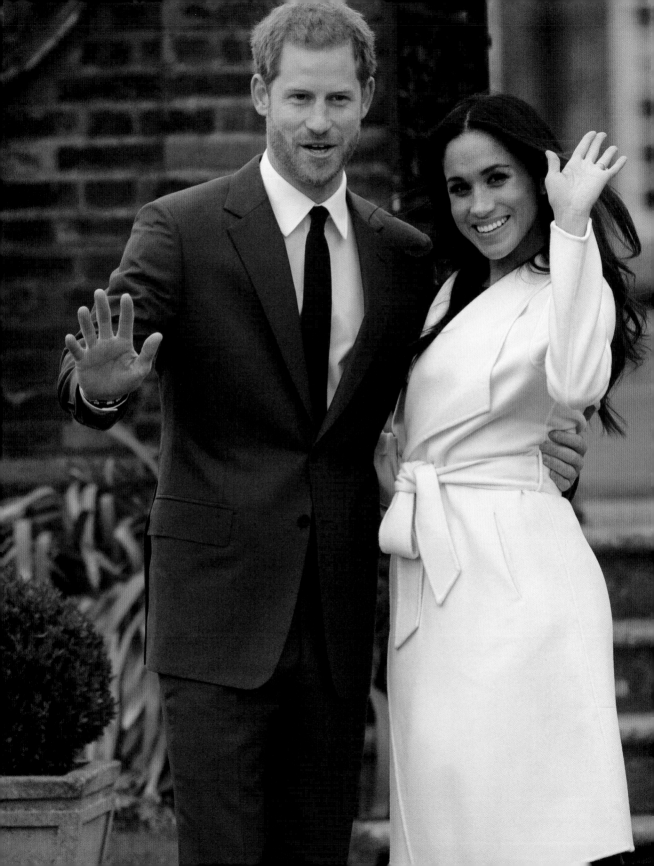

# Harry & Meghan

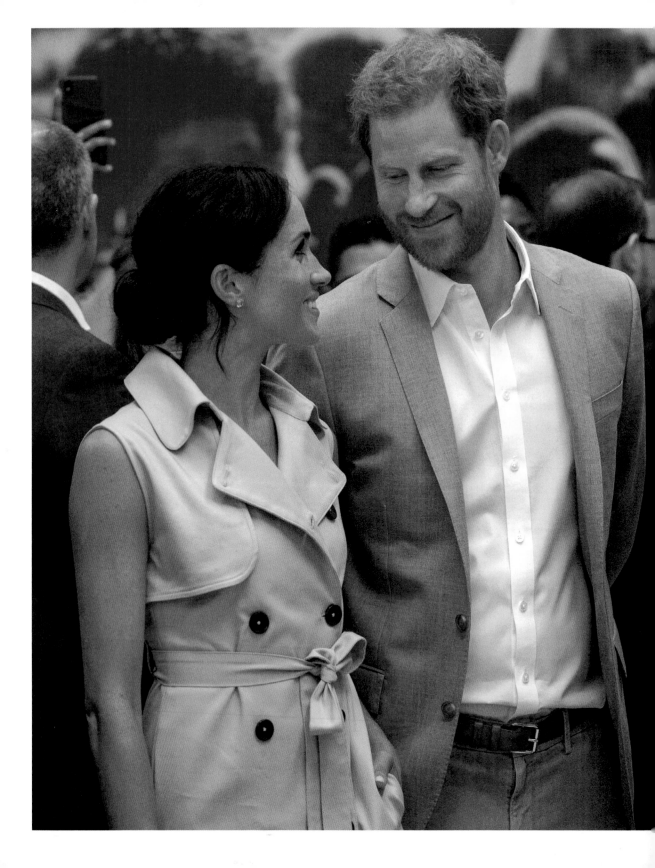

# Harry & Meghan

When I heard Harry was seeing a US actress called Meghan Markle, no one I knew had ever heard of her. Now she's one of the most talked-about women in the world. After they married I travelled with them around the UK, Ireland and Morocco and they both put their heart and soul into it. Meghan had superstar quality but I don't think stuffy court life and stage-managed tours were what she really wanted. After their first child Archie was born, they moved to the US, where daughter Lillibet was born. The family seem very happy and have immersed themselves in charity work, very much in the footsteps of Diana. The Sussexes still make fleeting visits to the UK but I hope that one day they will return for good. They have the compassion and star quality that make them a great asset to the Royal Family.

◄◄ **Love at last for Harry, 2017**

Prince Harry coyly introduced his fiancée, American actress Meghan Markle, to the world in the Diana Garden at Kensington Palace after a whirlwind romance that was the stuff of Hollywood movies.

◄ **A new world, 2018**

Newly married Duke and Duchess of Sussex visit an exhibition at the Southbank Centre, in London, celebrating the life and work of Meghan's hero, Nelson Mandela.

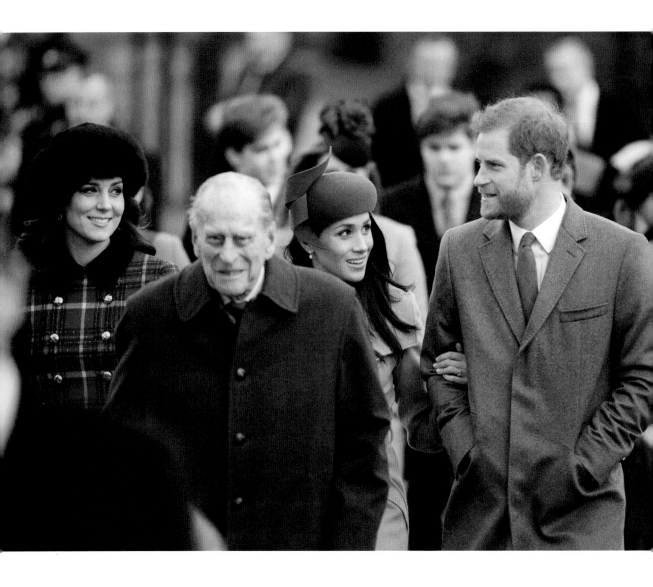

**▲ Christmas with the Royals, 2017**

Prince Harry and Meghan spent their first Christmas as an engaged couple together in the UK, and attended the traditional Christmas Day service at Sandringham with the family.

'When Meghan smiled the room lit up. She is a stunning woman and a photographer's dream. She made my job easy.'

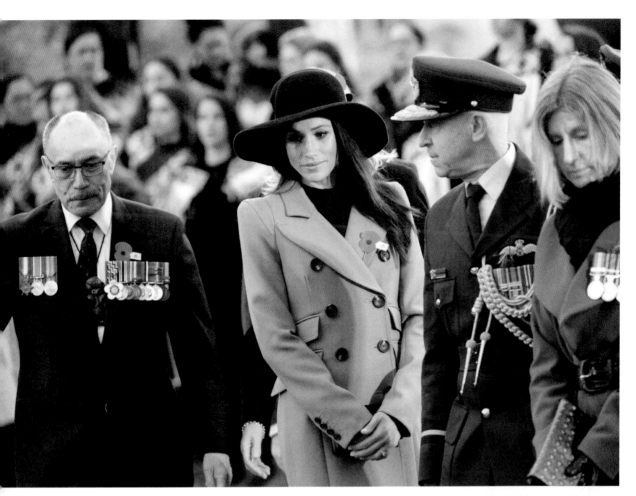

### ▲▶ Dawn salute, 2018

Harry and Meghan started Royal
duties early on Anzac Day, when the
couple attended a dawn service at
Wellington Arch, Hyde Park Corner,
welcomed by Te Ataraiti Waretini
from the London Maori Club.

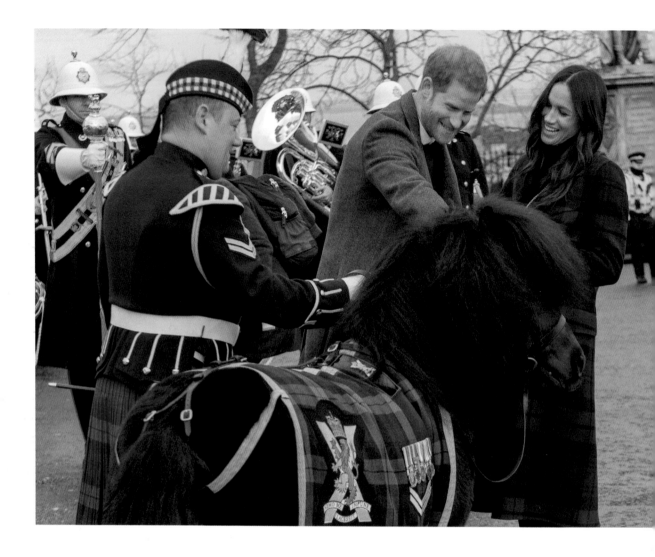

**▲▶ Meghan's mascot, 2018**

Royal duties continued for Meghan ahead of their spring wedding, when the couple visited Scotland. They were introduced to the mascot of the Royal Regiment of Scotland on a walkabout in Edinburgh, before visiting social projects close to their hearts.

'They are a magnificent couple. She is a very beautiful lady, and it was so obvious how much he loved her because they were always hand in hand everywhere they went. This was just what he wanted – he wanted a woman to love and to love him.'

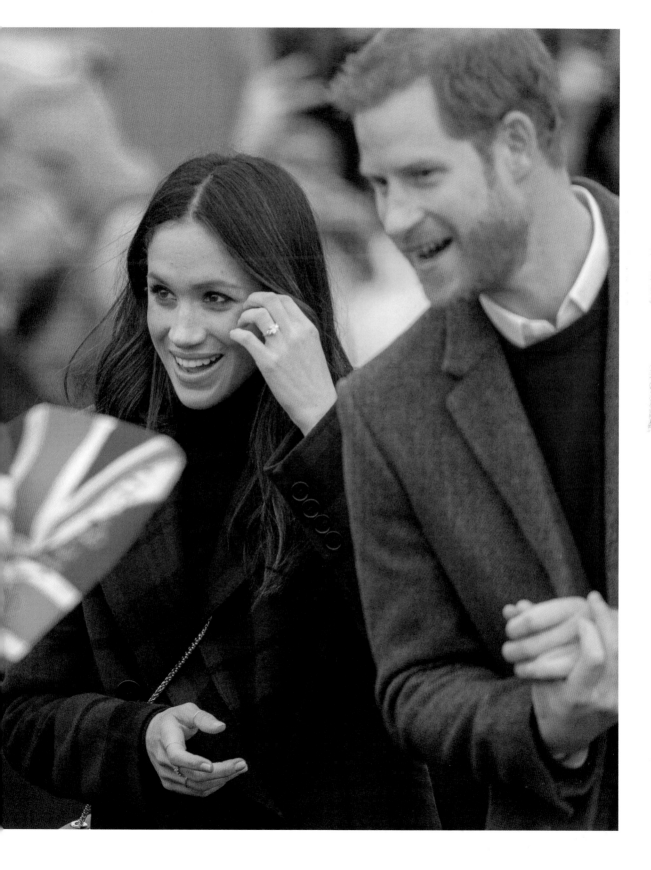

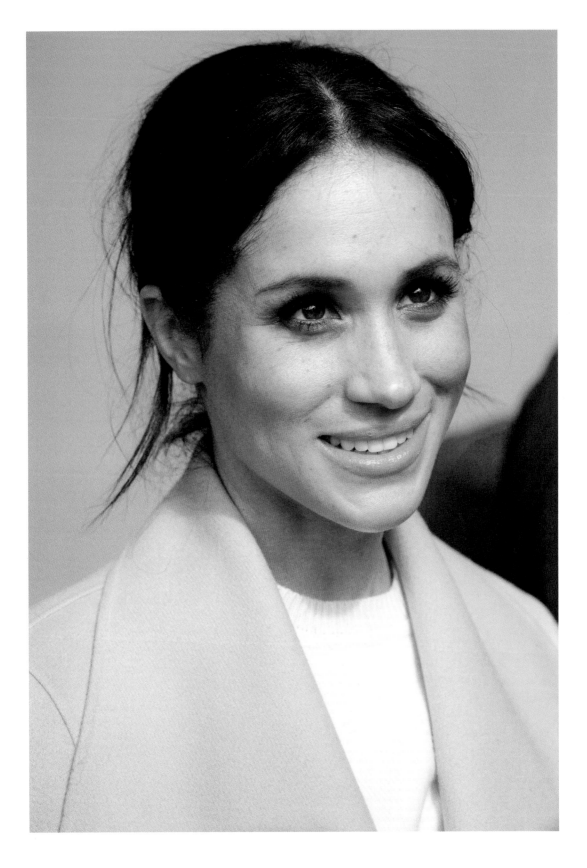

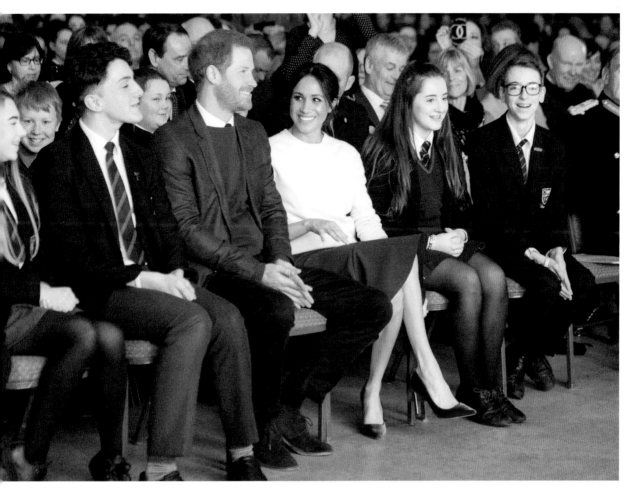

**◄▲▶ Harry and Meghan in Northern Ireland, 2018**

On another trip ahead of their wedding, Meghan connected with the crowd and looked very much at home in her new role.

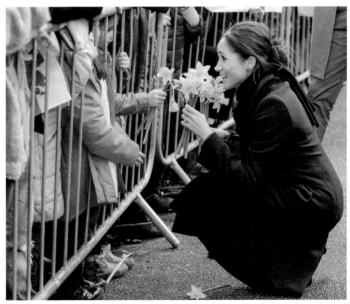

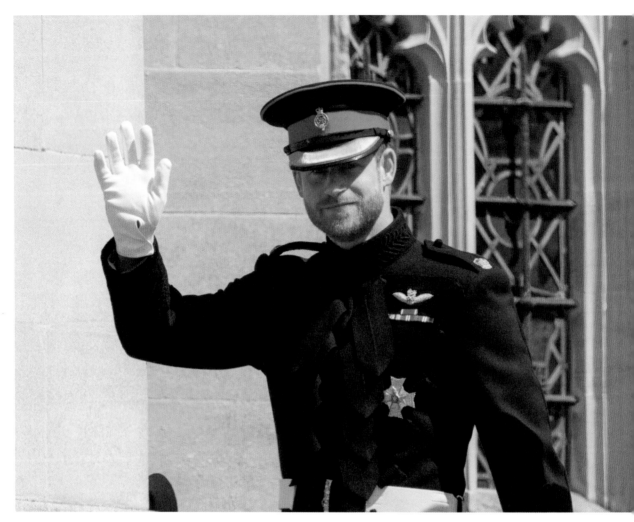

**▲▶ Best men, 2018**

While I was photographing the
guests, William and his brother
walked down to the chapel, and
I managed to get a nice shot of
the pair of them.

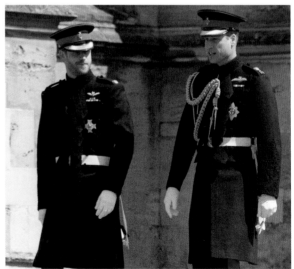

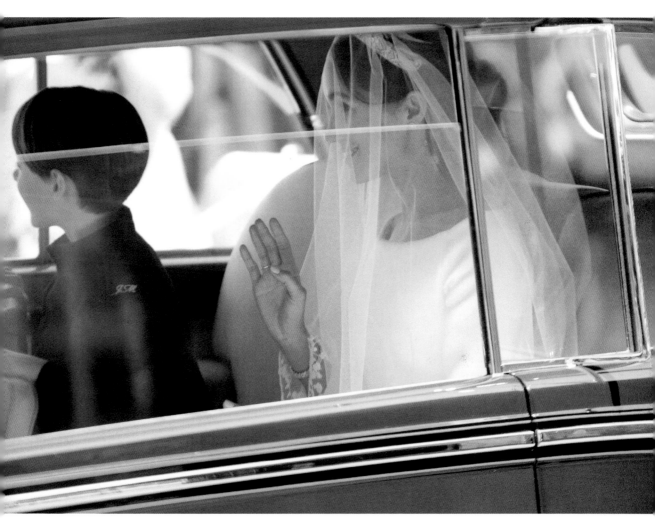

## ◄▶ Wedding day, 2018

Unfortunately only the Press Association were given permission by the couple to photograph their wedding, so the rest of us had to make do with getting what we could on long lenses. I still managed to get some nice shots of the bride and bridesmaids as they passed by.

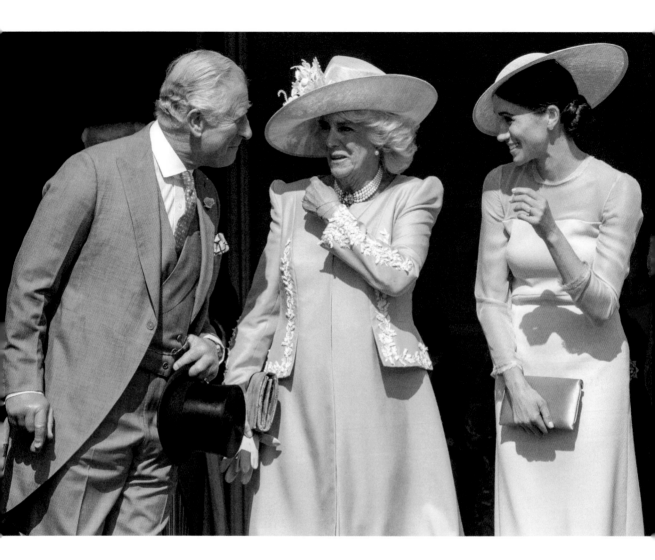

▲ **Happy birthday, Sir!, 2018**

Newlyweds Harry and Meghan delayed their honeymoon to attend Prince Charles's 70th birthday bash at Buckingham Palace.

▶ **Duchess of Sussex goes solo, 2018**

Her first solo engagement as a working Royal, the Duchess of Sussex attended the opening of the Oceania exhibition at the Royal Academy in London.

'As Meghan arrived at the Royal Academy she shut the car door herself. It caused a bit of a stir. The Royals normally have this done for them.'

**▲ Striding into the new year, 2018**

Parents-to-be Harry and Meghan once more spent Christmas with the Royal Family. No one knew at this point that this would be the last time we would see them all at Sandringham together.

'I think the world of Harry. He was one of the loveliest people to work with over the years. I worked with him in many places all over the world. He created one great picture after another and I can only remember happy times working with him.'

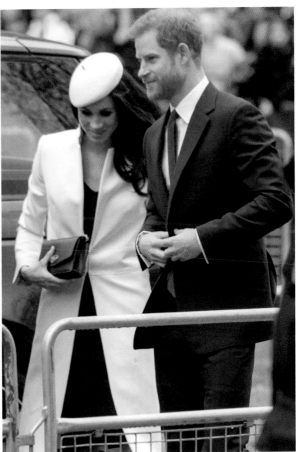

▲ **What a difference a year makes, 2018 and 2019**

Harry and Meghan attending the Commonwealth Day service at Westminster Abbey in both years. In 2018 Meghan was just weeks away from her wedding; in 2019, she was pregnant with her first child.

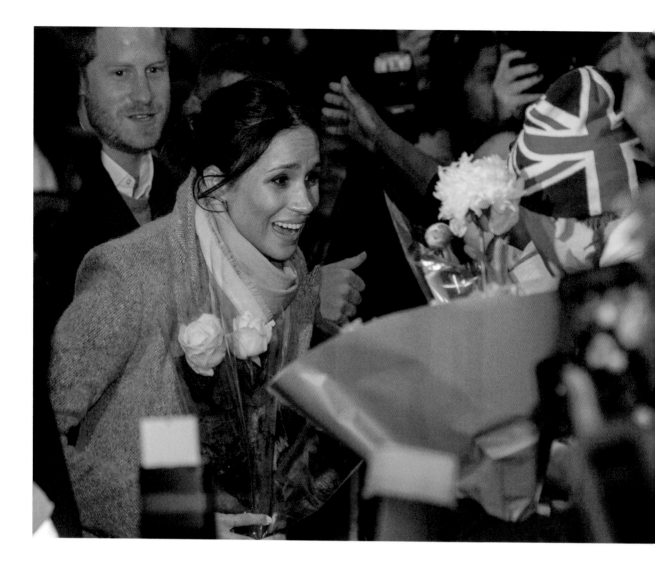

'Meghan would squat down
to talk to the kids and she was
just great. I mean, she was great
with children and adults alike.'

▲ **Brixton, 2018**

Harry and Meghan were welcomed
by cheering crowds as they visited
Brixton, south London.

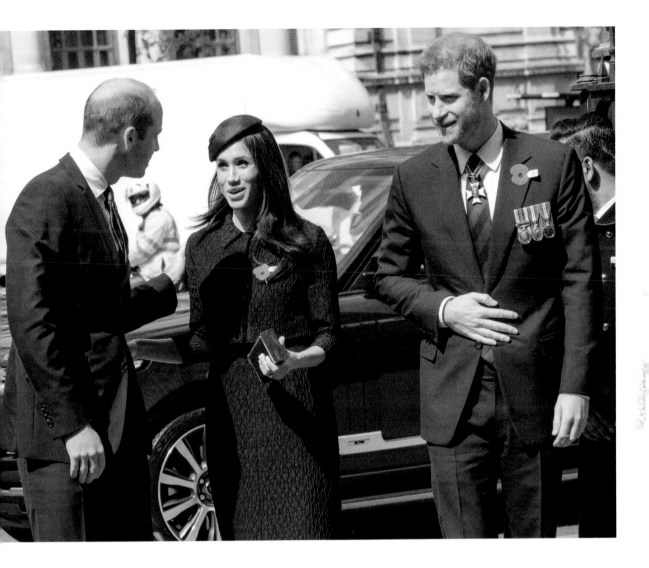

**▲ Happy families, 2018**

All smiles for future brother-in-law Prince William as Meghan and Harry attend Anzac Day celebrations at Westminster Abbey in their second duty of the day.

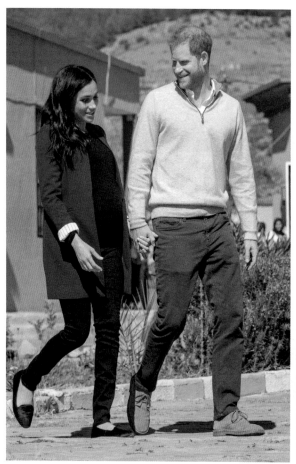

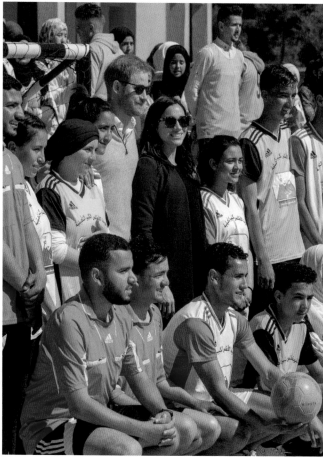

### ▲ Walkabout in Morocco, 2019

The Royal tour of Morocco was a great success, with Meghan impressing locals by speaking French. The couple seemed relaxed and happy.

### ▲ One of the team, 2019

Visiting a school for students from remote communities, Harry joined in the football with them, never one to pass up a game.

### ▶ A glamorous entrance, 2019

Meghan looked positively radiant attending a reception at the Rabat residence of British Ambassador Thomas Reilly.

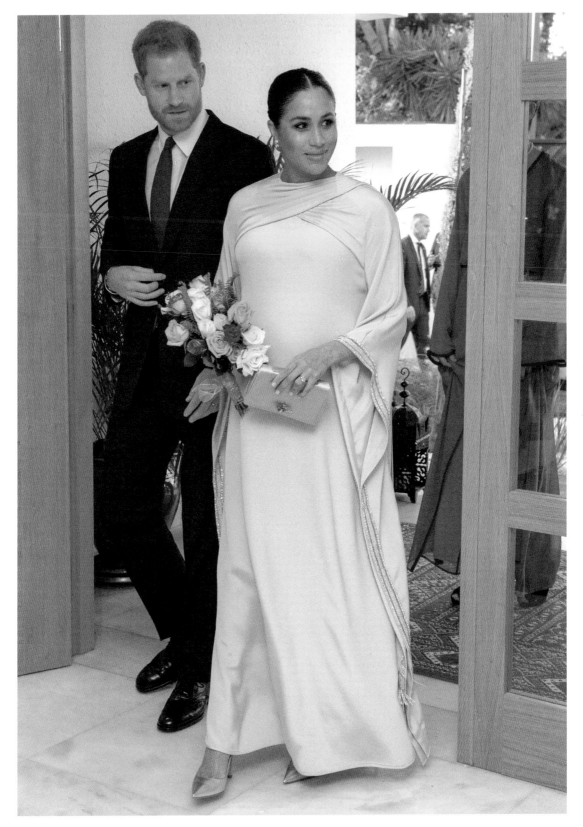

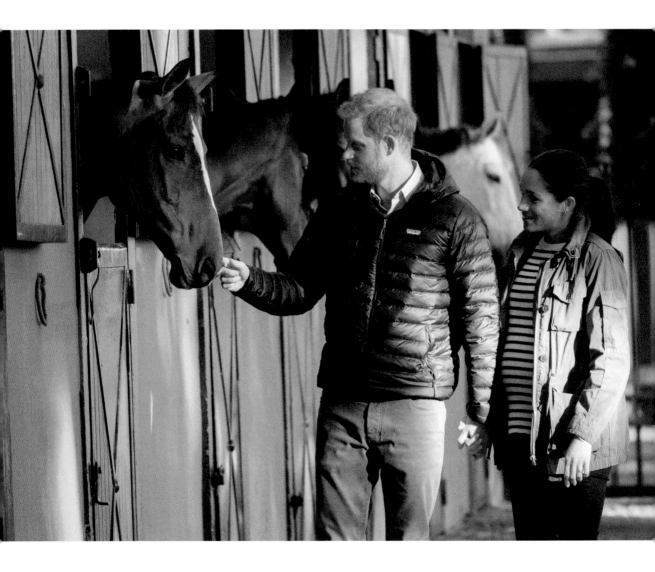

**▲ One more trip before the baby, 2019**

Seven months pregnant, Meghan and Harry visited an equestrian centre for children with disabilities on their tour of Morocco.

**▶ Prayers for the fallen, 2019**

Paying their respects at the Field of Remembrance and later Westminster Abbey on Remembrance Day. This was the last time we would see the couple at this service.

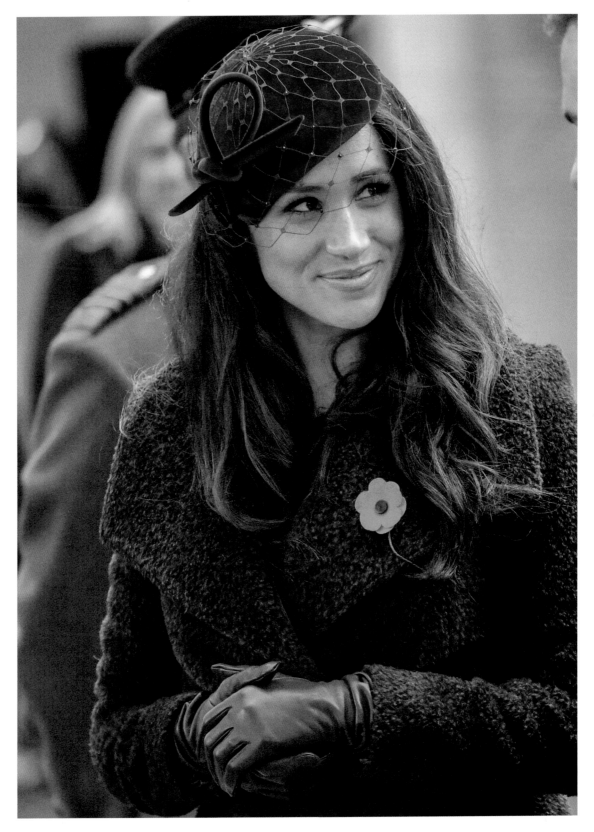

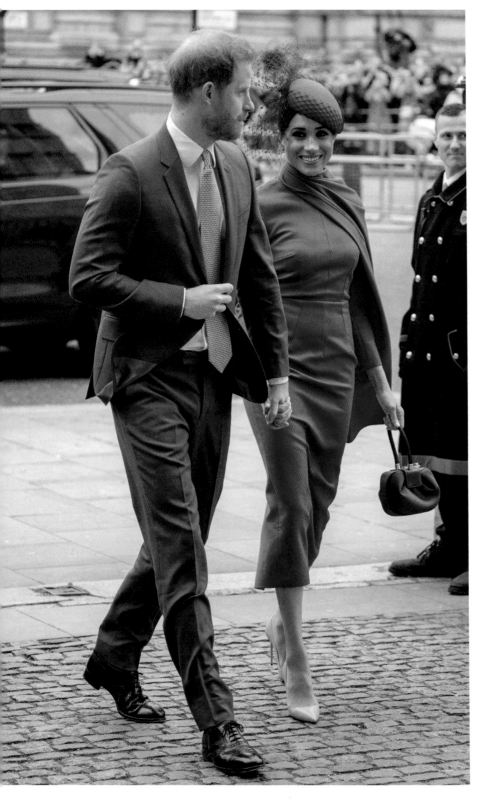

◀ **Goodbye to all that, 2020**

The final engagement of the Duke and Duchess of Sussex as working Royals before they left the country for a new life in America.

▶ **Royals reunited, 2022**

Harry and Meghan made a fleeting appearance during the Jubilee celebrations, attending the service for his grandmother in St Paul's Cathedral before their return to America.

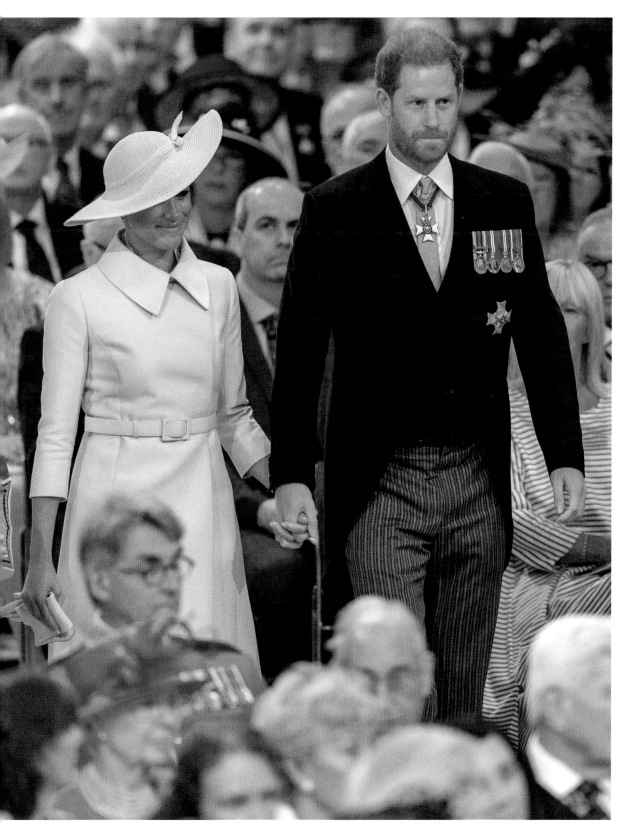

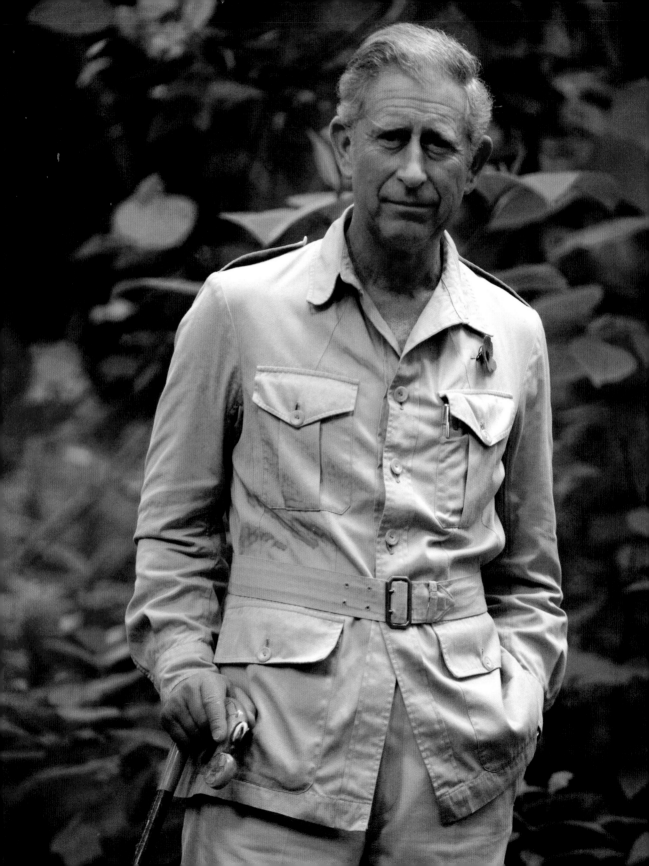

# King Charles III

## Later Years 1998–2022

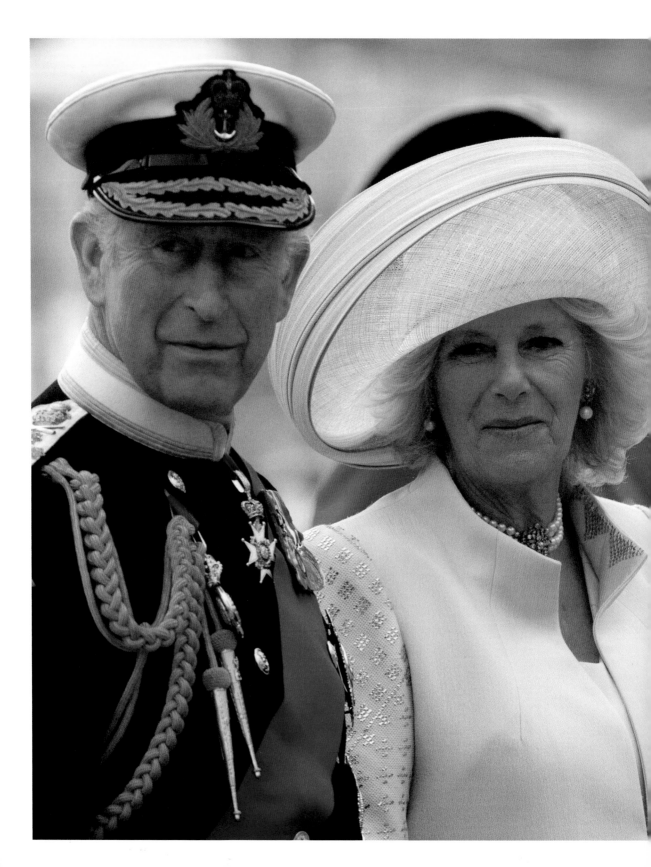

# King Charles III

*I* am often asked, 'Who is your favourite royal?' Without hesitation I say King Charles. I've been photographing him for 40 years and he's never compromised his views and is never afraid to let his feelings be known. Decades ago he was criticising brutal urban planners and speaking up over environmental concerns. I believe the thing that really made him happy in life was marrying Camilla. She has been a magnificent support and, just as importantly, she makes him laugh. In 2015 the couple made an emotional trip to Mullaghmore Harbour in Ireland, where Charles's 'honorary grandfather' Lord Mountbatten was murdered by the IRA. I asked him if he would pose for me looking at the sea where Mountbatten was blown up on his boat, but he started to object. Camilla said: 'Come on, darling, let's do it.' They did and that poignant picture was published widely the next day. Charles later told aides: 'Now I know why Arthur told me to do that.'

◀◀ **Conservation in action, 2008**

His Majesty's passion for conservation and the environment is well known, and trips like this one to the Harapan Rainforest in Jambi, Indonesia, were among his favourites, where he can see preservation and conservation in practice in exciting ways.

◀ **All aboard, 2012**

Camilla joins Charles and other senior royals on board the Royal barge amongst the celebratory flotilla that cruised down the Thames for the Queen's Diamond Jubilee.

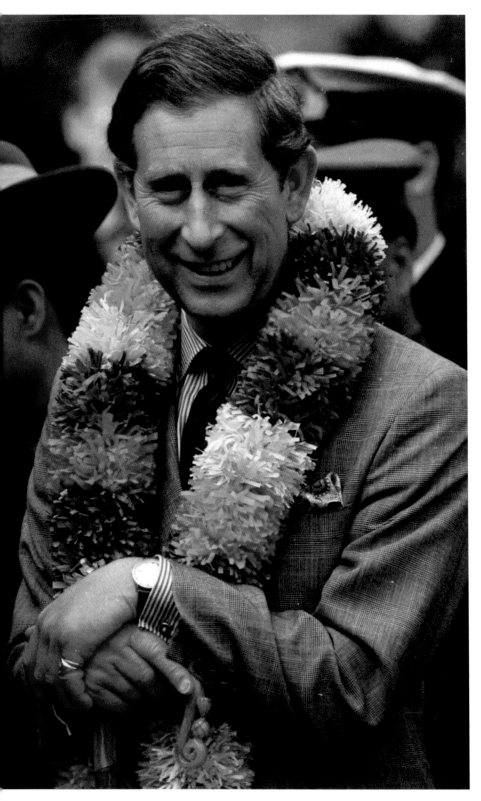

◀ **A warm welcome, 1998**

As Colonel-in-Chief of
the Royal Gurkha Rifles,
the Prince paid a visit to
the village of Lamjung
in Nepal, where he met
several veterans who'd
won the Victoria Cross
in Burma in the Second
World War.

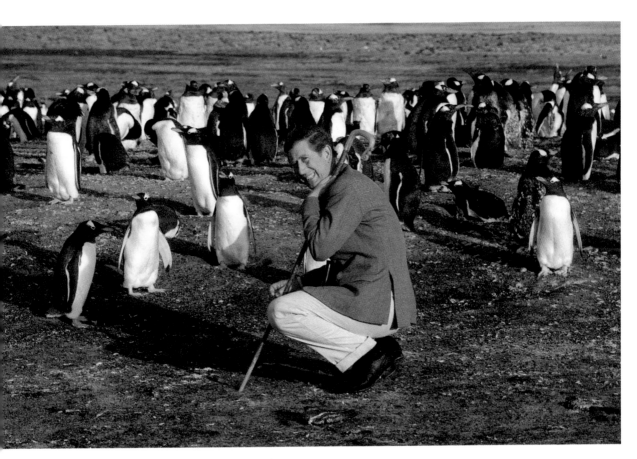

**◀ Pretty in pink, 1999**

One of His Majesty's many patronages is Breast Cancer Now. The importance of this research means he was happy to pose for the camera to support their work while at the Toby Robins Research Centre, at The Institute of Cancer Research.

**▲ King penguin, 1999**

A more unusual meet and greet on the Falkland Islands. As Charles crouched down amongst the penguins at a colony on Sea Lion Island he joked, 'Spot the penguin!'

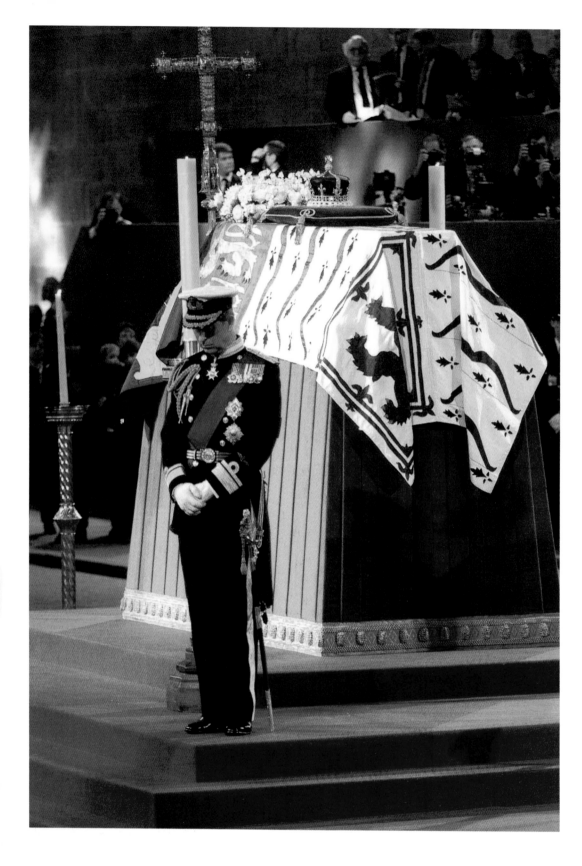

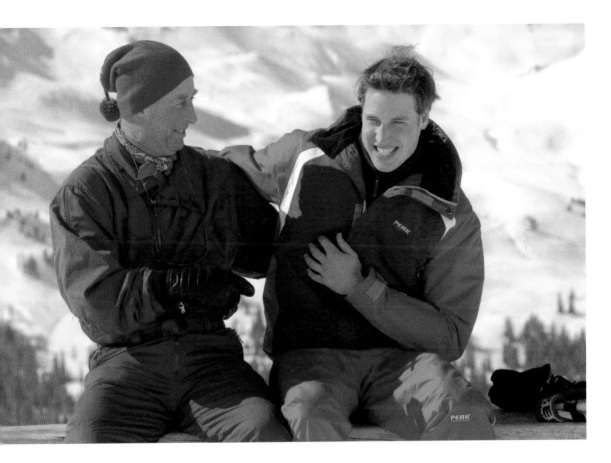

### ◀ A silent vigil, 2002

Princes Charles, Andrew and Edward and Viscount Linley, the son of Princess Margaret, paid their last respects to the Queen Mother in Westminster Hall on the eve of her funeral at Westmnister Abbey. The men took their places at the four corners of the two-metre-high catafalque where they stood, silent, for 20 minutes.

### ▲ Larking around, 2004

One of my favourite pictures – William and his father at Klosters on their annual ski holiday. His Majesty loves his boys more than anything in the world, and every now and then the public image drops and you see their bond, full of humour and love.

### ▶ Oman tour, 2003

Charles dressed for the occasion – with the perfect accessory for the bright Oman sunshine at the Nakhal Fort, Muscat.

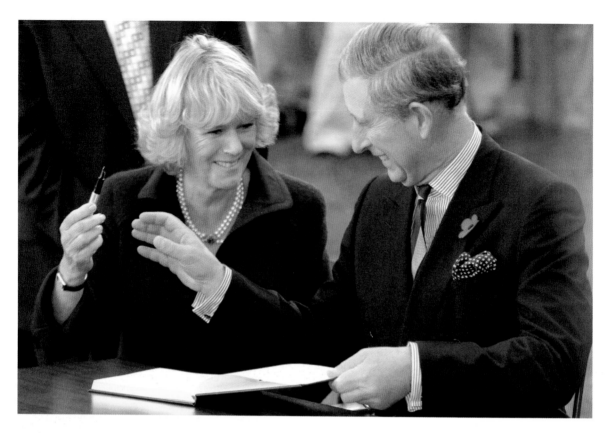

### ▲ Perfect partnership, 2005

Camilla has such a wonderful sense of fun, which she shares with her husband. On this tour of America, she jokingly refused to give Charles back his pen as he attempted to sign a book at a school they were visiting. Their ease with one another was clear to see.

### ◄ The smile that says it all, 2005

Camilla has always got a smile on her face, and the broadest one I've ever seen was on the night I was asked by the Prince's Press Secretary to photograph the happy couple for their engagement.

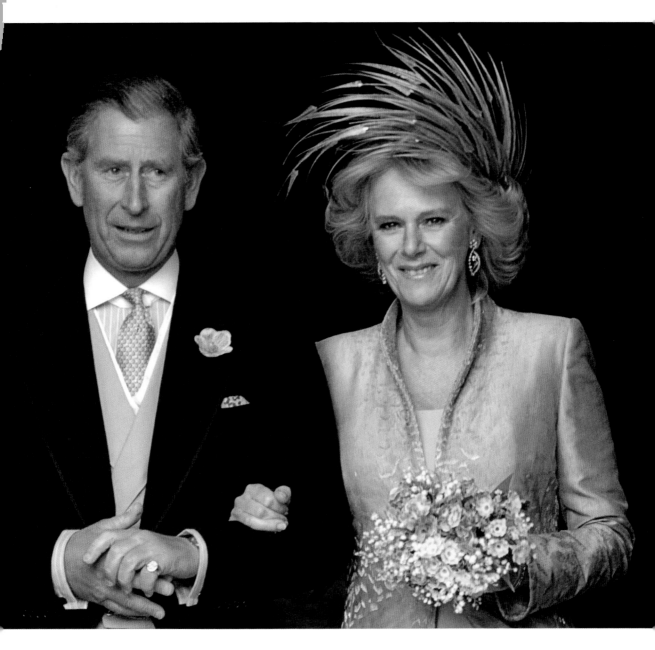

**▲ Happy ever after, 2005**

Camilla looked staggeringly beautiful as she married the equally overjoyed Prince Charles. She has brought a spring to his step and now, as he takes on his new role as *King Charles III*, she will be the most wonderful support as Queen Consort.

'Camilla has had this enormous uphill struggle, but she has done it brilliantly. She has just smiled and smiled and smiled and she has embraced the job as best she possibly could. She is amazing.'

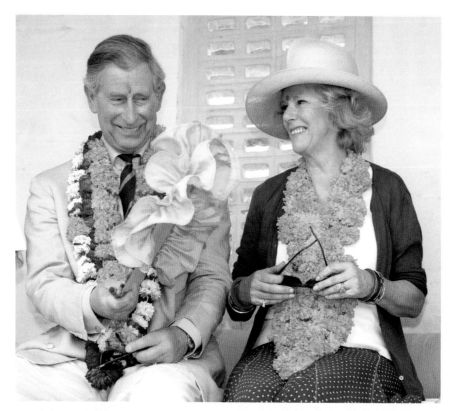

### ▼ Jokes in Jodhpur, 2006

Charles has not slowed down
his tours in recent years, visiting
projects around the world. Camilla
joined him for his visit to Artiya,
near Jodhpur, to watch water
conservation in action.

### ◀ The music man, 2006

The Prince made a brief two-day
visit for the first time to Sierra Leone
to a warm welcome, and tried his
hand at some drumming, too.

### ▲ Always learning, 2006

Prince Charles's three-day tour of
Nigeria included a visit to school in
Kano as he promoted female literacy.

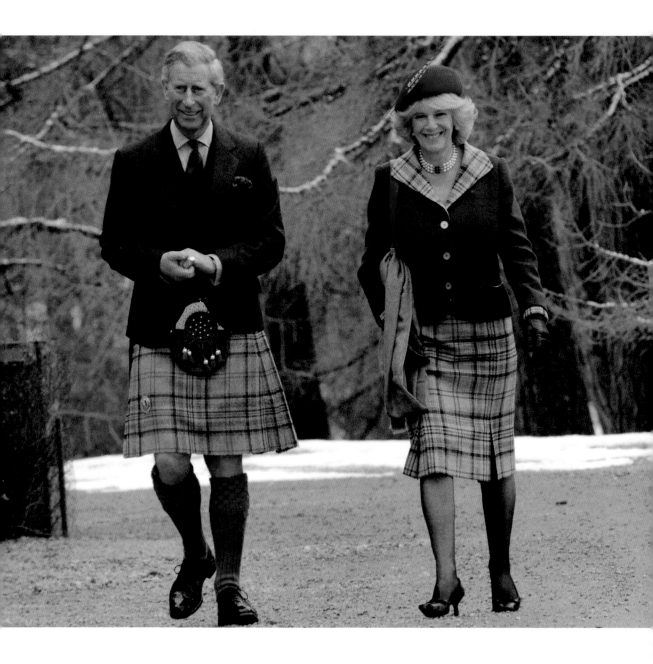

#### ▲ Suits you!, 2006

Charles and Camilla stepped out in matching traditional tartan as they attended Craithie Church near the Balmoral Estate.

#### ▶ Keep calm and carry on, 2003

Always a good sport, a rather worried-looking Prince Charles was carried at shoulder height clutching the match ball for the ancient Royal Shrovetide football game in Ashbourne, Derbyshire.

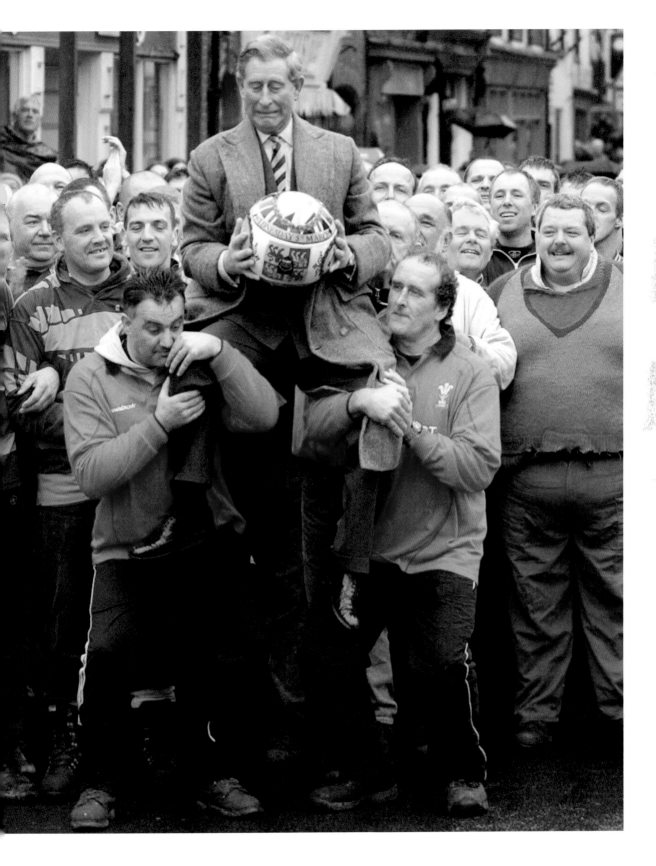

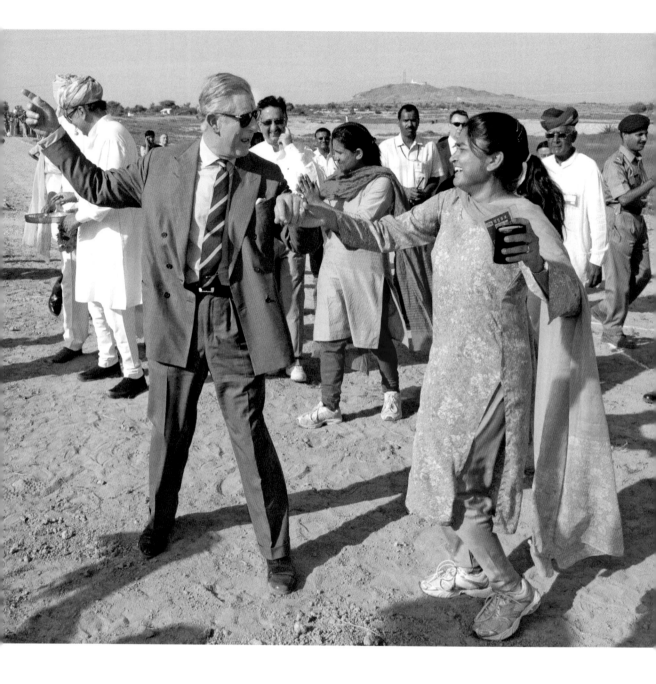

**▲ Long may he rain, 2008**

A great mover, Charles joins in with
local people in Rajasthan, India, in
their rain dance.

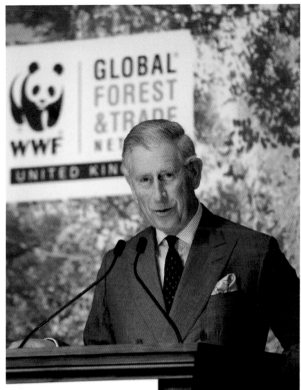

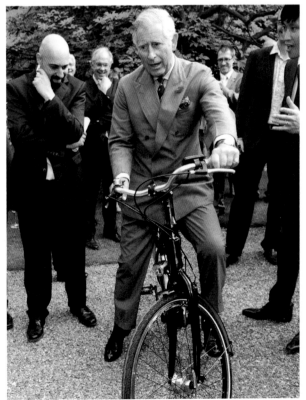

▲ **Cheers!, 2010**

When asked to taste Slivovitz brandy in Monravia, in the Czech Republic, Charles offered me a glass, saying, 'Why don't you give this a try, Arthur?' I replied, 'I don't drink,' and he responded, 'You should. It's delicious.'

◤ **Happy birthday WWF, 2011**

As a lifelong conservationist and President of the World Wildlife Fund, Charles delivered the keynote speech at St James' Palace for the charity's 50th anniversary.

▶ **Eco in action, 2011**

Prince Charles seized the opportunity to have a go on an electric bike, taking it round the garden of Clarence House at the launch of the Start eco-festival.

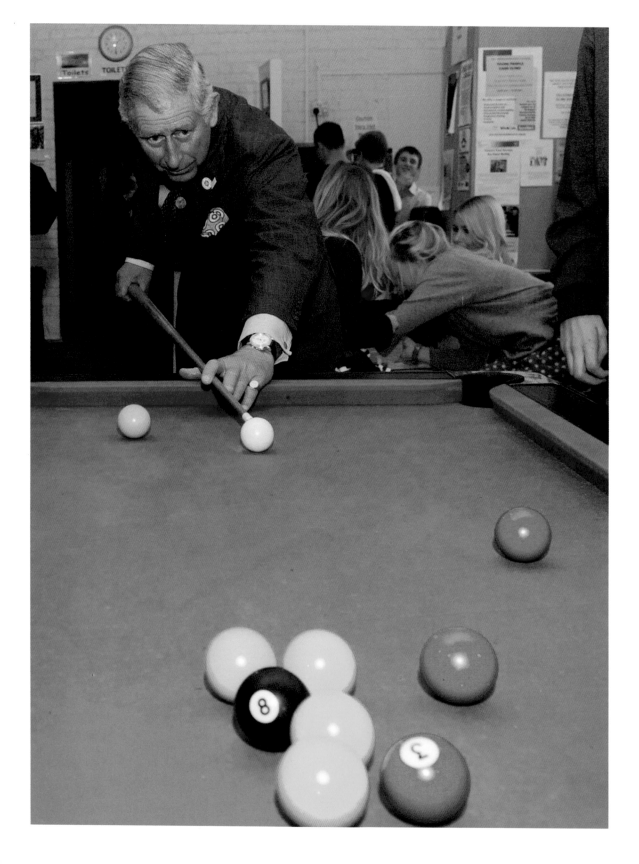

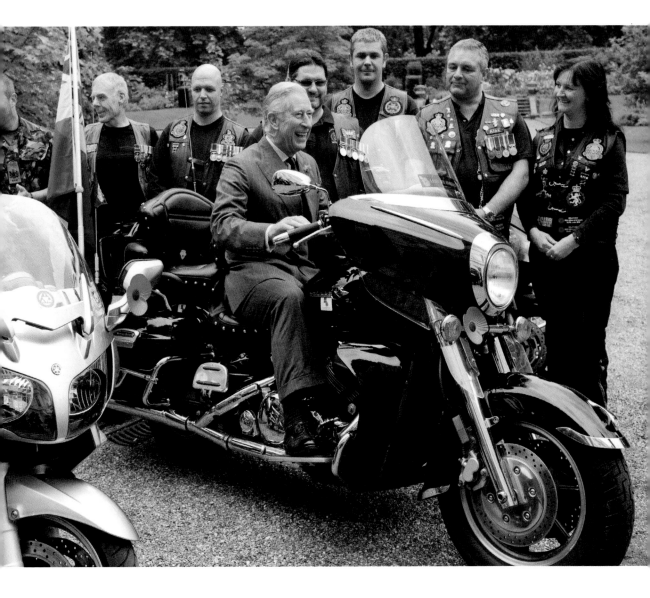

**◀ A quick game with the Upper Teesdale Agricultural Support Services, 2012**

His Majesty has always taken a keen interest in rural affairs and the people who live and work there.

**▲ On your bike, 2012**

Putting aside his well-documented fear of motorbikes and his sons riding them, the Prince met with bikers from the Royal British Legion Riders Branch as part of a Poppy Day campaign.

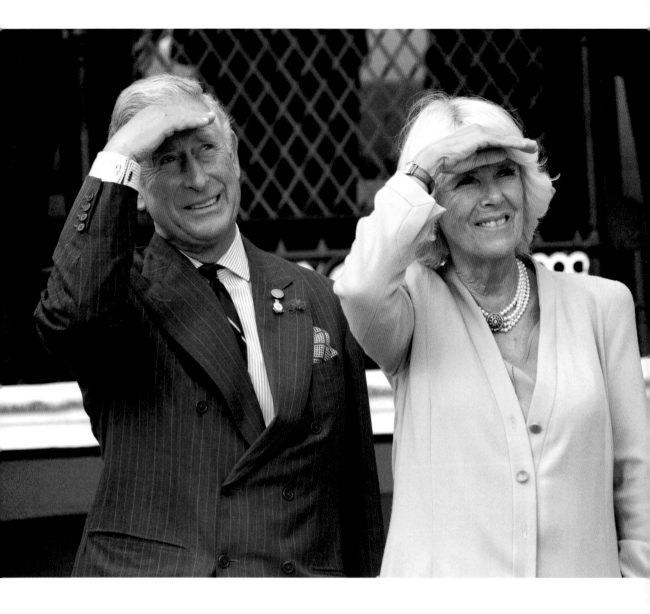

**▲ A Royal view at Bentley Priory, Stanmore, 2013**

The Royal couple shielded their eyes as a Hurricane and Spitfire flew above the Bentley Priory Battle of Britain Museum during their visit.

**▶ Dinner with Commonwealth heads, Colombo, 2013**

Camilla is just a very nice person. She's not vain. She dresses beautifully. She looks so much younger than her years. I mean, she's in her seventies, and that's a time when people put their feet up, but she's still working incredibly hard.

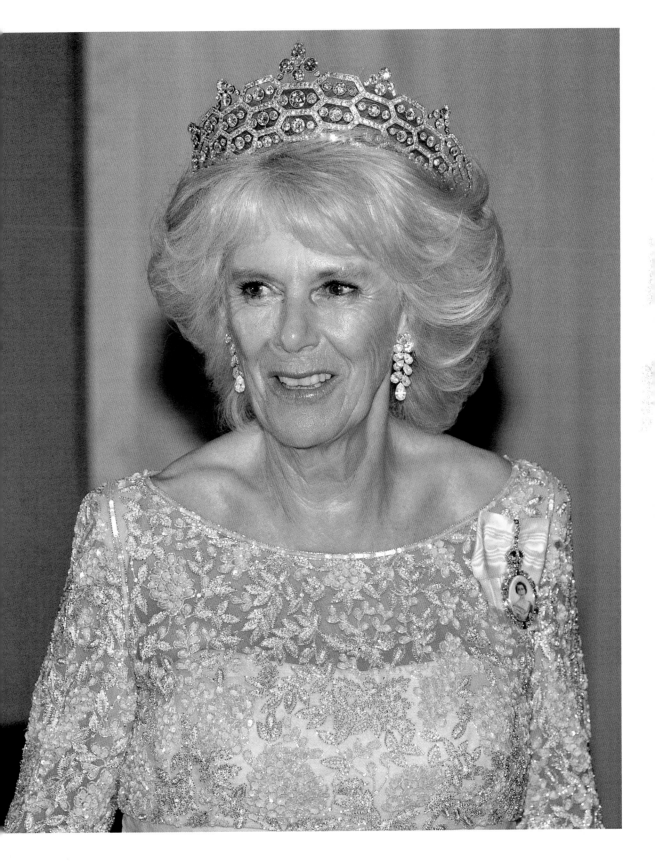

**◄ Dancing King, 2014**

Charles once again needs no encouragement to show off his fancy footwork along with a troupe of dancers in Campeche, Mexico.

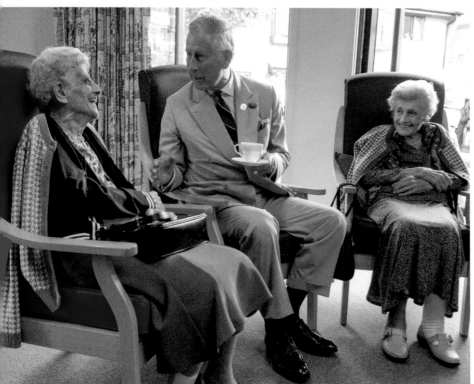

**◄ Prince of the people, 2014**

On a trip to Rutland, Charles and Camilla visited residents of the St John and St Anne Almshouse. A real man of the people, His Majesty is always happy to have tea and a chat.

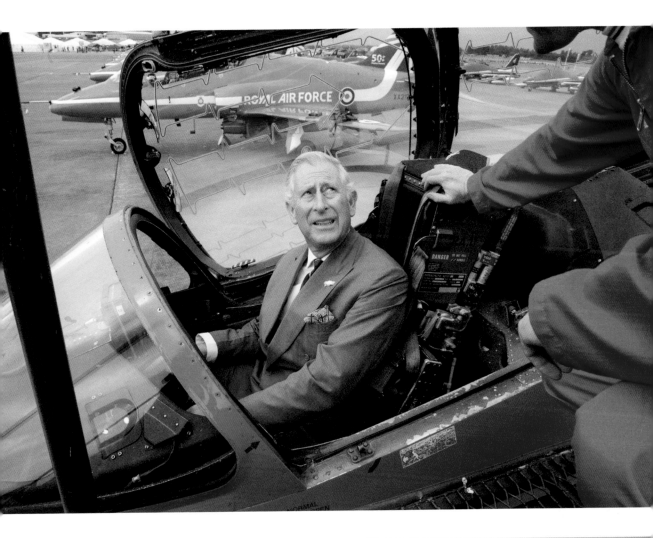

## ▲ Top Gun, 2014

Prince Charles attended the Royal
International Air Tattoo where he joined in the
celebrations marking the 50th anniversary of
the Red Arrows display team at RAF Fairford,
Gloucestershire. As ever, the Red Arrows put
on a stunning display and painted the sky red,
white and blue in their classic formation, along
with breathtaking aerobatics.

## ▶ Visiting Dubai's EXPO 2020 Bureau, 2016

His Majesty is hugely popular in the Middle
East.

**▲ Hospices of Hope, 2017**

**▶ Partner in crime, 2019**

On a visit to a children's hospice in Bucharest, Charles shared hugs and chats with its residents. Ever kind to all, he even cut and served me a slice of the delicious cake brought out to celebrate 25 years of the hospice!

Camilla is great fun and the perfect partner for King Charles. On Royal engagements she's always at his side, happy to sample some of the local brew at the Hofbräuhaus in Munich, to gaze at the Great Pyramids of Giza and to take a stroll along Grand Asne beach in Grenada.

'Camilla will support him in every possible way; she will encourage him, praise him. She will try to slow him down without saying, that's impossible!'

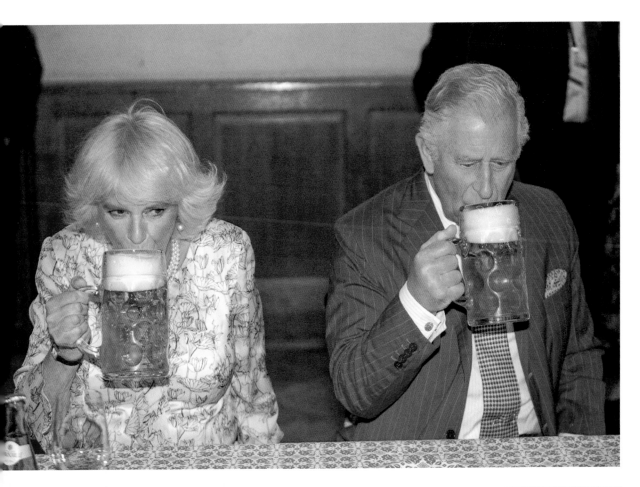

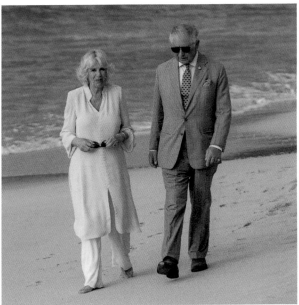

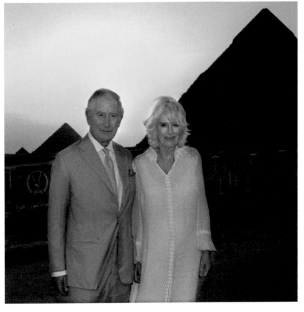

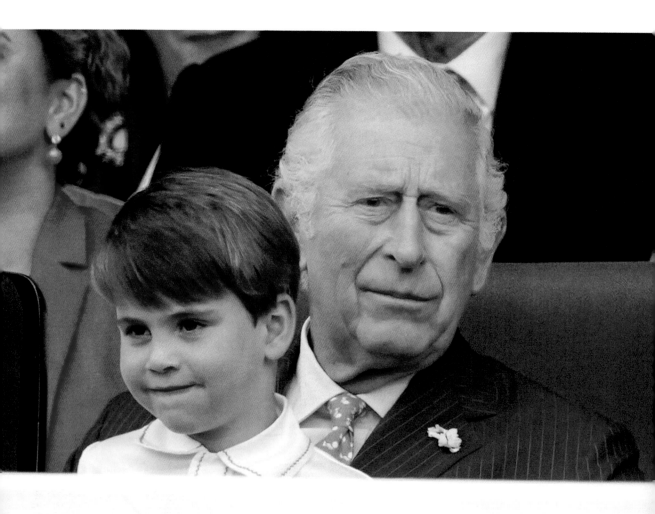

**▲ Doting grandfather, 2022**

Little Louis was getting excited and
fidgety at the Jubilee celebrations,
so he was passed on to his father,
William. Then he got passed on
to Charles, who I could see loved
tending to his grandson. I sent His
Majesty a copy of this picture – which
I hope he places in his archives.

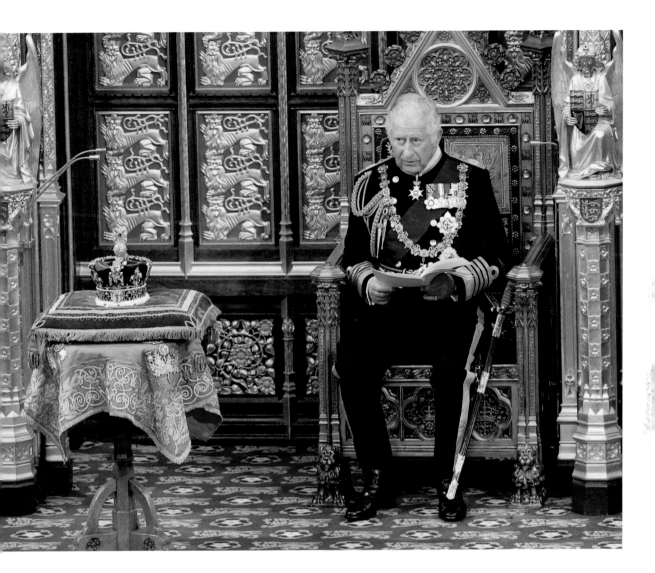

**▲ A glimpse of the future, 2022**

In the years leading to her death, we saw the Queen slow down. In 2022, Charles stepped up at the State Opening of Parliament and took on additional duties. The sudden death of the Queen shocked the nation, but King Charles III is the most prepared monarch-in-waiting we've ever had and will do a fantastic job leading our Royal Family into a new era.

'I think this man is special. I think he's not yet reached his potential. Every day he gets up and tries to do his best for other people.'

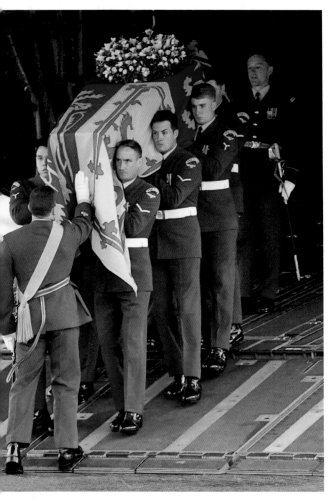

I'd followed the Queen across continents, photographing her radiant smile, for 40 years. Now it was time to say goodbye.

I have always tried to be dispassionate when photographing the Royal Family, but I'm not ashamed to say I broke down not once but twice at her funeral service, amid the splendour of Westminster Abbey. Tears came when I read the deeply moving order of service that reflected a life well lived. I wept again when the Queen's coffin passed my vantage spot in the Abbott's Pew, among the 2,000 souls honoured to be inside the Abbey.

The pomp and splendour on display that sunny September day surpassed anything I'd ever witnessed throughout my long career.

King Charles III was bereft as he walked behind his mother's coffin, but he did so with resolve. Behind the King were the Prince of Wales and his son George. The Queen may be gone, but her precious monarchy, that she did so much to preserve and strengthen, will live on.

◀ **The King and I, September 2022**

It was King Charles III's first day of his reign. He'd flown to RAF Northolt from Balmoral following his mother The Queen's death. After disembarking the aircraft he approached me and I said: 'Sorry for your loss, Your Majesty.' Charles replied: 'It had to happen some day.' RAF photographer Emma Wade captured the moment. Charles was in the first day of a job he'd waited for all his adult life, yet he was also grieving for his dear mother. I really felt for him.

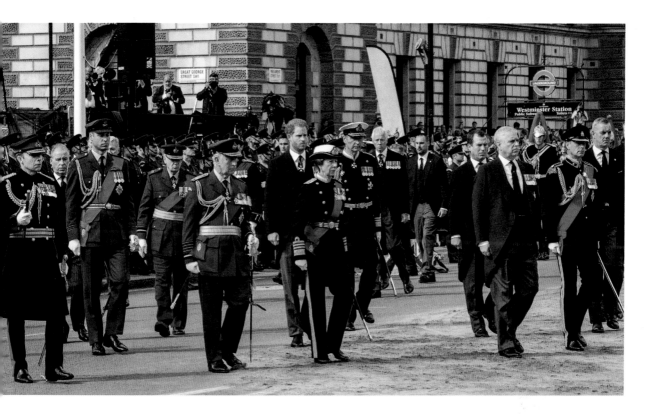

**◀ Back to Buckingham Palace, September 2022**

The late Queen's English oak casket arrives at London's RAF Northolt Airport from Edinburgh on board a Royal Air Force C17 Globemaster. Despite being incredibly sad about the passing of this wonderful woman whom I'd photographed so many times, I had to keep my emotions in check and make sure I captured the moment for posterity. Her coffin was then taken by hearse to Buckingham Palace.

**▲▶ A family in grief, September 2022**

The funereal walk from Buckingham Palace to Westminster Hall, where the Queen would lie in state for four days. King Charles and his siblings Anne, Andrew and Edward were in the rank behind their mother's coffin. They were followed by William, Harry and cousin Peter Phillips. It's such a powerful image – a family united behind their late matriarch. The Princess Royal played a key role in the mourning. She and Charles were at the Queen's bedside when she passed away at Balmoral Castle. Then Anne accompanied the Queen's coffin on its journey across the Highlands to Edinburgh and on to London. Anne will provide wise counsel to the King. I was so pleased to see the Prince of Wales and the Duke of Sussex walking side by side behind their grandmother's coffin.

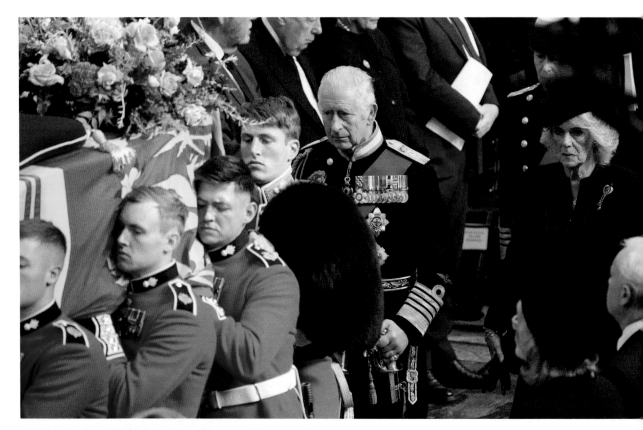

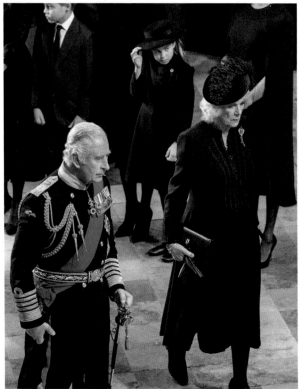

**◄ Goodbye to Gan-Gan, 19 September 2022**

Princess Charlotte tips her hat as the King passes in Westminster Abbey. I love this picture, seven-year-old Charlotte has so much character. She joined her older brother as they honoured the memory of the great-grandmother they called 'Gan-Gan'.

**▲ Westminster Abbey, 19 September 2022**

I had a ringside seat for history being made, but was choking back emotion as I took my pictures. In this photo you can see the pain of losing his dear mother was etched on King Charles's face.

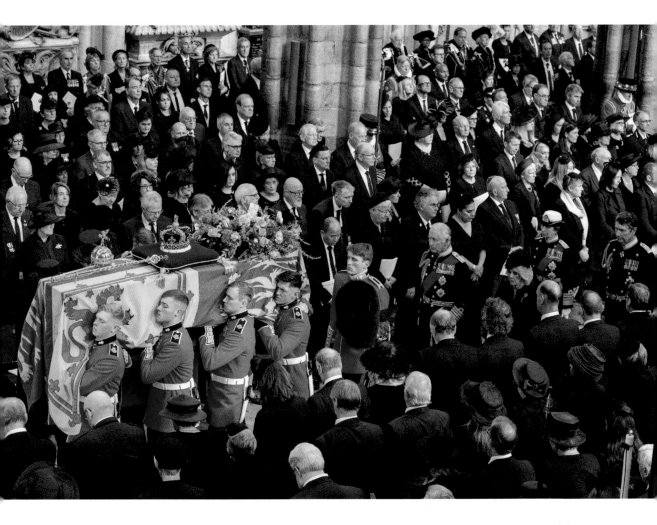

## ▲ Saying my farewells, 19 September 2022

I said my farewells to the Queen from the Abbott's Pew inside Westminster Abbey. It was an incredibly emotional day for the nation, and I was reduced to tears on a couple of occasions. You can see just how upset King Charles was as he walked behind the monarch he called 'Mummy'.

## ▶ Heirs to the Throne, 19 September 2022

The Prince of Wales brought along nine-year-old Prince George to Westminster Abbey to pay respects to his great-grandmother. It must have been quite overawing for such a young lad, but I believe it was the right decision to bring him. George will now better understand the great responsibility that awaits him in later life.

# Picture credits

While every effort has been made to trace the owners of copyright material reproduced herein and secure permissions, the publishers would like to apologise for any omissions and will be pleased to incorporate missing acknowledgements in any future edition of this book.

All images by Arthur Edwards © News Group Newspapers Ltd, with the following exceptions:

p.6, Richard Young/Shutterstock

p.7, Darren Fletcher/The Sun

p.8 (top left), News Group Newspapers Ltd

p.8 (top right), Eamonn M. McCormack/WPA Pool/Getty Images

p.8 (bottom left), With and Beans/Alamy Stock Photo

p.8 (bottom right), Paul Edwards/The Sun

p.9 (left and right), Paul Edwards/The Sun

p.10 (top), News Group Newspapers Ltd

p.10 (bottom), PjrNews/Alamy Stock Photo

p.11 (left), Paul Edwards/The Sun

p.11 (right), Chris Jackson/WPA Pool/Getty Images

p.12 (top and bottom), News Group Newspapers Ltd

p.13, Paul Edwards/The Sun

p.40, JB/Pool/Arthur Edwards/Reuters

p.42 (top), Courtesy of British Ceremonial Arts Ltd

p.42 (bottom), Gareth Fuller/Reuters/Alamy Stock Photo

p.43, © Michael Lloyd/Hyde News and Pictures

p.72 (bottom), News Group Newspapers Ltd

p.215, Arthur Edwards/Associated Press/Shutterstock

p.239 (bottom), Arthur Edwards/The Sun/PA Images/Alamy Stock Photo

p.246, Arthur Edwards/Pool via Reuters/Alamy Stock Photo

p.252, Arthur Edwards/Pool via Reuters/Alamy Stock Photo

p.273, Arthur Edwards/WPA Pool/Getty Images

p.282, News Group Newspapers Ltd

p.299, Arthur Edwards/WPA Pool/Getty Images

p.300, Emma Wade/RAF